Women in Welsh History

Women in Welsh History

by

Derek Draisey

Draisey Publishing

DRAISEY PUBLISHING
77 Geiriol Road
Townhill,
Swansea, SA1 6QR

First published in 2004 by Draisey Publishing
Copyright © Derek Draisey 2004

ISBN 0-9546544-1-2

Set in Times and Garamond by Logaston Press
and printed in Great Britain by
Biddles, King's Lynn

Contents

Acknowledgements

To Ann for all her love, for putting up with time spent in researching this work, and for her enthusiastic support and proof reading, and to her brother, Mike, for his welcome suggestions and support. Special thanks, as always, to the staff at the Swansea Central Library who made researching this work much easier by their unstinting assistance, in particular Mrs. Marilyn Jones for her continued support and kindness. Special thanks also to the staff at the Miners' Library, Hendrefoilan, for their ready assistance; to Prof. Deirdre Beddoe for allowing me to include a summary of her work entitled *Welsh Convict Women* (1979); to Ursula Masson for permission to refer to an article by her on women conscientious objectors during World War II, and for her permission, on behalf of the Swansea Women's History Group, to quote the statements made by a former munitionette at the Bridgend Ordnance Factory (the statements have been taken from Fay Swain's *Women: Wales and the Second World War*), to the University of Wales Press for permitting quotes from Teresa Rees's *Women and Work: Twenty-five Years of Gender Equality in Wales* (1999); to the British Library for the loan of several books, and for allowing an extended loan on one book in particular; to the National Library of Wales, to Carol Edwards and Bethan Lewis in particular, for assisting in research; to the Welsh Assembly, in particular Neil Cane, for providing the statistics for 1971 and 2001; to the National Museum & Galleries of Wales (Nantgarw), in particular Peter Bennett, for his assistance in selecting images; to the Museum of Welsh Life (St. Fagans), in particular Lowri Jenkins, for her assistance in selecting and tracing the whereabouts of images.

Also to be acknowledged are the Museum of Welsh Life (St. Fagans) for permission to reproduce the image on p.85 (love spoon), on p.88 (bidder), on p.89 (bidding wedding), on p.114 (worker's home) and on p.116 (domestic); the National Museum & Galleries of Wales (Cardiff) for permission to reproduce the image on p.76 (Katheryn of Berain), on p.117 (surface hauliers), on p.165 (porters), on p.172 (Smith's Clocks), on p.173 (tinplate girl) and on p.183 (Rhymney women); the *Western Mail and Echo* for permission to reproduce the photograph (Welsh Pit Disaster) on p.119 and the cartoon (Peaceful Persuasion) on p.120; the National Archives for permission to reproduce the image of a Welsh soldier on p.26; to Plaid Cymru for permission to reproduce the cartoon (Bevin's Breakfast) on p.166. The photograph of the Ace sisters on p.122 was taken by Henry Chapman and is reproduced by kind permission of Michael Gibbs. The images on p.25 (Welsh couple kissing), on p.106 (Welsh costumes No. 6, *The Bidding* by Newman and Co.),

on p.107(Welsh costumes No. 2 by Newman and Co.), on p.119 (Senghenydd disaster), and on p.137 (Amy Dillwyn 1907) are reproduced by permission of the National Library of Wales. Finally to family and friends for permission to reproduce all other images that are not listed above.

Special thanks is also due to Paul Copp for his sketches of women in various dress (on pp.1, 6, 27, 141, 142); to Christine Einion for the cover design; to Ron Shoesmith, FSA, for the layout of the text and his perfection of maps and diagrams; and to Andy Johnson (Logaston Press) whose willing assistance made this publication possible.

The courteous assistance of all the above is commendable.

Derek Draisey
August 2004

Chapter I
Women in Celtic and Roman Wales

Celtic Women — their Appearance

The 'women, dressed in black like the Furies, were thrusting about' among the men arrayed for battle, 'their hair let down and streaming, brandishing flaming torches'.

That is how the Roman historian, Tacitus, described women on Anglesey in the late 1st century A.D. It is the earliest known reference to women in Wales; it is also the only one that relates to the period under review. In order to expand on Tacitus's account it is, therefore, necessary to consider what other Classical writers — Roman and Greek — have to say about Celtic women in general. One writer claimed they wore trousers, which may well be true, but the most common attire of women throughout Europe at that time was the *peplos*, consisting of two strips of material, one to cover the front of the body, one to cover the back, which were stitched together at the sides. The *peplos* was held together at the shoulders by brooches, and in Mediterranean countries it fell to the ankles. It is also likely that Celtic women wore wrap-around skirts. The material used for all such clothing, including the cloaks that were common to all Europeans, was either linen or wool, often tweedy with tartan patterns. Long hair, hair-pins, eye shadow and jewellery in the form of necklaces, bracelets and anklets complemented their appearance.

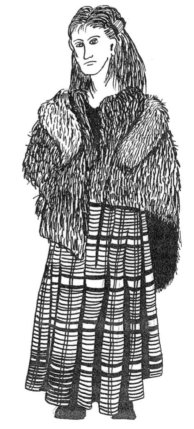

Celtic woman in fur cape and a wrap-around tartan skirt

Marriage

In the mid-1st century B.C. Julius Caesar claimed that, with regard to the Celts in Britain,

> The wife was owned by 10 or 12 men, the husbands being each others brothers, fathers and sons, the children belonging to the nominal father who had contracted the marriage and taken the woman into his house, a form of polygamy in which the woman has more than one husband, all living in one large house.

Caesar also claimed that, in Gaul (France and the Low Countries),

> When (*Celtic*) men marry, they receive a dowry (*pecunia*) from their brides, to which they add a portion of their own possessions that is equivalent in value after assessment; they keep a single account of this common property and preserve all that is accumulated from it. When one of them dies, the surviving spouse acquires both portions with the accumulated profit. Husbands have the right of life and death over their wives and children. Whenever a high-born head of a family dies, his kinsmen assemble and, if there is any suspicion surrounding his death, the wife is interrogated as if she were a slave. If she is found guilty, she is put to death by fire after suffering torment.

Living Conditions

The houses of Continental Celts were described by one Classical writer as 'large and circular, built of planks and wickerwork, the roofs being a dome of heavy thatch', added to which the late 1st century B.C. geographer, Strabo, observed that British Celts lived in enclosures, like round kraals, in which they kept their cattle. In Wales, there are hundreds of enclosures known as hill-forts, most of them partially or completely surrounded by one or more banks and ditches. The majority of these so-called forts are believed to have been defended homesteads, the interiors of which — encompassed by a palisade — were large enough to contain one of more circular huts and sufficient space to herd cattle. It requires little imagination to picture a household of three or more generations occupying any one of these defended enclosures.

The hill-forts in Wales were not occupied all at the same time, but at various times between 1,000 B.C. and 600 A.D., which suggests immigration and settlement by small, kindred groups over a long period of time. On the other hand, it could be argued that the hill-forts were a product of troubled times, that Celtic culture spread as a result of contact and trade, but the fact remains that people speaking a Celtic tongue did settle in Wales, as evidenced by the Welsh language. Their numbers, however, would appear to have been relatively small because one classical writer described the Continental Celts — whose heartland encompassed Austria, Bavaria and Switzerland — as 'tall, their flesh moist and white ... their hair naturally blond', whereas in Wales the evidence points to a people who were short and swarthy, usually with dark curly hair. These differences may be explained by the fact that the warlike Celts are known to have absorbed other people into their tribal entities,

people whom they subjugated, and upon whom they imposed both their language and their culture. It is even possible the immigrants were, for the most part, non-Celtic people who had been celticized long before their arrival in Wales.

Two Formidable British Women

Celtic women were not matriarchs. The descent of a woman's children was reckoned through the nominal husband and his forefathers. Only when a child was born out of wedlock was descent reckoned through the mother and her forefathers. Yet there are hints that some high-born British women exercised a degree of political and military leadership — for example, Boudicca, Queen of the Iceni, is often portrayed as a formidable leader in battle, but the Roman historian, Tacitus, does not portray her as such. The Iceni were a Celtic tribe that occupied East Anglia and when, in 43 A.D., the Romans invaded Britain and took control of what is now south-east England, the Iceni voluntarily acceded to the Romans, the consequences of which was that their country became a client kingdom.

Eighteen years later, when Prasutagus, King of the Iceni, died, it became apparent that he had made the Emperor, Nero, 'his heir, along with his daughters, under the impression that this token of submission would' ensure that his kingdom would pass to his daughters. Unfortunately, the Roman administrators in Britain took the bequest literally with the result 'that his kingdom was plundered by centurions, his wife, Boudicca, was flogged, his daughters were outraged and all the chief men were stripped of their ancestral possessions'. These acts drove the Iceni and several other tribes to revolt, and when Roman troops met them on an unlocated plain in the Midlands:

> the army of the Britons was so fierce in spirit they brought with them, to witness the victory, their wives riding in wagons, which they placed on the borders of the plain ... Boudicca, with her daughters before her in a chariot, went up to tribe after tribe, protesting that [while] it was indeed unusual for Britons to fight under the leadership of a woman,

they should at least fight for freedom. The outcome of the battle was that the Iceni and their allies were massacred and Boudicca poisoned herself.

What is noteworthy about Tacitus's account — which was written within living memory of the event — is that he stated 'that it was unusual for Britons to fight under the leadership of a woman', that the women who were present at the battle were there as spectators; moreover, we may surmise that Boudicca did not lead the rebellious tribes into battle, for if she had, she would surely have died in the massacre. Boudicca, therefore, did not have political or military leadership by right, but had seized the opportunity to wreak vengeance on the Romans for their brutality. Had the Romans lost, then the Kingdom of the Iceni would have been divided between her daughters, and their husbands would have become kings. This form of succession may, in the absence of heirs, have been the reason why another Celtic woman was able to leave her mark on British history.

Cartimandau was Queen of the Brigantes, apparently a federation of Celtic tribes occupying what is now the north of England. As a client ruler she made the decision, in 51 A.D., to hand over to the Romans the most wanted man in Britain — Caratacus — who had taken refuge in her realm. A few years later, Cartimandau's husband, Venutius, took up arms against her, supported by those who found feminine rule abhorrent, but the rebellion was quelled by Roman troops. Trouble broke again in c.70 A.D. when Cartimandau deposed her husband in favour of his arms-bearer. So serious was the backlash that Cartimandau had to be rescued by Roman troops while her former husband usurped her realm.

Celtic women were, nevertheless, considered formidable by several Classical writers, one of whom, Marcellinus Ammianus, declared that:

> A band of foreigners would be unable to contend with a *Celt of southern Gaul* if he called his wife, for stronger than he is she, with flashing eyes; least of all when she swells her neck and gnashes her teeth, and poising he huge arms, begins to rain blows, mingled with kicks, like shots from a catapult. The voices of most women [in these parts] are formidable and threatening, irrespective of whether they are friendly or hostile.

Romanization

It took the Romans more than 30 years to subjugate Wales; thereafter the country was part of the Roman Empire for over 300 years, though whether the whole population was subject to Roman law is an open question. Not only is there no recorded history relating to Wales during this 300-year period, but archaeological evidence suggests that romanization in the region was uneven. Initially, the country was studded with forts, almost all of them garrisoned by auxiliary troops from all over the empire; there was even a legionary fortress at Caerleon. With or without official sanction many of the soldiers married — presumably local girls or slaves — the wives living in settlements outside the forts. There were also Roman citizens and retired soldiers living in the towns at *Venta Silurum* (Caerwent) and *Muridunum* (Carmarthen) in Wales and *Magnis* (Kenchester) and *Ariconium* (Weston under Penyard) in southern Herefordshire. The most romanized area was in the south-east — in southern Herefordshire, in pre-1974 Monmouthshire and in the Vale of Glamorgan — where the remains of villas have been unearthed. In all these places Roman law is likely to have prevailed. Elsewhere, a Celtic way of life may have persisted.

Roman Law Relating to Women

Under Roman law a woman would appear to have been placed in a more subservient position than her Celtic counterpart. The head of a Roman household (the *paterfamilias*) had authority over not only his children, but his grandchildren and great-grandchildren as well, having power, until 374 A.D., to dispose of unwanted offspring if they were illegitimate, or physically or mentally deficient by dumping them on rubbish tips, or selling them as slaves. No child, not even a great-grandchild, could marry without the *paterfamilias's* consent.

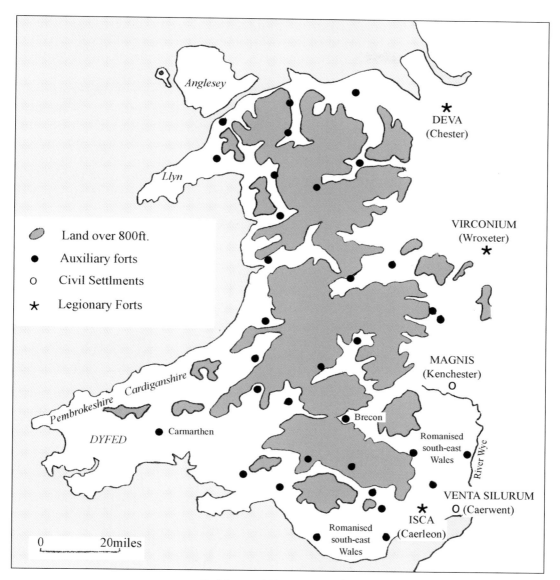

Legend:
- Land over 800ft.
- Auxiliary forts
- Civil Settlments
- Legionary Forts

Anglesey

Llyn

DEVA
(Chester)

VIRCONIUM
(Wroxeter)

MAGNIS
(Kenchester)

Cardiganshire

Pembrokeshire

DYFED

Carmarthen

Brecon

Romanised
south-east
Wales

River Wye

VENTA SILURUM
(Caerwent)

ISCA
(Caerleon)

Romanised
south-east
Wales

0 20miles

Celtic and Roman Wales

Marriage, according to Roman law, was a civil contract, not a religious union, and all the parties were required to determine was whether the couple would live together as man and wife. In Caesar's day, the usual form of marriage was that of *manus*, which was distinguished by a ceremony whereby the *paterfamilias* performed, in the presence of witnesses, a fictitious sale and delivery of the bride to the husband, thereby signifying that she had been given over to the paternal authority (*patria potestas*) of the husband, or his *paterfamilias*. Whatever property accompanied the bride passed

into the hands of the husband's family, the bride having no right thereafter to dispose of it, nor would it ever be returned to her own family in the event of her death. The woman became, in fact, a victim of circumstance, having no right to divorce, although the husband could divorce her.

By the time the Romans had subjugated Wales this form of marriage had been overshadowed by one in which a contract was concluded in the presence of witnesses. Part of the contract would have been relevant to property and, in time, it became customary for a bride to be endowed with a dowry (*dos*) by her parents, which remained hers until death, subject to forfeiture in the event of misconduct. At a later date a woman was also endowed, prior to marriage, with a *donatio ante nuptias* by the husband, which she could claim only if her husband predeceased her; it was intended to support her in the event of widowhood.

Another advantage of a marriage by contract was that a couple could divorce by mutual consent providing they did so in writing and in the presence of seven witnesses. However, should one of them divorce the other against the latter's will, the former incurred heavy penalties unless the divorce was on grounds of adultery or criminal misconduct. It would appear also that in this form of marriage the woman was, to some extent, still under the dominion of her own *paterfamilias* who could dissolve the marriage at will. After divorce both parties were free to remarry.

Yet another form of marriage was that of continued cohabitation, which must surely have prevailed among the auxiliaries who were stationed in Wales as well as the merchants and craftsmen who serviced the garrisons' needs. An example of this type of marriage is evidenced by two memorial inscriptions discovered at settlements near Hadrian's Wall. One inscription at Corbridge commemorates Barates of Palmyra in the Middle East, who furnished the Roman army with military standards and flags. The inscription to his wife, Regina, was found several miles away at South

Woman in a 'peplos' — a form of dress that would undoubtedly have been worn by women in the romanized parts of Wales

Shields. This second inscription makes it clear that Regina was originally Barates' slave, whom he freed and married, and that she was a British Celt, a member of the Catuvellaunian tribe that occupied territory north of the River Thames.

What is particularly noteworthy about Roman law is that a boy became of age and, therefore, marriageable at 14; a girl at 12. Marriage to first cousins was prohibited until legalized during the latter part of the Empire. As to children born out of wedlock, they followed the condition of the mother, but they could be legitimatized by the putative father if he admitted paternity.

To what extent these marital arrangements were applicable to Wales is difficult to determine. They would surely have been applicable to the wives of centurions, legionaries, auxiliaries, traders and craftsmen. They may even have been applicable to the wives of romanized Celtic landowners – privileged aristocrats who had become Roman citizens, who wore the toga, who owned villas in the countryside and imposing houses in the towns where they served on the local councils. In 207 A.D. Roman citizenship was extended to all free men, but in Wales free men are believed to have been a minority, most of them far removed from even the outposts of Roman civilization. It would appear, therefore, that only a minority of women in Wales were affected by Roman law.

The End of Roman Rule
Roman rule effectively ended in c.410, but a romanized way of life, even a form of imperial government, was still evident in Britain 40 years later, and may have persisted, albeit in decline, until the early 6th century when it becomes apparent that Angles, Saxons and Jutes had established themselves in the coastal areas adjoining the North Sea and the English Channel. Elsewhere petty kings had taken control of the country, by which time, Roman law in Wales may have become a dead letter and a people unaffected by Roman law had established themselves in the most westerly parts.

Irish Settlement
Wales suffered increasingly from Irish raids from the mid-3rd century onwards, but immediately before or soon after 400 A.D. the Irish turned to conquest and colonization, their arrival in Wales coinciding with a period when Roman troops were withdrawn from mainland Britain. The records, questionable though they are, refer to an Irish presence on Anglesey, in the Llyn Peninsula and throughout west Wales, particularly in Cardiganshire and northern Pembrokeshire were countless place-names testify to a concentration in Irish settlement. These settlers would have brought with them their laws — laws that, because Ireland never experienced Roman occupation, were akin to the old Celtic laws of Caesar's day, but modified to the detriment of women.

Irish Law

A great deal is known about Irish law because much of it was written down by professional jurists known as *fili*, the earliest redaction being the *Senchus Môr* of mid-5th century A.D. date. The *fili* — later known as *brehons* — were arbitrators who only interceded in a dispute when called upon to do so; they were the upholders of customary laws, and what is ever apparent about these laws is the importance attached to kinship. With regard to women, they were certainly not 'owned by 10 or 12 men' as polygamy was no longer in vogue. As to a woman's status, this was considerably less than that of a man — for example, her honour-price, should she be insulted, was, if she were married, half that of her husband, which in turn was calculated according to his position in society.

Marriage, according to Irish law, was a civil contract; there was no require-ment for a religious ceremony unless the parties so wished it. What was required was the consent of both the woman's relatives and the chieftain of her kindred group, irrespective of whether she was a maiden or a widow. Failure to obtain consent was considered an insult to the kindred group, which had to be compen-sated for if a blood feud was to be avoided. If consent was given, the woman was, then, made a gift of kin and delivered to the husband, but under no circumstances was she expected to marry beneath her status.

As in most European societies at that time, marriage entailed the transfer of property, and Irish law refers to a dowry, or marriage collection, provided by the woman's relatives, a third of which went to the husband. A more important gift in the form of a dowry (*coibche*) was provided by the husband, supposedly for the benefit of the wife, but the *coibche* went to the woman's father, if he were alive, to a brother or the chieftain if he were not. Should the husband prove unfaithful, he was obliged to pay the woman her honour-price, which could not be subse-quently taken from her.

Anyone who took a woman without her kindred's consent was considered an abductor, even when the woman absconded of her own free will. If she was abducted by force, violated or deflowered by deception, the man responsible became liable to pay the woman's honour-price to her kindred group, to her immediate relatives and to the woman herself, and also the woman's blood-fine (the worth of her life) if, as a result of abduction, violation or deception, she died giving birth to a child. If the woman absconded of her own free will, no honour-price was payable to her, only to her kin. As to her relationship with the abductor, if this endured by continued cohabitation for a month, it became recognized as a marriage, but only as one less reputable than a union that had the consent of kin.

Under normal circumstances children belonged to the father, but in cases where a woman was abducted, either by force or with her consent, and became pregnant within a month, then the child belonged, not to the natural father, but to the woman's father. If pregnancy had been the result of abduction by force, the

woman's relatives could sell the child to the natural father; if they chose to do so, the natural father had no option other than to purchase the child. If the woman had absconded of her own free will, the natural father had the option of purchasing the child; if he chose to do so, the relatives had to sell.

In a marriage that had the approval of kin, the couple could separate by mutual consent, the property of both parties being divided lawfully. The same rules applied to a marriage by continued cohabitation, except that there was no division of offspring — the children belonged to the father. A wife, however, could separate from her husband if he made a habit of committing adultery. If he brought a strange woman into the house, he insulted her to the extent that, not only could she leave him, but she was entitled to demand her honour-price from both the husband and the strange woman; moreover, she was not held account-able for any violence, through jealousy, which she directed at the intruding woman.

When a woman had a child out of wedlock, it could prove difficult for her if she gave birth to a girl, but if the child was a boy, it was more likely for a man to admit paternity even though the child might not be his, the reason for this being that it increased the man's share in tribal land. The boy also benefitted from being affiliated and, therefore, legitimized because, when he became of age, he had a right to succeed to tribal land. It would go ill for the boy if he were not affiliated because, in one ancient manuscript, it states: 'children born of harlots shall not get a share of land; they belong to the tribe of the mother'.

The End of Irish Domination

It would appear that, in North Wales, Irish domination was short-lived because, according to tradition, a warlike people known as the Votadini were relocated from 'the district of Manau Gododdin' in southern Scotland to North Wales under their leader, Cunedda, who:

> *came with his eight sons ... and expelled the Irish ... with great slaughter, so that they never came back to live there again.*

This event has been dated to the late 4th or early 5th century, but in South Wales the Irish held onto power in what later became known as Dyfed until *c*.500 when they were apparently subdued by forces sent by a British government.

Welsh Law

It can confidently be assumed that native laws survived both Roman rule and Irish domination, and from the 7th century onwards there are a growing number of references to these laws and how they were upheld until, finally, law books that have survived from the 13th century onwards make it plain that these laws, espe-cially the ones relating to women, were unique. They were certainly not Irish laws (though they were undoubtedly Celtic in origin) nor were they a survival of the

laws that existed in the late Roman Empire (although they were influenced by them) — but before considering the position of women according to Welsh law it is necessary to reflect on the society in which they lived.

CHAPTER II
Welsh Society and Law

Status

To understand the position of women in Wales during the Medieval period — that is, the period between the 6th and 16th centuries A.D. — it is necessary to have insight into both the society in which they lived and the laws that governed their lives. Little is known of Welsh society prior to the 6th century. Thereafter it becomes increasingly evident that, with regards to status, there were two main classes — the free and the unfree (which at this stage may be equated with serfs), and the distinction applied to both men and women. It has been said, though not proved, that the free were the progeny of Celts — or celticized people — who began migrating into Wales as far back as the Late Bronze Age, whereas the unfree were the descendants of pre-Celtic people who, in the course of time, adopted a Celtic identity. Whatever the truth, the free were the dominant element in Welsh society, though not necessarily the most numerous class. It has been suggested that the free were originally a minority, their numbers rising steadily until, by the time of the Domesday Survey of 1086-7, they constituted about 31% of the Welsh population; perhaps 50% some 200 years later.

Kinship

What is ever apparent about the free is the importance they attached to not only status, but to blood relationships, both on the spear (father's) side and on the distaff (mother's) side. Every free person in the eyes of the law was presumed to have belonged to a *cenedl* (meaning kinship primarily, but in this context a kindred group), the members of which believed themselves to be descended from a common ancestor — real or imagined — in the male line; moreover, the bloodline claimed by members of some *cenhedloedd* were astonishingly lengthy. For instance, in the 9th century, an unnamed *cenedl*, led by a chieftain named Marr, migrated to North Wales from Strathclyde in southern Scotland, and did so at the invitation of a king of Gwynedd, either Rhodri Mawr or his son, Anarawd. One branch of Marr's *cenedl*, that of Edred ap Marchudd, was frequently referred to in a survey of 1334, which recorded that over 230 men of this particular *cenedl* held land, making it the largest of the 15 principal *cenhedloedd* that are known to have

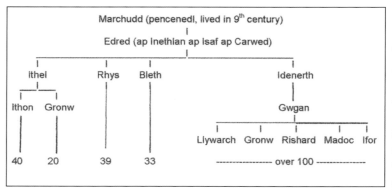

existed in North Wales at that time. The *cenedl* of Edred (who presumably lived in the 10th century) was still in existence in 1538, by which time its members were claiming a bloodline that stretched back some 600 years.

The nine gwelyau *and the number of landowners* (uchelwyr) *in the* cenedl *of Edred ap Marchudd in 1334*

The *Cenedl*

Unlike the Scottish Highland clans of the Early Modern period, the *cenhedloedd* of Wales did not occupy tribal territories. The original settlement area of Edred and his immediate descendants appears to have been in the vill of Llwydcoed, near Colwyn Bay. As Edred's *cenedl* grew in number, so too did their need for more land, but the *cenedl* could only expand peacefully into areas that were unoccupied. This led to the acquisition of dispersed holdings, and by 1334 the *cenedl* could lay claim to numerous holdings scattered throughout North Wales. In times of war, or in support of a blood feud, 230 men could be a force to be reckoned with, but for the purpose of holding land on a communal basis a *cenedl* of that size was unwieldy. Therefore, a *cenedl* of more than 20 landowners tended to split into smaller, more manageable *cenhedloedd*, though without severing their blood ties, which the members of the sub-*cenhedloedd* preserved by continuing to elect an overall chieftain known as a *pencenedl*. Edred's descendants, for example, had by 1334 split into nine sub-*cenhedloedd*, two of which were named after his sons, Rhys and Bleth, two after his grandsons, Ithon and Gronw, and a further five were named after great-grandsons.

The *Gwely*

From the 12th century onwards the term *cenedl* was gradually superseded by that of *gwely*, its literal meaning being 'bed' or 'resting place'. The connotation of *gwely* in the Medieval period, however, was a kindred group — be it a small *cenedl*, or a subdivision of a large *cenedl* — that had banded together for the purpose of holding land on a communal basis. That is not to say every landowner within a *gwely* had an equal share in *gwely* land (*tir gwelyog*; also *tref y tad*). The Welsh system of partitionable inheritance (*cyfran*), otherwise known as gavelkind, meant that when a man died his land was shared equally between his sons regardless as to whether they were half-brothers, legitimate or not. The accompanying figure illustrates how three sons shared their father's land, each receiving one third of their father's

estate. With regards to grandsons, however, there was a considerable difference in the amount of land each grandson stood to inherit.

No member of a *gwely* could alienate his land by sale or gift — although he could lease it on a short-term basis — nor could he deforest without the consent of the other

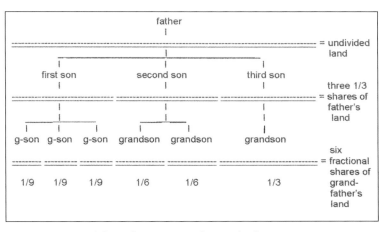

Partitionable inheritance through three generations

members of his *gwely*. When it came to paying dues to the king, all members contributed to a single payment. When it came to ploughing, it was done on a communal basis known as co-tillage according to contract. In short the members of a *gwely* — both men and women — jealously guarded their communal interests; they were a support to one another, especially against outsiders. The *gwelyau,* or at least their survival, was the reason why the Welsh married near relatives, for it was a means of keeping property within their kindred groups; hence the old Welsh proverb: 'marry in the kin and fight the feud with the stranger'.

Kinship by Degrees

It was not enough for anyone to know they were descended from a remote ancestor in the male line, for there were times when both men and women needed to know exactly who were of kin to them and to what degree. Relationship in four degrees was particularly important in that it had a direct bearing on the ownership of land

and the marital arrangements of a woman. In the case of a man, it was imperative that he could trace his descent in the male line to the great-grandfather from whom he inherited exclusive rights to a share in *gwely* land. For example, if a man occupied land, he had no right to exclusive possession, nor did his

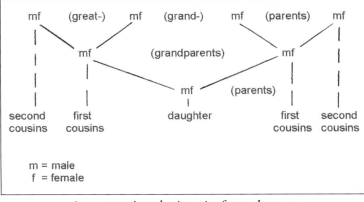

A woman's relatives in four degrees

sons or grandsons, but when, after three generations of uninterrupted occupation, a great-grandson succeeded to the land, then that great-grandson (the fourth man) acquired *priodolder* rights — rights to exclusive possession — and no one, not even a king, had the right to remove him from his land. Even if the great-grandson abandoned the land for any length of time, he could still return and reclaim it as his own. If he did not return, then any of his descendants, up to nine generations (the ninth man), could return and, in theory at least, reclaim the land as his. In practice, however, an absence of nine generations was time enough for another family to move in and acquire *priodolder* rights, in which case the returning ninth man was entitled to only a portion of the land in question.

With regards to a woman, if a man approached her father for her hand in marriage, the father had, then, to consult with all who were related to his daughter in four degrees, both on the spear side and on the distaff side, everyone, that is, who was descended from any one of her eight great-grandparents, be they male or female. Consultation with all these relatives might result in the woman being bestowed in marriage as a gift of kin (*rod o cenedl*) by her father, or, if he were dead, by her brothers, or failing them, by men related to her in four degrees, be they first or second cousins. The reason for all this family involvement was movable property, and women had as much an interest in that as any man.

Kinship in seven degrees could, on occasion, be equally important, and although Welsh law expressed this relationship from a man's point of view, it was, nevertheless, applicable to a woman. For instance, if a man killed another, whether intentionally or by accident, he was obliged to compensate the dead man's kin by paying them the dead man's blood-fine (*galanas*). If the victim had been a free man, the blood-fine could vary between 63 and 252 kine (cows which, for the greater part of the Medieval period, had a fixed value of five shillings per head), depending on the victim's status. Few free men would have had the means to forgo 63 kine let alone 252. The law, however, provided a way of overcoming any deficit — to prevent a disruptive blood feud — in that the guilty party was at liberty to demand assistance from anyone related to him in seven degrees, be they men or women, both on the spear and the distaff sides — anyone, that is, who was related to him by descent from any one of his 64 great-great-great-great-grandparents. Kinship for the express purpose of paying a blood-fine was referred to as a *galanas-cenedl*, but that did not mean that it was an easily identified association because no one, except brothers and sisters, could have identically the same people of kin to them in seven degrees. At one time the blood-fine thus raised went to the dead man's *galanas-cenedl* to be shared among its members, but by the late 12th century one third went to the king.

In the event that a full blood-fine could not be raised, the guilty party could extend his circle of kinship by two degrees (to within nine degrees) and demand from anyone so related a 'spear-penny', providing he did not call on a woman or a cleric. How all this collection and distribution was achieved in an overwhelmingly illiterate society is not known. What is known is that the same rules applied to a

woman whether she was the victim, or the person responsible for someone's death. Even if she was not involved in someone's death, she was still liable to contribute to, or receive a share in, the blood-fine because, like a man, she held movable property in her own right, even when married.

Men!

When a woman looked beyond her abode her horizon was invariably limited to the scattered homesteads of her own and neighbouring *gwelyau*. If she had an eye for men, she would, if she considered their status, be aware that free men fell into one or other of three categories. Most were *bonheddigion* (gentlemen), the value placed on their lives, should they die at someone's hand, being determined according to whether they were married or not. The pecuniary worth — or blood-fine — of an unmarried *bonheddig* stood at 63 kine; that of a married *bonheddig* 84 kine. A minority of free men ranked as *uchelwyr* (high men), their pecuniary worth varying between 126 and 252 kine. The *uchelwyr* were the heads of households, the owners of *gwely* land; they were the men who assembled to discuss matters affecting the community in which they lived, judicial or otherwise.

Halls

In the late 12th century, Gerald de Barri claimed 'the Welsh content themselves with small huts made of boughs of trees twisted together, constructed with little labour and expense, sufficient to endure for a year'. A house of this sort was known as a hall (*neuadd*), a longhouse by today's definition, being on average about 14m. in length by half as wide. Extant lawbooks provide a glimpse of their construction when they refer to six roof-trees, which were arranged in pairs to form arches — one pair placed midway along the length of the building, one pair near each of the opposing ends. The purpose of the roof-trees was to carry ridge-poles, from which rafters sloped to rest on, and extend beyond, low walls of turf or stone. The roof, which might be of straw, broom or even sods, reached almost to the ground. There were usually two doorways, each with a porch, set opposite each other about midway along the length of the building. A fire occupied a central position between the middle roof-trees. One half of the hall may have been occupied by cow stalls; the other half served as living quarters. Two parallel rows of posts (between the ridge-poles and the low walls) provided additional support for the rafters, creating, where the roof was low, side aisles for sleeping and storage. A description of conditions within a hall is to found in an old Welsh tale known as *The Dream of Rhonabwy*; it reads

> As they [the travellers] approached the homestead of Heilyn Goch ap Cadwgan they could see an old hall, black with gable-ends, from which issued a great deal of smoke [through a hole in the roof]. On entering they found the floor uneven and full of puddles. Where there were bumps it was difficult to stand so slippery were they with

the mire of cattle; where there were puddles a man might sink to his ankles in ooze. There were branches of holly spread over the floor, the cattle having browsed the sprigs. On the bare, dusty boards of one dais sat a crone, throwing husks into the fire, the ensuing smoke proving unbearable. On another dais was a yellow, calf skin upon which it would have been a blessing to sit.

The crone refused to speak, save rudely. Then the householder, Heilyn Goch, entered and is described as a red-haired, balding and wizened man with a bundle of sticks on his back. Heilyn was accompanied by his skinny, livid, little wife, who was also carrying sticks. They gave the travellers a cool reception, but the wife did provide food — barley-bread, cheese and watered milk. When the travellers retired to a side aisle they found only dusty, flea-ridden straw ends as the cattle had eaten most of the straw. A threadbare, flea-infested blanket was placed in the side aisle; upon this a tattered sheet and a filthy, half-empty pillow. Two of the travellers soon fell asleep, but the activities of the fleas drove Rhonabwy to distraction, forcing him to retire to the yellow calf skin where he dreamed of meeting King Arthur.

The squalid conditions, coupled with the begrudging hospitality of Heilyn's household, suggest that the hall belonged to an unfree family. The halls of some free men may have been equally squalid, but no woman of standing would have tolerated such conditions. Mire might be unavoidable near the doors, but the cattle of a well-to-do household are more likely to have been housed in a purpose-built byre. In addition, penthouses are known to have been attached to the halls of both free and unfree, one of them serving as private quarters known as a chamber. Other buildings, or lean-tos, such as pigsties, undoubtedly formed part of any homestead, but the halls of prominent men are known to have been sited within enclosures defined by rubble walls, wicker fences, paling, or banks surmounted by paling

The Household

A household could comprise of any number of persons, but how large it might be would depend on who was the 'ancestor', be he a father, grandfather or great-grand-father. If the 'ancestor' was a great-grandfather, then he alone had the status of an *uchelwr*. All males, irrespective of their age, who had proceeded from his body, be they sons, grandsons or great-grandsons, were his 'heirs', each and every one of them a *bonheddig*, the reason for this being that 'no person could ascend to his father's status during the father's lifetime'. Only when the 'ancestor' died did sons (or grandsons if their father was already dead) ascend to the status of an *uchelwr*; only then did they succeed to a share in *gwely* land. The only sons who did not ascend in status and succeed to land were those who were blind, mute, deaf, crippled or lepers; they were supported by their nearest relatives.

Dependence on Agriculture

Free women lived in a predominantly agricultural society. Livestock was particularly important in a country where much of the land was best suited for grazing. Cattle

provided milk, meat and hides. Their value at birth could be as low as four old pennies (4d.), rising, in the case of a cow, to a fixed legal worth of 5s. after delivery of its first calf; after delivery of its fifth calf its value dropped, becoming subject to appraisement. Horses were valued according to use, whereas pigs, sheep, goats, chickens, ducks and geese all had a legal worth according to age. Cats were valued according to whether they were mousers; bees were valued by the swarm. Most dogs were considered curs, valued at 4d., but a trained sheepdog was worth 5s. Hunting dogs, greyhounds and hawks were valued according to the status of the owner as hunting and hawking were primarily the preserve of the more privileged.

Oats and, where the soil was fertile, wheat and barley were grown throughout the Medieval period, for the Welsh were not, as it has formerly been claimed, a pastoral people who lived mainly on the produce of their herds. Indeed, bread and ale formed an important part of the diet of both men and women. Oats, of course, could be used for fodder as well as human consumption. Other crops grown were hay, cabbages, leeks and flax (for linen); apple orchards were not unheard of.

Hardships and Danger

Life, even for a free woman, was by no means easy, for beyond the scattered settlements lay a remote and inhospitable landscape, for the most part mountainous, abounding in forests and windswept moorlands, where wild animals roamed free, where wolves prowled, howling at night. The rivers, which separated one kingdom from the next, were not bounded by raised banks, but spread across the valley floors, carrying brushwood as they flowed through extensive beds or reeds, flanked by treacherous bogs. In the early part of the Medieval period — in the 5th, 6th and 7th centuries — the climate was harsh, colder and wetter than it is today, the frost hardening the ground for weeks so that cattle had to be kept indoors, the relentless rain turning rivers into destructive torrents, sweeping away everything in their paths. Crop failure and famine, pestilences among the cattle, plagues and cholera all conspired to exacerbate a way of life in which even a broken leg could be fatal.

Violence could intrude on a woman's preoccupation with a family at any time, for in an age when most men carried arms, the approach of strangers, be they foreigners or Welshmen from neighbouring territories, was enough to alarm any woman, the more so if her own kinsmen were away in the fields. According to one 12th-century writer, the Welsh considered 'it right to commit acts of plunder, theft and robbery not only against foreigners, but even against their own countrymen'. All too often the object of this lawlessness was livestock, usually cattle. In coastal areas seaborne raiders were dreaded as much as plagues. Between the mid 9th and late 11th century, the Vikings were particularly active around St. Davids and on the Island of Anglesey where, on one occasion, they took 2,000 captives into slavery.

A potentially bigger threat lay in the east where, in the 7th century, the Anglo-Saxons arrived in the Welsh borderland. Yet, for 400 years, the Anglo-Saxons appear to have been incapable of extending their authority over the intractable wilderness

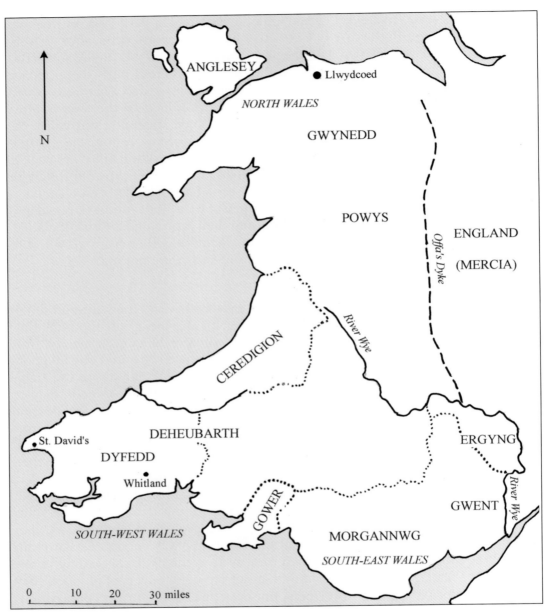

Wales in the 10th century

to the west. In the late 8th century they built what is now known as Offa's Dyke, the intention being to fix the frontier and put a stop to cross-border raids, most of which were carried out by the Welsh, but the frontier continued to fluctuate and there were incidents of ethnic cleansing even as late as the mid 11th century. When treaties, dykes and demands for subordination to English kings all failed, the Anglo-

Saxons fell back on doing what they had always done in response to Welsh raids — they launched punitive raids into Welsh territory, some penetrating as far west as Dyfed, the objective being to teach the Welsh a lesson by causing as much devastation as possible, all to no avail.

To Summarize

The society in which free women lived during the Medieval period was, therefore, one in which kindred affiliations provided support in times of need and protection against lawless and violent neighbours, but before considering the laws that governed women's lives it is necessary to consider another aspect of Welsh society.

Kings

Kings existed in Wales as early as the 6th century, if not earlier, their title that of 'lord' (*arglwydd*). Some 6th-century kings ruled small kingdoms such as Gower and Ergyng; others ruled larger entities such as Gwynedd and Dyfed. By the late 10th century most of the smaller kingdoms had been absorbed into one or other of four principal kingdoms — Gwynedd, Powys, Deheubarth and Morgannwg. Kings were necessary to unite the dispersed *cenhedloedd*, to prevent anarchy in times of peace and to provide leadership in times of war. Their propensity to plunder neighbouring kingdoms, however, made them agents of much grief, for not only did their raids provoke reprisals, but the more powerful kings, in their efforts to eliminate rivals, ranged far and wide, laying waste whole territories 'with robbery, fire and sword', famine often following in their wake.

Law and Order

Initially, kings appear to have had little to do with law and order, for there is evidence to suggest that, as early as the 7th century, the *uchelwyr* of certain localities in South Wales assembled to settle disputes by arbitration in accordance with the customs and established practices of their communities. The purpose of the *uchelwyr* was to 'make peace ... in order that there would be no long-lasting animosity between the parties'. This the *uchelwyr* achieved by ensuring that the injured party was suitably compensated by the perpetrator. The laws that are believed to have existed in Wales as early as the 7th century were, therefore, customary laws; they were the laws of a people (the Welsh) and not of kings. Only gradually did kings become involved in law and order.

Hywel Dda — Hywel the Good

It was the goal of ambitious kings to subdue neighbouring kingdoms, thereby creating a hegemony in which their kingdom was acknowledged as supreme. One such king, Hywel of Ceredigion, succeeded, by marriage and by war, in establishing a hegemony over the greater part of Wales, a rare achievement in a country divided by conflicting loyalties. Long after his death in *c.*950, Hywel was given the epithet

of *Dda* — the Good — for reasons that are unknown, but what Hywel is remembered for most is that, according to tradition, he codified existing customary laws; that is, he had them committed to writing. These laws — the Laws of Hywel Dda — have not survived in their original form. What has survived are some 40 manuscripts (said to be excerpts from a common original) that were written by practising lawyers between *c.*1200 and *c.*1500 and, therefore, as lawbooks, belong to a period when Hywel's Laws were still current. It is from these lawbooks that most of what we know about the position of women in Medieval Wales is derived — reason to consider the laws more closely.

Hywel's Laws (*Cyfraith Hywel*)

Hywel, as stated above, did no more than have existing customary laws committed to writing, and this is made evident in that all extant lawbooks, except those that have lost their opening pages, for they begin with a preface which (if the fanciful embellishments are ignored) state that (1) Hywel summoned six men from each administrative district in his realm and (2) instructed them to deliberate on the laws of Wales for 40 days and (3) as a result of their deliberation some of the laws 'they suffered to continue unaltered, some they amended, others they abrogated entirely, and some new laws they enacted', and (4) the revised laws were committed to writing. The assembly met at a hunting lodge known as Ty Gwyn — the White House — situated at Whitland in Carmarthenshire, and it is from Ty Gwyn, some would say, that the White House in America got its name.

The Laws of Hywel Dda were not immutable; they were subject to change. They also took into account regional difference and in 1841, a Mr. Aneurin Owen attempted to reconstruct the original codes, commonly known as the *Venedotian, Dimetian* and *Gwentian Codes*, each of which expound the regional variations in the laws that were to be found in north, south-west and south-east Wales respectively. The *Venedotian Code*, although specific to Gwynedd, was also applicable to Powys except that certain clauses were overridden by what were known as the 'Privileges of Powys'.

One of the most evident ways in which the laws changed is that, at the time of their redaction, an offence was not considered a crime to be punished by the state in the person of the king. Rather it was considered a tort — a wrongful act against a person or persons for which reparation had to be made — and in Wales, where there were numerous *cenhedloedd*, compensation was an effective way of averting blood feuds. By the 13th century, however, some offences such as theft had become breaches of the king's peace and, therefore, crimes. As to when these changes were affected, the evidence, such as it is, suggests that kings became increasingly involved in law and order from the late 11th century onwards, with the result that, by the 13th century, courts were conducted in the name of the king. There was, however, no uniform progression, for in North Wales, where the king's authority was less likely to be challenged, the king appointed trained judges to take

charge of proceedings in a manner similar to a modern judge, whereas in South Wales, although the king's representative presided, it was still the *uchelwyr* who decided whether a man was guilty or not and what the punishment, if any, should be.

Comparisons

When considering, in detail, the position of women in Medieval Wales there is a natural tendency to draw comparisons with the way things are today. Unfortunately, comparisons of this sort do not take into account the prevailing attitudes of a different age. A more realistic viewpoint as to how good or bad the position of women was in relation to the Laws of Hywel Dda can only be effected by making comparisons with the laws and attitudes of a contemporary society. The Anglo-Saxon and, later, Norman-dominated society in England is an obvious choice, being one the reader will be acquainted with; moreover, the two societies — Welsh and Anglo-Saxon — rubbed shoulders with each other to the extent that not only are their histories inextricably linked, but the Laws of Hywel Dda were eventually superseded by English law during the reign of Henry VIII (1509-47).

England

In common with Wales, England was a land of petty kingdoms, often warring among themselves, but in the mid 10th century these kingdoms were united, not by a short-lived hegemony as was the case of Hywel Dda's southern supremacy in Wales, but as a kingdom, its rulers holding the title of 'King of England', and remained as such even when ruled by Danish and later French-speaking kings. Anglo-Saxon laws, however, were never codified. What has survived are amendments to what were once customary laws; they were promulgated by several petty kings, beginning with Aethelbert, King of Kent (597-616). Long after England had become a unified kingdom, many of these amendments remained in force as regional variations of Anglo-Saxon laws.

There were many similarities between the Laws of Hywel Dda and those of the Anglo-Saxons, but one of the most noteworthy differences between the two societies is that, in Wales, kinship remained an important bond among the free until well into the 16th century. Tribal entities are recorded among the Anglo-Saxons in the late 7th century. Thereafter there are many references in the amendments to Anglo-Saxon laws to kinship in degrees — both in four and in seven degrees — but in the first half of the 11th century the kinship's role in law was replaced by artificial creations that had little to do with kinship, such as the *tenmann-tale*, the members of which were held responsible should one of them commit an offence.

Summary

It would appear that in a society where the ties of kinship were strong the law focused on reparation, whereas in a society where a king ruled with a strong hand,

punishment was often physical, in many respects harsh in order to deter potential lawbreakers. This may explain why the position of women in a tribal society was, in many respects, better than in one that was ruled by a strong king, one who was remote from the majority of his subjects.

CHAPTER III
Welsh Law with Regard to Free Women

According to the Laws of Hywel Dda, a girl 'remained at her father's platter' until she reached puberty, which the laws identified with the age of 12. Throughout that time she could not be held accountable for any crime or tort, nor could she sue or be sued, except through her father who was liable to pay any damages that might be due. Her worth, in the event of her death at someone's hand, whether intentional or by accident, was valued as half that of a son, meaning that her blood-fine (*galanas*) was fixed at 31½ kine until such time as her brother married or became an *uchelwr*.

It was customary that she be baptized and, in all probability, like a son, she would, at the age of seven, have been placed under a priest for religious instruction. She would also have been given a name such as Gwenllian — meaning 'white stream' —which was undoubtedly the most popular name for girls throughout most of the Medieval period. To distinguish her from other Gwenllians she would, if her father's name was Gruffudd, be known as Gwenllian *ferch* Gruffudd — *ferch* meaning 'the daughter of'. She might also be known by a distinctive feature as in Gwenllian *Goch* — meaning Gwenllian 'with the red hair'. She might even be known — if she moved away from her place of birth — by the name of the territory from whence she came, as in Gwenllian Gwent, meaning 'Gwenllian of Gwent'.

Home Life

At an early age she probably received instruction on how to be a hostess. In the late 12th century an Anglo-Norman, Gerald de Barri, better known today as Gerald of Wales, provided a glimpse of what went on inside a hall and what was expected of maidens. In his *Description of Wales* Gerald wrote of how travellers, on arriving at the hall of an *uchelwr*, were received. After handing over their weapons they were given the opportunity of having their feet washed; if they accepted, it signified they would stay the night. They were, then, 'entertained till evening with the conversation of young women and the music of the harp, for unlike the insanely jealous Irish, the Welsh did not hide their women away'. In the evening, when it was time to partake in the only meal of the day, the guests sat upon the floor, which was strewn with rushes or fresh grass, in groups of three to be waited upon by the younger members of the household, supervised by the host and his wife. The food — which might comprise of vegetable broth, chopped meat and cheese — was often served to each group of three on a large trencher (*lagana*) of thin,

oaten bread that had been freshly baked that day; this might be washed down with either milk or ale. Only after the guests had had their fill, did the host and his household eat. More entertainment followed — storytelling, poetry and song — until, finally, everyone settled down for the night on one side of the hall (probably in a side-aisle) where they lay upon a bed of rushes, heads to the wall, feet towards the fire, wrapped in their cloaks with a coarse blanket (*brychan*) over them. Should they become restless due to the 'hardness of their bed' and the cold, they went to the fire to relieve their discomfort.

Brothers

If a maiden had an older brother, then at 14, when he became of age, she would witness his departure for seven years, being commended to serve in the king's bodyguard (*teulu*) where he underwent military training. As a lightly-armed foot soldier, he was attached to and resided with the king's heir (*edling*) in the royal hall, but was, in fact, subject to the authority of the captain of guard (*penteulu*), usually a close relative of the king. Both the laws and Gerald mention these bands of youths, the laws referring to their habit of roaming in distant territories, searching for occasions to display their prowess. Both sources also imply that some men were commended to serve their *pencenedl* (head of *cenedl*), which may have been so in territories that, from the late 11th century onwards, were no longer subject to Welsh kings, but to Anglo-Norman conquistadors. Indeed, Gerald's statement that in times of peace young men accustomed themselves to war in family groups 'under the direction of a chosen leader' would support such a view, and the laws make it plain that men of high rank were 'elected' to the office of *Pencenedl*, which they held for life.

Becoming of Age

This was an unprecedented occasion for a woman in that she was now free to choose between remaining 'at her father's platter, or go the way she willeth freely'. She also acquired, on becoming of age, an honour-price (*saraad*), assessed at half that of a brother — to whit, 1½ kine plus 30d. if he were an unmarried *bonheddig* — which she could claim from anyone who insulted her, even her father if he physically chastised her. Insult could, in fact, be occasioned by anyone striking her, violating her, or by kissing or caressing her against her will. There were, however, occasions when kissing or caressing a woman against her will would not be regarded as an insult, to wit, if such acts occurred during a game of skipping, or during a carousal in honour of someone's arrival from distant parts.

There were, of course, other things that a woman could expect on reaching maturity. With regard to property, she would appear at first hand to have been allocated a share in her father's movables, which amounted to half of what a brother would inherit 'so as to procure a husband'. This share, which was known as *gwaddol* in South Wales, is often referred to as a dowry, and is believed to have consisted mainly of cattle, but it must also have comprised of all manner of movable property, including other livestock and household chattels. How this allocation was achieved in an illiterate society is difficult to deter-

mine, but with regard to cattle it has been suggested by one eminent historian that if a man had three daughters, two sons and eighteen cows, then each of the daughters would have received two cows apiece, whereas the sons would each have received six cows; thus twelve cows were apportioned to the sons and six to the daughters. This method of sharing movable property, however, could only be achieved after the father's death, for not only would the number of cows in the father's possession have varied from year to year due to a variety of reasons, but if they were apportioned each time a child became of age, then the father would have eventually become destitute. It is reasonable to assume, therefore, that the likelihood of a maiden receiving her *gwaddol* after her father's death would have been enough for her 'to procure a husband'. As to land, in North Wales a free woman could not succeed to *gwely* land, but could do so in South Wales in default of male heirs, or male collaterals in four degrees (first and second cousins).

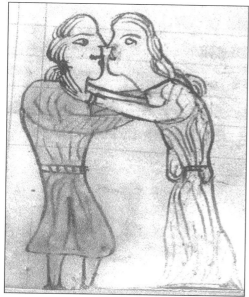

Welsh couple kissing as shown in the Laws of Hywel Dda — 13th century

It is possible that becoming of age may have been the occasion whereby a woman had her hair tonsured (cut close round to the eyes and ears). This style of tonsure was, according to Gerald, peculiar to both men and women, and a ceremony of tonsure in respect of a man becoming of age is mentioned in a collection of old Welsh tales known as the *Mabinogion*. Gerald's observation on hair, however, has to be treated with caution, and for good reason. Sketches of Welsh men appear in an English exchequer of *c.*1300, but none of these sketches depict hair in a way that supports Gerald's claim that it was 'cut close round to the eyes and ears'. What the sketches depict is the hair behind the ears falling to the nape of the neck, often in what appears to be two layers, although the appearance may be due to a ribbon placed across the forehead and tied at the back of the head. Sketches of Welsh men and women are also to be found in the Latin text of Hywel's Laws that appear in the Peniarth MS 28, which is dated to *c.*1280. One such sketch depicts a woman kissing a man passionately; her hair is long and plaited.

Tonsure or not, the time had come for a woman to give serious thought as to who she should marry, whether to allow herself to be given as a gift of kin, or to bestow herself with or without the approval of her relatives. The question, then, was what was on offer?

Men — their Appearance and Temperament

From Gerald's generalizations it is possible to obtain a picture of what the average Welshman looked like and what his disposition is likely to have been. Gerald describes

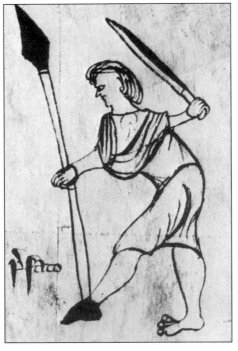

A Welsh soldier as depicted in an English Exchequer of c.1302

the Welsh as physically 'light and active, hardy rather than strong', and refers to their swarthy complexion, which he believed was due to their Trojan descent. Most men cut their hair 'close round to the eyes and ears'. Some shaved their heads bare so as to run freely through the forests without fear of suffering the fate of Absalom. Some men had beards, but the majority appear to have had moustaches, shaving not only their cheeks and chin, but also the lower part of their bodies. Welshmen, it would seem, were not a 'pretty' sight, but at least their teeth were white like ivory as a result of 'continually rubbing them with a green hazel and polishing them with a woollen cloth'. As to age, it is unlikely that a man became marriageable until, at the age of 21, he had completed his military training; moreover, a high mortality among women, often the result of giving birth to a child, must have prompted many older men into more than one marriage. All things considered, who could blame a woman if she pulled a face when suitors came a-calling?

As to a man's dress, nothing could be more descriptive than Gerald's reference to a prince whom he met in Ceredigion in the spring of 1188.

> The young man was of fair complexion, with curled hair, tall and handsome; clothed only, according to the custom of his country, with a thin cloak and inner garment, his legs and feet bare, regardless of thorns and thistles.

The inner garment was, in fact, a voluminous, below-the-knee-length tunic with long sleeves, possibly girded at the waist. A tunic and a thin cloak — which may have displayed a tartan — may seem inadequate clothing for spring, but other sources make it plain that the Welsh were 'taught to endure cold'. This may have been so in the 12th and 13th centuries when the climate was warmer that it is today, but additional clothing must surely have been worn in winter, especially in the 5th to the 7th centuries. Baggy trousers were worn by court officers, as evidenced by drawings dated to the 13th century, and Gerald mentions that prominent men wore high boots of untanned leather, although he makes a point of saying that the majority of men seldom wore shoes due to the marshy nature of the soil. Most men travelled armed with a weapon — a spear usually.

The laws refer to other articles of clothing besides those mentioned above: plaids (long pieces of material worn over the shoulder in the manner of Highland clansmen), wadded (lined) boots, thonged shoes, buskins (calf- or knee-high boots), girdles (leather

belts, often with a pocket attached to the front), coats, shirts, head coverings, waistbands and robes (long, loose, outer garments worn as an indication of the wearer's rank). With regard to women, Gerald mentions only one item of womanly dress — her headdress, a white veil 'raised up in folds like a crown', or more likely a turban. The laws mention other articles of clothing: a shift (a straight, unwaisted dress, which probably fell to her ankles), a mantle (often with a hood), shoes (although most may have been barefooted), and some, at least, covered their face with a veil, as did Rhiannon in the *Mabinogion*.

When commenting on the Welsh in general, Gerald refers to their warm-blooded temperament 'from which their confidence is derived', claiming that 'nature had given not only to the highest, but also to the inferior classes a boldness and confidence in speaking and answering, even in the presence of princes and chieftains'. These generalizations applied to women as well, but Gerald makes it plain that the men of South Wales were difficult to govern because there were so many *uchelwyr* who 'were often rebellious of their lords and impatient of their control'. It would appear that reserved, more thoughtful types were hard to find.

Gerald maintained that the Welsh were shrewd and quick-witted, delighting in wordplay and sarcastic comments, which they often uttered 'under the guise of a double meaning', sometimes lightheartedly, sometimes intending to hurt. These attributes were, according to the laws, apparent in royal courts where there was much revelry, and where allowances were made for certain kinds of insult. An officer known as the dung bailiff (*maer biswail*), for instance, could not complain that his honour had been slighted by coarse words whenever he got in the way of others whilst carrying victuals into the hall. Gerald, moreover, provided several examples of what he considered to be droll comments, which he picked up on his travels. One concerned two princely brothers, one of whom was Dafydd; the name of the other is unknown. Both brothers had, in their turn, ruled over a territory known as Tegeingl, and both brothers had, in their turn, a mistress named Tegeingl. Gerald, who was always one for gossip, heard it said that someone had remarked, 'I don't think Dafydd should have Tegeingl — his brother had Tegeingl first'.

Men were not all bad, however, for most were God-fearing by the standards of their day. This is borne out by several Anglo-Norman and English commentators, including Gerald, who stated:

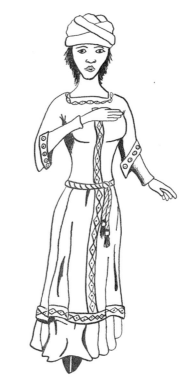

Medieval Welsh woman wearing an overtunic which conceals all but the hemline and sleeves of a shift

The Welsh show greater respect than other nations to churches and ecclesiastical persons, to relics of saints, bells, holy books and the Cross, which they devoutly revere; hence their churches enjoy more than ordinary tranquility.

As with most men, Gerald was often contradictory, claiming, on the one hand, for example, that Welshmen 'never scruple at taking a false oath' and, on the other, that they were 'much more frightened of breaking the oaths they swear on' the handbells, croziers and relics of saints 'than those they swear on the Gospels. This is because such objects are possessed of some hidden power' in that the saints with whom they are connected 'will take vengeance on all ... oathbreakers'.

In Conclusion

From a woman's point of view men may not have been particularly attractive, nor did they show individuality in their dress. They were evidently warm-blooded, outspoken and quarrelsome too, but such qualities may have been acceptable to women with similar temperaments; they may even have found their ability to be quick-witted tolerable, something they could match and, no doubt, surpass. The fact that men were said to be God-fearing might be a bonus, and if they were 'frightened of breaking' oaths, then that could limit how far they went with their lies. Being superstitious, moreover, was something a woman could use to her advantage. Indeed, one is tempted to consider what would be a man's response if, having been away for many months, he returned to find his wife not only pregnant, but claiming that an incubus was to blame — that demon who descended upon a woman while she slept. Gerald wrote about a red-haired young man with mystical powers who claimed to be the offspring of a Pembrokeshire woman, fathered by an incubus that had descended upon her in the form of her husband. Gerald appears to have accepted the story — he even went so far as to say the woman, when questioned, confirmed her son's claim, but Gerald was a man who would not dismiss the existence of fairies.

The Three Shames of a Maiden

The first shame occurs when 'her father tells her, "I have given you a husband."' The second occurrence is 'when she first goes to bed with her husband'. The third occasion is 'when she first rises from the bed in the midst of people'; that is in the presence of wedding guests.

Marriage by Personal Bestowal

The laws state that, once a maiden (*morwyn*) reached maturity, she could leave her father's house and 'go the way she willeth freely', meaning, presumably, that she was at liberty to bestow herself in marriage (*llathlud*) to the man of her choice without the approval of her kin. She might even bestow herself secretly in a manner which, today, we would regard as elopement, but which, in the Medieval period, would have been seen as abduction. The laws are, however, ambiguous as to whether she was allowed to get away with personal bestowal, for they state that her kinsmen could, if she were a maiden,

pursue her and bring her back 'even if it should annoy her husband'. This last quote may seem strange, but it must be remembered that, according to Hywel's Laws, all that was required to make a marriage by personal bestowal legally binding was three days continued cohabitation. If the absconding woman had cohabited, or was already sexually mature as a result of a previous relationship, then her kinsmen no longer had a right in law to bring her back against her will. If, however, the man to whom she had bestowed herself deserted her, then he insulted her and had to pay her honour price; failure to submit to law when summoned rendered him in contempt of court, penalties for which only added to his misfortune.

Marriage by Gift of Kin (*rhodd y cenedl*; also *rod o cenedl*)

This form of marriage was probably the norm; it was certainly the more honourable option. As with Culhwch in a tale known as *Culhwch and Olwen*, a man probably approached the father for his daughter's hand in marriage. The father, then, took counsel with all who were related to his daughter in four degrees, anyone, that is, who was descended from any one of her eight great-grandparents, be they male of female. One of the issues to be discussed was the status of the suitor. The *Venedotian Code* of North Wales states that 'a woman is not to be given in marriage except where the sons can obtain ancestral land'. This was to ensure that if the woman gave birth to sons, they would have the same status as her father; that is, they would be free men with a right to inherit *gwely* land. There could be no question of bestowing a woman beneath her status; the suitor had to be a free man.

Another consideration was whether the suitor was of kin to the woman and to what degree. At an early date the Catholic Church prohibited marriages between persons related to one another in three degrees, to whit, between first cousins. By the 12th century the prohibition had been extended to include all who were related in seven degrees (fifth cousins), but the Welsh had ignored these prohibitions to the point that Gerald complained:

> The crime of incest hath so much prevailed [among the Welsh], not only among the higher, but among the lower orders, that, not having the fear of God before their eye, they are not ashamed of intermarrying with their relations, even in the third degree of consanguinity [first cousins]. From their love of high descent they unite themselves to their own people, refusing to intermarry with strangers [people outside their *cenhedloedd*].

The reason for their so-called 'crime of incest' was that it kept movable property within their kindred groups. Marriage entailed the transference of a great deal of movables (or the promise to do so if the need arose) and a primary consideration was the woman's *gwaddol* (so as to procure a husband), which would eventually become the joint property of both husband and wife. Another consideration was the woman's marriage portion (*argyfrau*), which is also referred to as a dowry and appears to have been an advance on her share of her father's movable property (*gwaddol*); the marriage portion was probably a matter of bargaining. The marriage portions that are recorded in

late Medieval sources (1284 - 1536) vary considerably. One bride was given 16 sheep, another received one cow and 3s., and one generous father presented his daughter with a herd of 80 oxen, kine, heifers and bullocks. Livestock other than cattle or sheep are also recorded, as are household chattels, bedding, measures of cloth and even cash. The suitor's wealth, or what he stood to inherit, would have been yet another consideration in that it is likely that his wealth would have provided the bulk of what would ultimately be joint property. It is, therefore, likely that not only would the suitor be related to the woman in some way, but that he would be a member of her *gwely*.

Consultation might result in a contract whereby other issues — such as the woman's virginity, the payment of fees and the penalties for breech of contract — would be agreed upon, the culmination of which would be the betrothal and, eventually, the bestowal of the woman as a gift of kin by the father, or failing him, a brother, or nearest male relative in four degrees. A woman, however, could not be forced into a marriage against her will, especially if she had been married before. This is borne out by a tale in the *Mabinogion* in which Rhiannon says to the man she admires:

> 'I am Rhiannon, the daughter of Hefeydd Hên, and they [her kin] sought to give me to a husband against my will, but no husband would I have, and that because of my love for you.'

Rhiannon's announcement is evidence enough that a woman could not be forced into a marriage against her will, for if Rhiannon had had no right to refuse a husband, then her statement would have been totally unacceptable to anyone listening to the tale. What is also noteworthy about her statement is her declaration of love. The laws have nothing to say about love, but the tales that are to be found in the *Mabinogion* refer to it frequently. It, therefore, follows that love was a theme acceptable to all, recognized, albeit vaguely, by the provisions in the laws relating to personal bestowal.

Some form of ceremony would undoubtedly have taken place on the day of bestowal, but a religious ceremony, though likely, was not essential as it could add nothing to what was purely a civil contract. It was, however, an occasion for a feast (*neithior*) and bards were present for a fee of 24d., which they shared equally among them. The wedding guests (*neithiorwyr*) may have regarded the bestowal as an occasion to celebrate, but their presence was required as they would be witnesses to the event, and were not expected to leave until after the bride had risen from bed the following morning.

Marriage among the Anglo-Saxons

Marriage in Anglo-Saxon society was a contract between the groom and the woman's relatives, but unlike the Welsh gift of kin it was one in which the groom agreed to pay the asking price, usually in cattle, for the woman he wished to marry. The extant Laws (or amendments) of Edmund, King of England (940-6), provide insight into the negotiations that took place between the parties.

> If a man desires to be betrothed, and the relatives of the woman agree, let the bridegroom ... give surety [a person who will guarantee payment] for the foster-lean [purchase price].

Then let him declare what he will grant the wife, if she will choose his will [submit herself to his dominion], or what he will grant her [in the way of a dowry] if she survives [him]. If it be so agreed, she shall be entitled to half the property [if he dies first], and, if they have children, to all [the property] until remarriage, surety being given for all these promises. Then, when agreement has been reached, let the kinsmen betroth their kinswoman to wife to him who desires her.

This amendment makes it plain that, in Anglo-Saxon society, marriage was the result of a woman's relatives handing her over in return for the purchase price. It is also easy to see why, under these circumstances, a marriage by personal bestowal would have been unacceptable, the view being that it deprived the woman's kinsmen of her purchase price. Indeed, the man with whom she allied herself against the wishes of her kin was regarded as an abductor who, if apprehended, had to pay the purchase price and a heavy fine. This state of affairs continued until Canute, a Danish king of England (1016-35), passed the following amendment:

Let none compel either woman or maid to him, whom she mislikes, nor for money sell her, unless he be willing to give anything voluntarily.

At one time it had been permissible in Anglo-Saxon society to marry in the first degree of consanguinity, but as a result of continued pressure from Rome the number of degrees increased until, by the time of Gerald, it was forbidden to marry in seven degrees; hence Gerald's accusation that the Welsh were guilty of the 'crime of incest'. The Church also pressed for marriages to be sanctified, in response to which Edmund (940-6) decreed that 'at the nuptials there shall be a mass-priest by law, who shall, with God's blessing, bind their union to all posterity'.

Transference of Property

It appears that women who gave themselves in marriage without the consent of their kin may have forfeited their marriage portion (*argyfrau*). However, when a bride who had been bestowed as a gift of kin arrived at the bridegroom's hall she had in her possession all that was personal to her: her clothes and trinkets (usually rings and bracelets), and also her marriage portion, which had to be checked to the last penny as it formed an important part of the contract. All this property she would continue to hold independently of her husband for a period of seven years, after which it became part of the joint property held by both husband and wife. A woman held her *argyfrau* on the condition that she adhered to her *cenedl*, meaning she continued to support them in such matters as, for example, if someone related to her in seven degrees was held responsible for someone's death, she contributed towards the blood-fine (*galanas*) that was payable to the deceased's *galanas-cenedl*. Conversely, if a relative in seven degrees died at someone's hand, she received a share in the blood-fine that was due to her own *galanas-cenedl*. Her contribution to, or the share that she received, was equivalent to half that of a brother, and that on behalf of any children she had, or was likely to have. If she did not have children, and was unlikely to have them because she had reached the age of 54, then she was

exempt from contributing to, or receiving a share in a blood-fine. If a woman died within the first seven years of marriage, then her marriage portion passed to her children.

The laws presumed the virginity of every woman up to the age of 14; thereafter, if, as a suitor, the man had any doubts, he could demand that up to seven of his intended wife's nearest relatives swore to her virginity on oath. If, after consummation, a bride proved to have been a virgin, she was entitled to a maiden's fee (*cowyll*) to compensate for the loss of her virginity. The maiden fee was payable by the bridegroom, or husband, on the morning after consummation, but it was necessary for the woman to specify what her maiden fee should be in the presence of the guests before she arose; if she failed to do so, she forfeited her claim to a maiden's fee. The laws (which could be overruled by the terms of a contract) fixed the value of a maiden fee according to the status of the bride's father which, for most free women, could vary between £1 and £1 10s. The maiden fee was a woman's exclusive property, and under no circumstances could it ever be taken from her.

Irrespective of whether the bride was a maiden or not, she was promised a dowry (*agweddi*) by the husband, which she could claim in the event of separation by death or intent during the first seven years. The value of an *agweddi* varied according to the status of the bride's father, and whether she was married as a gift of kin, or by personal bestowal. In the case of marriage by gift of kin the value of an *agweddi* was fixed by law for most free women at £3, but this was only a guideline as a higher value could be fixed by agreement. However, if the woman was gifted on the understanding that she was a maiden, and the husband had reason to believe otherwise, then the laws provide that she be given a contemptuous *agweddi*; she would, in fact, be humiliated.

If, after consummation, or by the latest the morning after, the husband suspected all was not as it should be, he called for candles to be lit and, in the presence of the wedding guests, demanded that his hapless wife swore to her maidenhood on oath. If she was under 14, her oath was conclusive, but if she was a mature woman, her oath had to be supported by the oaths of up to seven of her nearest relatives — her father and mother included — all of whom were expected to swear to her maidenhood. If, however, the hapless wife did not swear to her maidenhood, then her gown was cut off at the waist. She was, then, made to hold the tail of a year-old steer, which had been thrust through a hole in the door and suitably greased. On the far side of the door two men goaded the steer; if she could hold onto the tail, she could keep the steer as her contemptuous *agweddi*. Failing that, she had to make do with only the grease on her hands.

The minimum *agweddi* of a woman who married by personal bestowal was, according to some authorities, fixed at six steers, but it could be determined by the couple themselves, preferably in the presence of witnesses. According to the *Venedotian Code,* however, if there were no witnesses to what had been agreed, and a dispute arose at a later date, then the wife's statement was conclusive because, as the relevant passage says, she had been taken 'to a place where there were no wedding guests', meaning that there was no feast because she had chosen to cohabit without the consent of her kin.

Amobr — the Fee Payable to the King

Amobr was a once-in-a-lifetime maiden fee, payable, in theory, when a woman lost her maidenhood, but in practice whenever she was given as a gift of kin, cohabited for the first time, made pregnant outside of marriage, or was violated as a maiden. The fee, which for the daughters of most free men was assessed at 10s., was payable usually to the king for the protection he afforded to women within his realm, or in certain specified cases to one of the king's principal officers, or to any great landowner, such as a bishop, in whose territory the woman resided. *Amobr* was usually paid by whoever bestowed the woman. If she were a gift of kin, it was paid by her father, a brother, or a male relative; if the marriage was by personal bestowal, she paid it herself, probably with the aid of her husband. In most other cases, such as seduction and rape, it was paid by the man responsible for her loss of maidenhood.

There is disagreement among historians as to whether *amobr* was a once-only payment. This is due to the fact that, by the 14th century, it had become payable on every occasion that a free woman remarried, or indulged in loose living. The *Venedotian Code* states that a king, or lord, could claim from a woman only her '*amobr*: and one amobr at that, for a woman ... is bound to pay only one *amobr*'. This is confirmed by another lawbook known as *Llyfr y Damweiniau*, which states 'whoever rapes a woman let him pay her *amobr* since a woman pays only one *amobr*'. Other manuscripts might cast doubt on these statements, but for the purpose of this work it can be assumed that *amobr* was a once-only payment.

Fees and Property in Anglo-Saxon society

There is little evidence of Anglo-Saxon women inheriting a share in their father's movables, though there are hints of an inheritance known as *fioh* or *fadr feum*, which reverted to the father's family when the wife died without issue. The bridegroom certainly provided a maiden fee, or morning gift, called *morgengyfa*, which corresponded to the Welsh *cowyll*. He also declared what he would grant his wife (or allow her to have) if he predeceased her (see section dealing with 'Marriage among the Anglo-Saxons'). Fees known as *merchet* and *leyrwite* resembled the Welsh *amobr* in so far as they were payable to a king or lord, but differed in that the former was payable each time a woman married, and the later every time a woman lapsed. It is clear from what has been considered so far that there were similarities between the Laws of Hywel Dda and the extant amendments to Anglo-Saxon laws. In one particular aspect, however, there was a significant difference.

Violation

When a Welsh woman was raped her oath was conclusive as to whether she had been violated and whether the rapist was known to her or not. If the man she accused denied the charge, the woman took his shame-bearing member in her left hand (none too gently presumably) and, with a relic in her right hand, swore that it was his organ that had brought shame to her, her *cenedl* and her lord. If the man still denied the charge, he had

to find 50 compurgators — all men — who would support his denial on oath. If he failed to find 50 good men to support him, he would be declared guilty of what — by 1200 — was regarded as both a tort and a crime. He, then, had to pay the woman's honour-price (at least 1½ kine plus 30d. if she were a maiden). He also had to pay the woman, if she were a maiden, a morning gift (*cowyll* — £1 to £1 10s.), a dowry (*agweddi* — £3) and, in addition, he had to pay the maiden fee (*amobr* — 10s.) that was due to the king. In cases where the rapist was not apprehended, then *amobr* was not paid by anyone as the king had failed to protect a maiden within his realm. Finally, for committing a crime the rapist had to pay the king a fine known as a *dirwy* consisting of 12 kine or £3, or face banishment. In total these penalties could, when the victim was a maiden, amount to about 40 kine, enough to ruin most men financially. If all that were not enough, then, according to the *Dimetian Code*, the rapist had to answer for violating the king's protection to virgins and render to the king a silver rod and, according to some authorities, a gold cup as well.

If the victim was a married woman, she would receive little in the way of recompense. She could claim her honour-price (*saraad*), and although this might be increased by augmentation, it would amount to no more than the equivalent of six kine if her husband's status was that of a *bonheddig*. Nevertheless, the rapist, if convicted, could still face financial ruin because rape of a married woman was considered an insult to the husband as well, for which he also claimed an augmented honour-price (*saraad*); moreover, the king would still demand a *dirwy* of £3. Finally, it is stated in the *Dimetian Code* (and this also applied when the victim was a virgin) that 'if the man cannot pay, let his testicles be taken. If there were two women, let him give one testicle to one and the other to the other [woman] if he lies with both'.

Rape among the Anglo-Saxons

In Anglo-Saxon society rape remained solely a tort until 1275 when the Crown took it upon itself to intervene in cases where no private action had been taken within 40 days of an alleged offence. Prior to 1275 English law recognized that only a virgin could be raped, which makes it plain that the prime consideration was that a woman's worth in terms of cattle had been reduced. The punishment for violating a virgin was death until William the Conqueror (1066-87) changed it to blinding and castration. The accused could, however, escape punishment if he provided his victim with a dowry (thereby restoring her marriageability), or if he married her. It must have been doubly horrifying for a young woman to be first raped, then coerced into living with the very man who had violated her. The chances of this happening, however, were remote. Rape rarely occurs in the presence of witnesses. Usually it comes down to the word of the victim against that of the accused, and her word, even her character, could easily be called into question. This would appear to have been the case of Agnes, a poor Shropshire girl who, in 1256, lost her cause because she got confused over the day on which the offence took place. She was subsequently imprisoned for making a false accusation.

CHAPTER IV
Welsh Law with Regard to Married Women

With regards to the Law

Once married, a woman would find that, with regard to the law, her situation had changed. She could still sue anyone, including her husband, for her honour-price, but in almost all other matters she could neither sue, nor be sued by anyone except through her husband, for the laws say that 'for everything a woman shall do, let her husband answer for her' even to the extent of paying her fines. If she committed an offence jointly with her husband, action could not be taken against her on the ground that she had acted under the 'dominating rod' of her husband. There were, however, two offences for which action could be taken against her. If, for example, she stood accused of someone's death, her husband was not liable to contribute to the dead person's blood-fine, whereas she still had every right in law to demand assistance from her *galanas-cenedl*. It must also be said that, in the event of her death at someone's hand, her widowed husband had no right to a share in her blood-fine — that went to her *galanas-cenedl* — nor was she entitled to a share in her husband's blood-fine.

In the event of a married woman committing an act of theft on her own initiative, then she alone would be held accountable. By the 12th century theft had become a crime, classified according to whether the thief had been caught with the stolen property in his or her possession (theft present), and the stolen property produced in court, or whether the charge was based on suspicion or the word of an informer (theft absent, meaning the stolen property had not been found in the accused's possession). Theft present was the more serious offence, punishable by death by hanging, except when the stolen property was worth 4d or less, or when the thief was in want and had failed to obtain sustenance at a prescribed number of houses. A pregnant woman, however, if found guilty, could not be hung as two lives could not be taken for one theft. As to the husband who had not been party to the offence, it mattered not whether his wife were found guilty of theft present or theft absent, he still had to make good the stolen property and his house and its contents were forfeited. If, however, the husband committed an act of theft without involving his wife, then the wife could neither testify for or against him.

A New Life

During the first few weeks of marriage a woman would have to adjust to the fact that her husband had taken the place of her father; she was now under the lordship of her husband. She would also have to adjust to unfamiliar surroundings, for if she had married a *bonheddig*, she could find herself in an extended family household, although it was customary for the son of an *uchelwr*, on attaining the age of 21, or on marriage, to be settled on *gwely* land even though his rights to a share in *gwely* land would not be realized until his father's death. As a member of her husband's household she experienced no change in name, nor did she become a member of her husband's *cenedl*. What changed was her honour-price, its value being assessed at one-third of her husbands. In the case of a married *bonheddig* this amounted to one-third of four kine and 80d, and remained as such even after his death, or until such time as he became an *uchelwr*.

As a wife a woman's duties were that (1) she did not play ducks and drakes with joint property, that (2) she refrained from using contemptuous and insulting speech towards her husband, that (3) she did not leave his bed, or refuse him his conjugal rights, and that (4) she remained chaste. If she failed to abide by the first three expectations, she was liable to be chastised, the punishment limited to three strokes with a rod no longer than the length of a man's arm, no thicker than his middle finger, and the blows had to be delivered to her body, not her head. If the husband exceeded the number of strokes, or chastised her for any other reason, then he insulted her and was, therefore, liable to pay her honour-price which, in these circumstances, was known as *wynebwerth* — literally 'face value' — and also *gowyn*, meaning 'offence payment'. Furthermore, if the husband proved oppressive, his wife had every right to appeal to her kin.

Rather than chastise his wife, the husband could demand from her his honour-price which, likewise, was referred to in these circumstances as his *wynebwerth*. This did not necessarily mean the husband had to take her to court, for it becomes apparent in the late Medieval period that many claims for reparation, even blood-fines, were settled out of court by the appointment of mutually acceptable arbitrators; the territorial court was usually the last resort. In any event the husband had 'no right to [both] compensation and chastisement for any [one] offence'.

With regards to squandering joint property, it is necessary to consider first how much control a husband had over his wife's property. It would appear that, during the first seven years of marriage, the husband had little or no control over his wife's property, for the *Venedotian Code* states that 'if she has an *argyfrau* [marriage portion], let it remain unconsumed until the end of seven years. If she herself allows it to be consumed, no compensation is made to her by reason of wear by teeth and body'. After seven years, when the movables of both became joint property, his control may have been unrestricted, although even then some marriage contracts may have stipulated that the husband should not alienate his wife's property by sale

or gift, or that to do so required his wife's permission. The laws, however, make it plain that the wife, if she were a free woman, was entitled to give away her own clothes, as much meat and drink as she pleased, as well as the contents of her store-room. She was even at liberty to lend household utensils. What she dare not give away were her husband's harp, cloak or cauldron; if she did, she could expect trouble.

As to using contemptuous and insulting speech towards her husband, there are illuminating examples of what a husband might regard as insulting in the *Venedotian Code*, or at least that part of the code known as the *triads*, which state that (1) a woman was forbidden to wish a blemish on her husband's beard, meaning she was not to cast aspersions on his virility, and (2) she must not wish dirt on his teeth, and (3) call him a cur — nothing, one might say, to get worked up about, but in all probability her words would have been unrepeatable once her blood was up.

How far all this was adhered to in practice is debatable. The Welsh have been described by one eminent historian as a 'race of quarrelsome nightingales', and this applied to both men and women. Whenever Welsh women are mentioned in ancient manuscripts it is rare — if at all — that they are depicted as anything other than spir-ited. Women in Medieval Wales were tough; they had to be hardy to survive. Even Gerald, who was bent on exposing the malice of a woman named Nest, could not resist making generalizations from the safety of his residence at Llanddew, near Brecon, about there being 'no wrath above the wrath of a woman', and how 'they lose their temper and become incensed'. With regards to domestic quarrels the laws could do no more than provide guidelines — on the one hand, upholding the husband's right to be 'master in his own household', and on the other, seeking to protect the woman and her interests; nowhere is this more evident than in matters relating to unfaithfulness.

A Strong Scandal

A wife was not to kiss or caress another man, nor, heaven forbid, was she to commit adultery as that constituted a strong scandal (*cadarn enllib*). The wife, if careless, might be caught in the act, or she might even be accused on account of her husband's suspicion, the more so in relation to adultery, in which case the husband, if he were to make accusations, would have to state on what ground he based his suspicion. Incorporated into some lawbooks are tractates known as *triads*, in which matters pertaining to the laws are listed in groups of three, presumably as an aid to memory. Some historians dismiss the *triads* as of no historical value; be that as it may, the *triads* can be humorous in that they often state the obvious — for example, the *triads* in the *Gwentian Code* state that a husband had good reason to believe that his wife was having a liaison with another man if she was seen (1) coming from behind a bush in the company of a man, or (2) rising from beneath a mantle that she shared with another man, or (3) with a man between her thighs. Of course, the wife

could deny impropriety, but she would have to do so on oath and be supported by up to 50 female compurgators (character witnesses) who would swear that what she said was true, that she was incapable of committing such a disreputable act. The paramour would also be expected to find up to 50 male compurgators to support his denial.

In the event of a husband establishing that adultery had taken place, both the wife and her paramour would have to pay the husband his *wynebwerth*, the value of which, in these circumstances, would be augmented. The wife could also be put away for her indiscretion, losing all claim to the *agweddi* (dowry) that her husband had promised her and, in North Wales, she might forfeit her *argyfrau* (marriage portion) as well. She might even have to pay a penalty for the breakdown of the marriage if such a clause had been stipulated in the marriage contract.

In the event of a woman discovering that her husband had been unfaithful, the laws provided that the offending husband should make restitution to the wife by paying her *wynebwerth*. For the first offence the penalty was 10s.; for the second £1. Should the husband lapse a third time his wife was at liberty to leave him, taking with her all that was hers, including any fines for previous misconduct, or for insulting her by administering unjustified or excessive chastisement. If, however, she did not leave him, then the Law gave up and declared that she had no further cause for complaint.

Should a husband be so foolish as to bring a 'strange' woman into the house, he not only dishonoured his wife, but he committed one of the three great scandals, which, in this particular case, exposed him to the wrath of his wife's kinsmen; more-over, not only could the offended wife leave him, but she had a right in law to kill the 'strange' woman, provided she did it with her bare hands, one of the rare occasions in which a blood-fine could not be demanded.

Misconduct among the Anglo-Saxons

Anglo-Saxon laws were similar to those of Hywel Dda insofar as, if a husband lapsed, he had to compensate his wife, but if the wife committed adultery, her punishment became increasingly brutal. Ethelbert of Kent (957-616) decreed that, if a free man committed adultery with the wife of another free man, he had to compensate the injured husband and provide him with a new wife, which, of course, had to be purchased. Canute (1016-35) added to this by directing that an unfaithful wife forfeited all her property to the husband and that her ears and nose should be cut off. William the Conqueror (1066-87) went one step further by providing the death penalty for women caught in the act.

Different Homes

Had a woman married in January she would have taken up residence in her husband's 'old home' (*hendre*) — a hall situated usually in a sheltered location and built to withstand the rigours of winter, its worth according the southern codes

being 50d. In mid-March she may have taken part in burning withered grass in areas reserved for summer grazing; that same month she would certainly have been aware of, if not witness to, the ploughing of fields that had been earmarked for sowing oats. In early May livestock had to be moved to areas where fresh grass had replaced what had been burnt two months earlier. It is not known if the whole *gwely* moved, or whether the herds of the community were accompanied by just a few *bonheddigion* — either way a woman could find herself residing in a flimsily-built 'summer abode' (*hafod*), valued in South Wales at 12d. During the summer months the herds had to be guarded against man and beast; wolves still prowled in remote areas as late as the 13th century. Cows had to be milked twice a day, a chore that may have been shared by both husband and wife. Some milk would have been churned into butter or cheese, a task that invariably fell to the woman, whereas sheep shearing was reserved for the man. In August a woman might find herself moving again, this time to a 'harvest home' (*cynhaefdy*), its worth 24d. Corn and hay had to be fenced in throughout the summer, safe from stray livestock and red deer, but they still had to be watched over; they had to be harvested too and, in the autumn, fields in fertile areas had to be ploughed for sowing next year's wheat and barley. By late autumn a woman could find herself back at the *hendre* to witness, in November, the slaughter of livestock that had become unproductive with age, their carcasses smoked or salted. From 1 December all fields were open to grazing, the productive livestock feeding on stubble and whatever grass remained. When the snow came cattle had to be kept indoors, sheep in pens. The winter was no less busy than the summer, a time for threshing, winnowing and grinding corn, spinning and weaving, both wool and flax, making clothes, gathering fuel and doing all that was necessary to survive.

Children

It would have been a momentous occasion to discover that a wife was with child. In anticipation of a miscarriage at someone's hand the laws prescribed a blood-fine for the foetus which, in North Wales, and based on the assumption that the child might be a male, amounted to one-third of a living person during the first three months, two-thirds for the second three months and a full fine from then until baptism; thereafter the blood fine changed if the child was a girl. For the next three months the child was nurtured by the mother who was, then, given a choice: either maintain the child herself, or foster it — with the king's consent — on someone of inferior status, to wit an unfree man and his family. If the mother chose to maintain the child herself, then each year the father provided her with:

> A fat sheep with its fleece and its lamb; an iron pan or 4d.; a measure of corn for making pottage or rhynion [grits or groats] for the child; three loads of wood; two ells of white cloth for swaddling him or 4d.; two ells of striped cloth for his nurse or 12d.; a choice cow with its calf; three loads, that is, one of wheat, one of barley and one of oats. All these are to be given the mother if she wants them.

39

If the child was fostered on the unfree, the same items were given yearly to the foster-family, and if the child remained with that family for a year and a day, he or she was entitled to a share in the foster-father's movable property. This must have been an onerous task as, indeed, it was for the free who considered it one of the *curses of a cenedl* to have a king's son fostered upon it, and for good reason. In the 12th century a king of Gwynedd entrusted his son to a *pencenedl* named Nefydd Hardd. The king's son was, unfortunately, murdered by a son of Nefydd Hardd and, as punishment, the king degraded the whole *cenedl* to the status of unfree.

Absence

There were periods when a married woman had no contact with her husband, for with holdings scattered far and wide a husband could be away for days at a time. Hunting and fishing might serve as pleasurable pursuits, but game and fish supplemented their daily diet. If the husband was an *uchelwr*, there were times when he and his fellow landowners met as the local judiciary. There were periods, too, when a husband's absence might be cause for a wife's concern.

After serving in the king's bodyguard, a free man passed into the general levy to be called upon by the king 'for protection against strangers and ... those violating privilege and law'. They might even be called upon for offensive operations beyond their borders, but they were 'not to go out of the country more than once a year, and that for six weeks only'. Active service was not an obligation, it was a privilege, and according to Gerald, whenever the alarm sounded, the farmer turned from the plough to pick up his weapons as quickly as the courtier did from the king's court to serve either as light cavalry, or lightly-armed foot soldiers.

To be effective they had to keep fit, and Gerald tells us that, in times of peace, young men, under their chosen leaders, underwent strenuous exercise, penetrating deep recesses in the woods and climbing mountains so as to accustom themselves to long, rapid marches by day or night. Practice made them skilful in the use of weapons: in South Wales they excelled with bows; in North Wales they favoured long spears. The *uchelwyr* were distinguished in the use of the lance; they, along with kings and court officers, were the only ones to have the privilege of riding 'swift and generous steeds', although they often dismounted to engage on foot.

What the women made of all this is debatable. They may have acquiesced to defence and training, but when it came to campaigning in distant lands some, at least, were prepared to object. In 1188, Gerald, in company with the Archbishop of Canterbury, toured Wales to recruit men for the Third Crusade. Gerald boasted, in his *Itinerary through Wales,* that he had been the first to volunteer in the service of the Cross, which he did at Radnor, confident that other would follow his example with as much dignity, but at Hay-on-Wye he was taken aback to see a number of volunteers running towards him, the wives of whom had tried to restrain them by holding onto their clothes until, minus their cloaks, the volunteers took refuge in a nearby castle.

The incident may have embarrassed Gerald; it was certainly not a welcome start to the tour to have women meddling in manly affairs. Only two days previously, when he had made a display of throwing himself at the Archbishop's feet, he had met the Lord Rhys, the man who governed all South Wales on behalf of King Henry II. Rhys, as he recalled, had been eager to enlist, but two weeks later when he met Rhys again in West Wales, he discovered to his dismay that Rhys's wife, Gwenllian, had put a stop to her husband's noble intentions. How Gerald had the gall to express disappointment in his book a few years later when he had himself obtained a dispensation from the Pope to be excused crusading on the ground of ill-health when, in fact, he was as fit as a fiddle, is unbelievable — testimony to his capricious disposition.

Entertainment

There were good times, however, when, in the evenings, the whole family gathered together for the only meal of the day, and people would walk in as though the house was theirs. The evenings were for relaxation, conversation, carousal, music and, no doubt, singing, which may have come natural as Gerald maintained that, from the moment they stopped squalling, children sang. He also took the trouble to explain that:

> the Welsh do not sing ... in unison, but in many parts, many modes and modula-tions, so that in a choir ... you will hear as many different parts and voices as you will see singers, all joining together at the end to produce a smooth, sweet B-flat resonance.

Undoubtedly the best entertainment took place when itinerant bards came a-calling. Some were storytellers (*cyfarwyddau*), entrancing all with tales similar to those in the *Mabinogion*. Others specialized in poetry, making 'use of alliteration in preference to all other ornaments of rhetoric', while others sang to the accompani-ment of a harp, pipe or a stringed instrument called a *crwth*. Most of the oldest extant poetry either glorifies military exploits, or extols love of one's homeland, but from the 12th century onward the theme inclined more to the adoration of women and the heartaches that stemmed from unrequited love. Unquestionably the best known exponent of this kind of poetry was Dafydd ap Gwilym, who flourished in the mid-14th century. Dafydd's purpose, however, was to amuse by making himself the butt of his thwarted amorous exploits. In one poem, for example, he is at an inn where he meets a 'black-browed beauty' whom he wines and dines, and with whom he enters into an assignation. When everyone else at the inn had retired for the night, Dafydd crept about in the dark, bent on finding her room. Unfortunately, he cracked his shin on a 'stupid noisy stool', fell and, in getting up, struck his brow against a trestle table, which crashed to the floor, causing a brass bowl to clatter. The din set dogs barking and consequently the whole household was aroused. It was fortunate for Dafydd that, in the dark, he was able to escape to his own bed.

Dafydd referred to numerous women in his works. Eight poems he addressed to the well respected Dyddgu, a woman of high birth, whose affection he was never able to win. Some 30 poems he dedicated to the ravishingly beautiful Morfudd — now here was a woman who responded to his advances, but she, being fickle, responded to the advances of every man that caught her eye until, eventually, much to Dafydd's disgust, she married a little hunchback. What is evident about Dafydd's works is that they were designed to entertain women, more so than men, which suggests that, far from sitting quietly in the background, women knew exactly what they wanted when it came to recreation.

Separation

The bond between husband and wife was not always 'till death do us part', and although the laws did not recognize divorce as we do today, they did acknowledge that two people could separate by mutual consent, or because one party so willed it. With regard to the latter option, however, separation (*ysgar*) could only take place as a result of specific circumstances, each subject to the restrictions prescribed by law. Gerald, who misunderstood the laws governing separation, misrepresented the practice by saying that 'an ancient custom also prevails of hiring girls from their parents at a certain price, and a stipulated penalty in cases of relinquishing their connection'. What Gerald failed to grasp was that when a couple separated the wife could, if she was not responsible for the separation, depart with whatever was rightly hers, or failing that, with a share in the division of joint property.

Initially, a husband could put away his wife if, on their wedding day, he discovered a shortfall in the marriage portion, or he found that, as a gift of kin, she was not a maiden as had been claimed (in which case she had a contemptuous *agweddi*). He could put her away if he caught her kissing or caressing another man, or committing adultery, or for being without issue, or for failing to observe a specific clause in the marriage contract. The woman, on the other hand, could leave her husband on grounds of impotency, leprosy or feotid breath, or because he had been unfaithful to her on three separate occasions. She certainly had a right to separate if he brought a strange woman into the house, thereby incurring the wrath of her kinsmen.

Whatever the circumstances, a wife had a right to nine days' grace before leaving her husband's hall, and no separation could take place within nine days of marriage. The reason for this, according to the *Venedotian Code*, was 'to know whether the parting was legal', and according to the *Dimetian Code* it allowed the wife time 'waiting for her share of the property'. If she was with child, then she had the right to stay until the child was born, being entitled to an allowance equivalent to what she could expect for rearing a child for six months. Once the child had been born, she left, taking with her both the child and the full entitlement for rearing a child for a year. Thereafter, she reared the child at her own expense for a further six months, after which she had the option of keeping the child; if she did

so, the father bore two-thirds of the cost for maintaining the child until he or she became of age. If, however, her claim to be pregnant proved to be untrue, she was fined three kine.

When two people separated the question of 'who gets what?' in the way of movables was decided by (1) who was to blame for the separation (if not due to mutual consent), and (2) whether it took place during, or after the first seven years of marriage. If separation took place during the first seven years, and was due to mutual consent, or because the husband was at fault, then the wife had an absolute right to leave her husband's hall with everything that belonged to her — clothes, trinkets, marriage portion (*argyfrau*), morning gift (*cowyll*), the dowry (*agweddi*) that she had been promised by her husband, and any fines (*wynebwerth*) that she had been awarded for her husband's misconduct. She might also receive a penalty payment if a clause in the marriage contract had been breached by the husband. What is not mentioned in the laws is that had her father died after she had been married, then she would have received her full entitlement to her father's movables (*gwaddol*), and this she would also have taken with her as part of her *argyfrau*. In the event that she was at fault, then she forfeited any claim to her *agweddi* and, in North Wales, she may have lost her *argyfrau* as well. All these rules applied whether she had been made a gift of kin, or had married by personal bestowal.

When it came to separation after seven years, then the wife's right to her *argryfrau* and her *agweddi* were replaced by a right to a division in joint property. Certain items, however, remained the exclusive property of both the wife and the husband. Three items constituted the wife's exclusive property — her maiden fee (*cowyll*), her honour-price (*saraad*) and any fines (*wynebwerth*) that she received for her husband's misconduct. The husband, on the other hand, retained his horses, arms, harp, plaid shawl, any rent from land and all fines (*wynebwerth*) that had been awarded to him for his wife's misconduct. When it came to dividing what remained — that is, the joint property — the laws attempted in a somewhat strange way to be fair; they also provide an inventory of what may be termed movable property.

According to one version of the *Dimetian Code* (known as the *Latin Redaction A*) all cattle and horses went to the husband, whereas other compilations are silent about such livestock. The *Venedotian Code* states that 'all pigs go to the man; all sheep to the woman. If they have only one kind, they are divided into two halves. And if there are sheep and goat, the sheep go to the man and the goats to the woman. If they have only one kind, they are divided'. It was generally accepted that all poultry went to the husband, whereas all cats save one were appropriated by the wife. All crops, whether standing or cut, belonged to the husband; the wife had a claim to all flax, linseed and wool. The *Gwentian Code* says the wife was to have all flour, whereas the other codes limit the amount to how much she could carry from the storeroom between her arms and knees. With the exception of bacon in cut — which was divided half and half — the wife was awarded a more favourable share in

meat, cheese and butter by the *Venedotian* and *Gwentian Codes*, but she did not do so well according the *Dimetian Code*.

All pans, the trivet (an iron tripod for a kettle to stand on), all milking vessels save one and all dishes save one went to the wife, whereas the husband, due to his greater thirst, retained all the drinking vessels and the cauldron; also sickles save one, the baking griddle, the fire-dog and the iron hob. The wife had the small sieve, the husband the riddle (large sieve). Most tools — the auger (for boring holes), plough, coulter (a blade fixed to the ploughshare), fuel axe, winnowing sheet, hand axe, tubs, boilers and iron implements — the husband could claim as his, although the wife was entitled to the medium-sized auger, broad axe, hedge bill, ploughshare, spade, ox-cart and yoke.

Some items such as mantles were divided half and half, as were gold and silver trinkets and all debts; so, too, were the nets and balls of yarn, except, when there were children, the yarn went to them. There were no beds as everyone slept on rushes, but the wife took the upper bedclothes, the husband the lower on the condition that, should he remarry, he handed them over to his first wife; he also had a right to the bed coverlet (*brychan*) and the bolster. The quern was rendered useless by the husband retaining the upper stone and the wife taking the lower. Only one piece of furniture is mentioned, to whit the settle (a wooden bench with a high back) and that went to the husband. All other items not mentioned in the laws relating to the division of joint property — which may have included a chest, stools and a mirror — were divided by the wife into two lots, the husband having first choice. As to children, if there were three, the eldest and the youngest stayed with the father; it was not stated what happened when there were more or less than three.

The wife was entitled to borrow oxen to pull the ox-cart and transport her property — presumably to her father's house, or the hall of a new husband. She did not depart, however, until the expiry of nine days. Both parties had, therefore, time to reflect on what they were about to do, after which the wife could depart, rejoicing or with a heavy heart.

Divorce

There was no official annulment of a marriage. A marital contract ended when one or other of the parties cohabited with a new partner. The husband, however, had a right to prevent his wife remarrying if 'he pursued her and overtook her before she had placed one foot on the bed of her new husband'. He, of course, had to make such a move quickly, because once his wife had lain with her new husband, there was nothing more he could do other than accept that his marriage had finally ended. In any event the woman's honour-price remained one-third of her first husbands, and continued as such until she died, or until such time as she took on a new husband.

Widowhood

When a man died, irrespective of whether he did so before or after seven years of marriage, his widow had a right to a share in the division of joint property, providing she had not cohabited with another man and remained unreconciled to her husband prior to his demise. This division of joint property — which in the late Medieval period was referred to in Latin texts as *legitim* — was not peculiar to the Welsh; it is evident in Anglo-Saxon society (see section on 'Marriage among the Anglo-Saxons'). Several sources state that, if there were children, the joint property was divided into three equal shares — one for the wife, one for the children, and one share was bequeathed according to the husband's wishes. If there were no children, the property was divided half-an-half. The widow's share was meant to support her during widowhood; when she died it passed to her children. It is assumed that nine days after the husband's death the widow returned to her *cenedl*, but if she claimed to be with child at the time of her husband's demise, she could remain in the marital home until the child was born, but if her claim proved to be untrue, then she was fined three kine.

Separation, Death and Divorce in England

The Laws of Ethelbert of Kent (597-616) recognized separation, for they state that, where a woman wished to depart with her children, she was entitled to a share in the division of joint property. In the event of her husband predeceasing her, she had a claim to half the property, the other half going to the children. If there were no children, then she left, taking with her only her morning gift (*morgengyfa*) and the *fadr feum* she inherited from her father, both of which reverted to her father's kin on her death. By the Laws of Canute (1016-35) a departing wife could lose her right to half the joint property if she remarried within a year; this, of course, applied only to a widow as the Laws of Ethelred (978-1016), under the influence of the Church, absolutely forbade divorce.

Summary

To sum up, a free Welsh woman, on reaching puberty, acquired an honour-price and a share in her father's movables that were assessed at half those of a brother. She had a right to refuse a husband and the laws recognized that she could marry by personal bestowal. Once married, she was, in theory at least, subject to her husband's will and protection, but she continued to hold movable property in her own right and could appeal to her father's *cenedl* for assistance if her husband oppressed or insulted her in a way that was unacceptable; she could even take her husband to court for his infidelity, or for excessive or unjustified chastisement. She, of course, could be put away for specific offences, but she also had the right to separate for a variety of reasons, including mutual consent. She also had a right to a share in the division of joint property if her husband predeceased her, or if she and her husband separated after seven years of marriage — providing the separation

was not due to her own free will or her own immorality. She was, of course, still married until such time as she cohabited with another man, but in the event of her former husband being the first to remarry, then he had an obligation to present his first wife with the lower bedclothes, or pay her *wynebwerth*.

CHAPTER V
Other Categories of Free Women

Women of Brush and Brake

The laws frequently refer to 'women of brush and brake', meaning women of easy virtue, those who abandoned themselves to casual connections. A woman of this sort was liable to pay the maiden fee (*amobr*) due to the king. She certainly paid *amobr* if she was found to be pregnant and failed to affiliate the child to the father; if she did affiliate the child, then the father paid.

It was important that an illegitimate child should be affiliated for several reasons: (1) the mother had a claim to maintenance until the child became of age, and (2) without affiliation the child had no paternal relatives. If the child was a girl, she had no father to provide her with a marriage portion (*argyfrau*), nor would she have, on her father's death, a share in her father's movable wealth (*gwaddol*); if a boy, he had no claim to *gwely* land. Should an unmarried woman with child simply make an oral declaration as to who had begotten the child, the putative father was under no obligation to deny or admit paternity. If, however, the woman made an assertion on oath, then the putative father was expected to respond within a year and a day.

What happened, according to the *Gwentian Code*, was that the local priest visited the pregnant woman shortly before childbirth. The woman, then, made an assertion on oath as to who had begat the child and, in doing so, made an appeal that the child should be born a snake if anyone was the father other than the man she named. The *Venedotian Code* provided a different scenario, one in which the woman, after giving birth, took the child to her local church, or to the church used by the putative father, approached the altar and, with her right hand on the altar and her left hand on the child's head, she swore to God, firstly by the altar and any sacred relics that were upon it, and secondly by the baptism of the child, that the father was the man she named. The putative father, if he were present, was expected, though not compelled, to respond and if, with one hand on the altar and the other on the child, he admitted the child was his, the child was immediately on his father's privileges, and could never be subsequently repudiated by the father or any of the father's *cenedl*.

Conversely, if the putative father denied on oath that the child was his, then his oath was conclusive and he could not, under any circumstances, change his mind and admit paternity, nor could the woman make a second assertion of paternity against

another man. If, however, the putative father chose to defer his response for a year and a day, the child became a 'reputed' child until the expiry of the prescribed period. If, after a year and a day, the putative father still did not admit or deny paternity, then his continued silence was construed to be an admission of paternity and the child became recognized by law as one of the father's *cenedl*. The *cenedl*, therefore, became liable to pay for any injury committed by the child for which reparation was due, and there was no point in the putative father denying paternity to avoid payment — the reparation had to be paid before a denial could be accepted; moreover, the paternal *cenedl* had no right to a share in the child's blood-fine should it die at someone's hand. This was a no-win situation for the *cenedl* and would have led to the putative father being pressurized into admitting or denying paternity.

The laws provided for other factors to be considered, such as, if the woman was dumb and, therefore, unable to make an assertion on oath, the putative father had to accept that, 'if the relatives [of the woman] admit the child was related to them', that sufficed as an assertion of paternity. Another provision in the laws was that, should the putative father die before the mother made an assertion, the task of admitting or denying paternity fell upon the dead man's *pencenedl* and seven kinsmen, each of whom were expected to swear 'to the utmost scope of reason and conscience' what the putative father would have sworn had he been alive. If they denied paternity, their oaths were conclusive; if they admitted paternity, the *pencenedl* took the child, kissed it 'as a sign of relationship', then passed the child to his seven kinsmen, each of whom repeated what he had done. In the event that some admitted and others denied, then the oaths of the former prevailed. A judge would be present and, to guard against ulterior motives operating, no kinsmen involved in the ceremony could be one who would benefit from making an oath of denial.

If the mother made no assertion of paternity immediately after the birth of her child, she could not do so until the child became of age. In the interim the mother might die, in which case, had she sworn to a confessor whilst *in extremis* that the man she named was the father of her child, then the child could seek admission into the putative father's *cenedl* providing that (1) the putative father was dead and (2) the child had the support of the confessor. This could only happen after the child had reached the age of seven, for only then would a child be competent to take an oath. Under no circumstances could the dead man's *cenedl* deny paternity if the dead man had in some way publicly admitted paternity, or if he had paid maintenance to the mother, or if he had cohabited with the woman and, therefore, nurtured the child for a year and a day.

If, as stated above, a mother did not make an assertion at childbirth, she had to defer making that assertion until the child became of age, in which case her claim had to be supported by the oaths of six of her nearest female relatives. This was the illegitimate offspring's last chance to be affiliated, but before considering how an admission or a denial of paternity affected such a person it is necessary to consider (1) the

precise meaning of illegitimacy and (2) to do so in terms of a son as the laws have little to say about illegitimate women.

Illegitimacy and Inheritance

In England, where ecclesiastical law defined an illegitimate child as one born of parents who had not been married in church, succession was mainly by primogeniture, meaning land passed undivided to the eldest surviving son. An illegitimate son, even if he were the eldest, was debarred from inheriting land, for the Church bastardized him, bringing the sin of the father not only against the son, but against grandsons and great-grandsons. In Wales, a child was legitimate by custom; that is, by continued cohabitation. He might also be legitimized by affiliation. It would appear, therefore, that only an unaffiliated child begotten in 'brush and brake' was illegitimate according to the Laws of Hywel Dda. This explication is borne out in part by the *Venedotian Code*, which states:

> The ecclesiastical law says that no son is to have the *tref y tad* [*gwely* land] except the eldest son born of a *wraig briod* [meaning a proper wife, possibly one married in church]; the Law of Hywel accords it to the youngest as well as to the eldest son, and decides that neither the sin nor the illegal act of the father is to be brought against the son where the *tref y tad* is concerned.

This clause gives the impression that all sons, including those who had been affiliated, were entitled to a share in *gwely* land. The *Gwentian Code* would appear to support this view when it asserts that 'no son begotten in brush and brake is entitled to a share in land, unless by favour', meaning, presumably, by affiliation. The *Dimetian Code*, on the other hand, states that 'if an uchelwr has an heir legitimate by custom and another who is illegitimate by custom, the legitimate is to inherit the whole, and the illegitimate is to have no share'. It, then, adds in the next paragraph that an unblemished illegitimate son — one who is perfect in limb, neither deaf nor dumb, nor insane — is to succeed in preference to a blemished legitimate son. It appears that in some parts of Wales affiliation was no guarantee to a share in land.

With regard to illegitimate daughters, their right to movables (*gwaddol*) must have been similarly uncertain even when affiliated, for the *Venedotian Code* accords that, when both parents of an illegitimate daughter were dead, and the girl sought admission into the putative father's *cenedl*, then the oath of a legitimate son of the putative father would suffice to have her affiliated, providing there was no property to be shared, thereby exonerating him from providing his illegitimate half-sister with either a marriage portion or a *gwaddol*. It would appear, therefore, that the person most likely to benefit from affiliation was the mother in that it gave her the right to claim maintenance until her illegitimate child became of age; it also transferred liability to pay the maiden fee (*amobr*) due to the king from the mother to the father.

Other Women of Ill-repute

When a woman cohabited for a short period in excess of three days, her entitlement to a dowry from her husband (*agweddi*) need be no more than a contemptuous penny, and no statement by her that she had been promised more would prevail against the man's denial. Should a woman of ill-repute be raped, she could not claim her honour-price as she had no honour to be insulted, but the rapist still had to pay a fine of between £3 and £7 (or face banishment) for what had become a crime by the 13th century. There is no evidence, however, that loose women were ostracized; they were not, as in Anglo-Saxon society, liable to pay a fine (*leyrwite*) for every occasion they went astray.

In the late Medieval period when, as a result of English influence, *amobr* became payable on every occasion that a woman lapsed, a woman of ill-repute could be a financial burden to a family, so much so that some families resorted to having a licentious daughter declared a prostitute and given a white rod in recognition of her immorality; this was permissible on the ground that the 'family should not henceforth be [repeatedly] charged with amobr'. A licentious woman, if she were married, could be the despair of a husband from whom she had separated as he was still her husband until one or the other remarried. In other words, a woman who had separated from her husband could have several liaisons with other men, leaving the husband to pay *amobr* — at around 10s. a time — for every occasion that she enjoyed life to the full. In these circumstances one could feel sorry for the frantic husband. His only hope was to have his errant wife presented with a white rod, and quickly.

Gwriag Briod

A woman described as *gwraig briod* — a proper wife — has been referred to above, and one of the privileges of such a woman was that, according to the *Venedotian Code,* 'she is entitled to buy and sell without the permission of her husband'. Occasionally a married woman is described as *agweddiol*; that is, one who has been promised a dowry (*agweddi*) by her husband, which suggests that she was one who had been married for less than seven years. It is reasonable to assume, therefore, that a *gwraig briod* was a woman who had been given as a gift of kin, married for more than seven years and entitled to an equal share in what had become joint property; she may also have been one whose marriage had been solemnized in church.

Foreigners

There were foreigners in Wales throughout the Medieval period. A strong Irish presence has already been considered and, in small numbers, Irishmen are known to have settled in Wales throughout the Medieval period. From the 7th century onwards the Anglo-Saxons were establishing themselves in the Welsh borderland and, in the 400 years that followed, it must have been expedient for natives and newcomers to intermarry for the sake of coexistence as opposed to burning one another's crops. There are hints, too, that from the late 11th century onwards, Norsemen from Ireland may

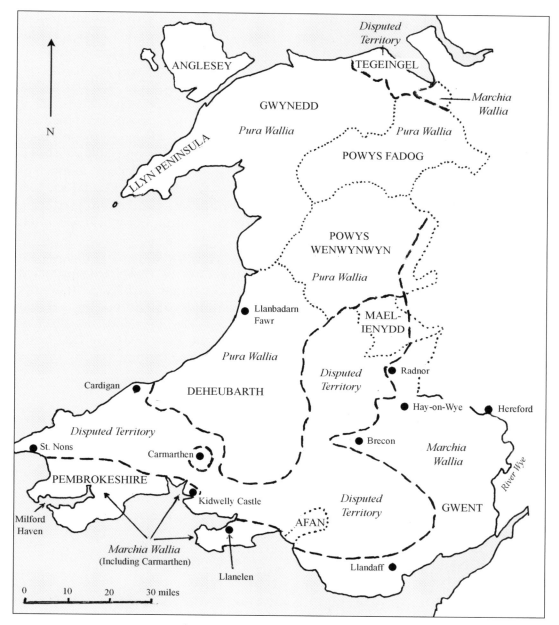

Wales prior to the conquest in 1282-3

have settled in small numbers in the coastal areas; they certainly did so as traders in the wake of Norman conquests.

When William the Conqueror defeated the Anglo-Saxons at Hastings in 1066, England became home to people from northern France and the Low Countries. The

most dominant newcomers were the French-speaking Normans, the descendants of whom — the Anglo-Normans — began making serious inroads into Wales in the 1080s. However, even after some 200 years of intermittent warfare, their conquest and settlement was confined mainly to the coastal areas of South Wales, and to eastern valleys such as the Wye and the Usk. In these areas, later known as *Marchia Wallia* (Marcher Wales), the Anglo-Normans built hundreds of castles and established walled towns to promote trade. They brought in Anglo-Saxon settlers, mostly from the west Midlands and the West Country; they even established Flemings in southern Pembrokeshire to the extent that, in later times, the area around Milford Haven became known as the 'little England beyond Wales'. In North, Central and in much of West Wales, Welsh princes continued to rule what was known in Gerald's day as *Pura Wallia* (Pure Wales). Between *Marchia* and *Pura Wallia* lay a band of disputed territory, over which the Anglo-Normans claimed political control, but which was often subject to the rule of Welsh princes.

This, then, was the political situation in Wales during the 200-year period known as the Norman Conquest. During this period the Laws of Hywel Dda prevailed throughout *Pura Wallia* and in the disputed territory mentioned above; they may even have continued in use in parts of *Marchia Wallia*. This turbulent, 200-year period was one in which mixed marriages served as a bond for temporary alliances between what were otherwise warring factions, and the Laws of Hywel Dda made provisions for such marriages, mainly for the benefit of any offspring.

Mixed Marriages

Unions between the daughters of prominent Welshmen and the Anglo-Norman aristocracy were not uncommon, nor were they difficult to arrange because the fathers on both sides provided their daughters with dowries — the Welsh gave an *argyfrau* consisting mainly of cattle, the Anglo-Normans a *franc-marriage* (or *maritagium*); that is, a grant of land that could not be disposed of for three generations. Gerald was himself of mixed stock, his grand-

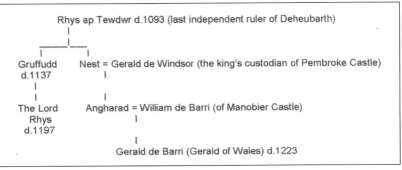

The lineage of Gerald of Wales

mother on the distaff side being a Welsh princess, as shown in the adjoining figure. The offspring of mixed marriages might complain, as did Gerald, that they were never fully accepted by either side, and they were often plagued by conflicting loyalties. In the earlier part of his life Gerald appears to have regarded the Welsh with a degree of

disdain, and complained, in later years, that his brother's son had gone native, preferring to speak Welsh rather than the cultured Norman-French of the nobility; he also bemoaned that his nephew was keen to develop skills in the use of the Welsh longbow and the harp, as opposed to devoting time to theology. Despite these grievances, Gerald had, by then, become pro-Welsh and a staunch supporter of an independent Welsh Church.

Right of *Mamwys*

The *Venedotian Code* states that:

> a woman is not to be given in marriage, except where the sons can obtain ancestral property, so that her children after her should have the same status and the same rights as her father before her had;

moreover, if she were given as a gift of kin to a foreigner, her husband had to be someone of at least equal status. The laws also accord that, if she had children as a result of such a union, her sons could return and demand by right of *mamwys* a share in her father's land, basing their claim on the fact that their grandfather (or possibly one of his sons) was responsible for bestowing their mother to a foreigner. Anyone descended from their maternal grandfather had, therefore, to provide the returning sons with a share in their grandfather's land, a share, that is, equal to a son's share, for the sons of mixed marriages ranked, for the purpose of inheritance, as sons of their mother's father.

There were, however, limitations as to what they could claim. They had no claim to their grandfather's homestead, nor could they (or their sons and grandsons) be elected to the office of *pencenedl*, unless their father was, or had been, a chieftain of Saxon or Irish origin. The same limitations applied to the sons of women who had been violated by a foreigner, or who had been given as a hostage to a foreign dignitary and, as a result, had been made pregnant. The right of *mamwys* did not apply to the sons of a woman who had married a foreigner by personal bestowal.

Royal Women

There is no evidence that women ever ruled in Medieval Wales. Some were, however, members of royal *cenhedloedd*, and by the 12th century there were, according to the laws, three royal *cenhedloedd* — those of Gwynedd, Powys and Deheubarth. That is not to say that each of the above kingdoms were ruled by a single king, for it became a frequent occurrence in the 12th and 13th centuries for kingdoms to be divided between two or more heirs, often warring among themselves, and that at a time when Wales was suffering from the affects of Anglo-Norman intrusion; moreover, by the mid-12th century it had become expedient for chroniclers to refer to Welsh kings as princes (*tywysogion*) because, by then, all of them owed at least a nominal allegiance to English kings. To add to the confusion and political fragmentation there were numerous territorial lords known as *arglwyddi*, each ruling a relatively small lordship

such as Afan or Maelienydd. One of the differences between the two ruling groups was that princes had exalted blood-fines, whereas the pecuniary worth of an *arglwydd* was no greater than that of an *uchelwr*.

In a politically fragmented society it was customary for royal women to be given as gifts to neighbouring rulers — be they princes or territorial lords, or even Anglo-Norman conquerors — usually with the intention of securing temporary alliances. Whether these women had the right to object — as did Rhiannon — to marriages that were political and for the purpose of producing heirs seems improbable.

According to the laws, a prince's consort — the queen (*brenhines*) — rarely dined with her husband and the principal men of his retinue. The queen had her own apartment, or penthouse, attached to the royal hall, where she dined with women of her choosing. She had, in fact, a degree of independence, being entitled to one-third of the income derived from her husband's estates, enabling her to manage her own domestic affairs. Her husband had 16 officers; she had eight, five of whom were her steward, priest, chief groom, doorward and handmaiden. In Gwynedd she also had a page, cook and candle bearer, whereas in South Wales it was customary to have, instead, a sewer, foot holder and a groom of the rein.

When she dined, her doorward, who was her personal bodyguard, stood at the door to announce the names of all who entered her apartment. Her steward, who managed her finances and the affairs of her household, stood beside the table, super-vising the young men who brought in the food. Her candle bearer, if she had one, stood beside her to cast light on her and the food that she ate; if she had a foot holder, he held her feet in his lap. Her priest said grace, the cook tasted her food as a precau-tion against poison, and the page, if she had one, carried messages, attended to her bed and exercised his role as cup bearer. The household bard (*bardd teulu*), who was one of her husband's officers, came in to sing to her in a low voice so as not to disturb the men in the hall.

The queen's chief groom was responsible for the horses in his charge and, when she went riding or hawking, the groom of the rein held a stirrup while she mounted, then ran beside her horse. One of her privileges was the right to a circuit (*clych*), taking with her, as she progressed among her husband's subjects, the maids and youths who were part of her household. According to the *Dimetian Code*, she went on circuit whenever her husband was absent on a foray, but all other sources limit the occasion to once a year. Another privilege was that she could, without the king's permission, give away one-third of the casual acquisitions (*dofod*) that she had received from her husband.

A queen's daily existence may appear sedate, and any influence she may have had upon her husband and, consequently, the affairs of state, may have been limited to her power of persuasion. Yet some royal women were truly spirited. Gwenllian ferch Gruffudd, for example, was the daughter of a prince of Gwynedd. Her husband, Gruffudd ap Rhys, was a member of the royal *cenedl* of Deheubarth, but he held little

in the way of land — just a small territory in the northern part of Carmarthenshire — and his capacity for war was, therefore, limited.

When the Welsh rose in revolt in 1136, Gruffudd journeyed north to enlist the aid of his wife's relatives. In the meantime, Gwenllian, 'like the queen of the Amazons', according to Gerald, raised a force from among her husband's subjects and marched on Kidwelly Castle, held at that time by an Anglo-Norman, Maurice de Londres. It was while she was laying siege to the castle that a relief column, led by a Welsh renegade, descended from the heights of Mynydd y Garreg. No sooner had she squared to withstand the onslaught than Maurice de Londres rode out of the castle at the head of his men to attack her rear. When the furore of battle died down, Gwenllian was taken prisoner and 'with many of her followers she was put to death'. Her name lived on, both as a battle cry and in the place where she fought — Maes Gwenllian (Gwenllian's Field) not far from the castle.

Another noteworthy queen was Joan, the illegitimate daughter of the infamous King John. Joan was given in marriage to Llywelyn ab Iorwerth, Prince of Gwynedd (1201-40), in 1204 and, during the troubled years that followed, she repeatedly conducted diplomatic relations for him with the Crown — but Joan, being a spirited woman, could cause problems. In 1228, Llywelyn caught her in the dead of night in a compromising situation with an Anglo-Norman, William de Breos. The indiscretion cost de Breos his life, whereas Joan is likely to have been spared, though at what cost is unknown.

Women of the Court

Young maidens, the daughters of prominent men, were commanded to serve in the queen's household. Some were given appointments as royal officers; the queen's handmaiden, being one, was in constant attendance, helping her mistress to dress and she, no doubt, took charge of all other maidens. The codes mention three other female 'officers by custom and usage' who were personal to either the prince or his consort — the sewer, laundress and the baking woman.

Concubines

Men undoubtedly had mistresses, but the laws state that 'no man is entitled to have two wives', and reference has already been made to the consequences of bringing a strange woman into the house. Even so, a variety of sources mention the existence of concubines. To understand what is meant by 'concubines' reference must be made to what has been said about illegitimate children, many of whom were not members of their father's household even though they might be affiliated and, therefore, maintained by him. In many instances an illegitimate child was either conceived or born of one woman, prior to the father marrying another woman. In these circumstances the first woman would appear to have been the concubine, the second the wife. The first-born son of Llywelyn ab Iorwerth of Gwynedd (1201-40), for example, was illegitimate and denied the right to succeed to his father's kingdom. Llywelyn's second son, David,

was the outcome of his marriage to Joan, and David inherited his father's kingdom. The Lord Rhys of Deheubarth (c. 1255-97) is believed to have fathered at least 18 children, obviously not all by his wife, Gwenllian. It can, therefore, be assumed that a concubine was not someone who lived under the same roof as a lawful wife.

Nuns

Some women, either by choice or in accord with their father's wishes, became nuns, living, for the most part, not in isolated convents, but in male-dominated monasteries such as Llanbadarn Fawr, in Cardiganshire, although a few small convents — such as Llanllugan in Powys — existed during the Norman Conquest period. One of the earliest instances of a Welsh woman becoming a nun is to be found among the Llandaff Charters, one of which records that, in Gower, 'Gwordog gave his daughter, Dulon, to the Archbishop of Llandaff to be a nun', and there are several references to an unlocated church called Porthtulon. Indeed, there are scores of ecclesiastical foundations in Wales that commemorate mainly 6th-century women who were considered saints, none of whom were officially canonized by Rome — St. Non's Chapel in Pembrokeshire, Capel Gwladys at Gelligaer in Glamorgan and Llanelen in Gower to name but a few.

Ecclesiastical Wives

Despite Rome's insistence that its clergy should be celibate, many Welsh ecclesiastics, including bishops, were married and, according to Gerald, their homes were 'infested with squalling brats'. The majority of these marriages were probably the result of personal bestowal, for no free woman would be given as a gift of kin to either a priest or a monk as such men were regarded as civilly dead and, therefore, unable to hold *gwely* land. There was, however, nothing to stop a married man taking holy orders, but should he subsequently have a son, that son was excluded from a share in *gwely* land.

Washerwomen

There is a curious entry in the *Dimetian Code* that says certain abbots had an honourprice of £7, and that should anyone insult one of these abbots, then, apart from the payment of £7, a woman of kin to the offender had to become a washerwoman for life as a disgrace to the *cenedl*.

Women in the *Mabinogion*

The *Mabinogion* consists of 11 tales. The earliest collection is in the *Llyfr Gwyn Rhydderch* (the White Book of Rhydderch), written in the early 14th century, although the tales must have been transmitted orally centuries before they were written down. The *Mabinogion* does not record historical events, but it is an invaluable source of customary material, each story providing a portrayal of Medieval women in a way that was obviously acceptable to mixed audiences. Each story also provides numerous

references to marriage and related issues, as well as an insight into how men and women related to one another.

Pwyll, King of Dyfed

In the first tale, Pwyll, King of Dyfed, is sat upon a mound near Narberth when a maiden in a garment of brocaded silk, wearing a headdress with a veil, rode past on a pale-white horse. Pwyll sends one of his retainers in pursuit, but the man fails to catch up with her. Exactly the same happens the following day; on the day after that Pwyll himself pursues her, but fails to draw abreast of her until he calls upon her to stop. When he asks her to identify herself she replies, 'I am Rhiannon, the daughter of Hefeyed Hên, and they sought to give me a husband against my will, but no husband would I have, and that because of my love for you'. That boosts Pwyll's ego and he agrees to a tryst at her father's court in a year's time. The tryst turns out to be a joyful occasion until a young man approached, requesting a boon. Without thinking, Pwyll declares that, if it is within his power, he will grant the boon, only to find that what the young man wants is Rhiannon as his wife. Pwyll is dumbstruck.

> 'Be dumb as long as you will'. Rhiannon pointedly remarks. 'Never has a man made such feeble use of his wits as you'.
>
> 'But, my lady', says Pwyll, attempting to excuse himself, 'I did not know who he was'.
>
> 'He is Gwawl ap Clud, the man to whom they would have given me against my will', says Rhiannon. Then she tells Pwyll to bestow her to Gwawl as he had promised. When Pwyll refuses to do so, she says, 'Bestow me upon him and I will see to it that he shall never have me'.
>
> 'How?' Pwyll asks.
>
> 'I will give you a small bag, and I will make a tryst with him a year from tonight, to sleep with him', by which Rhiannon meant they would become man and wife by cohabitation. 'The same night you will come, with the bag, and place 100 horsemen in the orchard yonder. Then, when Gwawl is in the midst of mirth, you will come in, dressed in rags, and ask a boon of him, that this bag may be filled with food. Now, this is the plan'.

After a year had passed, Pwyll follows Rhiannon's instructions to the letter. After placing 100 horsemen in the orchard he sets off on foot to the court of Hefeydd Hên, dressed in shabby garments, with rag boots about his feet. When Gwawl welcomes him, he asks a boon, that he might fill a small bag with food. Gwawl agrees, but no matter how much food is placed in the bag it will not fill.

> 'Will your bag ever fill?' Gwawl asks as Rhiannon had predicted.
>
> 'Not unless, my lord, a true possessor of land and territory shall tread down with both feet the food that is inside the bag'.

Prompted by Rhiannon, Gwawl places both feet in the bag. No sooner does he vanish from sight than Pwyll pulls on the strings, closing the bag tight. An instant later

Pwyll blows on a horn. The ground trembles with the rumble of hooves. Then a 100 horsemen file into the hall, each of them striking the bag with either his foot or a staff. Gwawl begs to be heard, his pleas supported by Hefeydd Hên.

Rhiannon takes control of the situation, telling Pwyll to

'Take a pledge from him that he will never again lay claim to me, nor seek revenge on you'.

'You shall have all that you ask', Gwawl calls from inside the bag.

When freed from the bag, Gwawl agrees that some of his men should stand surety for his good behavior. He, then, leaves with his retinue. The feasting resumes and, later, Pwyll and Rhiannon retire to the chamber. The next day they travel as man and wife to Dyfed where they rule the land prosperously.

At no time in this tale does Rhiannon have a passive role. She is portrayed as a woman who knows exactly what she wants and how to get it. She has absolutely no qualms about criticizing Pwyll for his *feeble wit*, nor has she any reservations about telling him what to do, despite the fact that he is a king and much older than herself. Her dominant character must have suited Pwyll because, two and half years later, when the *uchelwyr* of Dyfed suggest that Rhiannon should be put away because she is without issue, Pwyll will not agree to it.

Branwen, the Daughter of Llyr

In the tale of *Branwen, the Daughter of Llyr*, Branwen has a passive role to play, but there is, nevertheless, much in the story that relates to marriage. Branwen is the sister of Bendigeidfran, King of the Island of Britain, and it is agreed that she will sleep with Matholwch, King of Ireland, which again is the story-teller's way of referring to marriage by cohabitation. When Branwen's half-brother, Efnisien, arrives at court and hears of the bestowal from a groom he fulminates because, being of kin to Branwen in four degrees, he had not been consulted. In his rage he mutilates the horses of Matholwch and his retinue. Matholwch is insulted, but is appeased when he receives compensation for the horses and an honour-price suitable for his rank. He, then, returns to Ireland with Branwen only to find that his nobles, on hearing of the insult, demand that Branwen suffers for the insult in a way that is strangely similar to part of the honour-price that was due to certain abbots in South Wales, the difference being that, instead of becoming a washerwoman for life, she has to cook for the court and be boxed on the ear daily by the court butcher. What follows is beyond the scope of this work. Suffice to say that she is rescued by her brother, but dies of a broken heart.

CHAPTER VI
Welsh Law with Regard to Unfree Women

The laws recognized that a free woman might bestow herself in marriage to an unfree man, but no free woman would ever be given as a gift of kin to such a man as that would entail a loss of status — the woman would become unfree, her children would be born unfree. Little is known about unfree women, even though they belonged to the most numerous class, a fact borne out by the *Domesday Survey* of 1086-7, which records that, in the border areas of Wales, 52% of Welsh adult males were unfree. The laws, however, do provide snippets of information about unfree women, but before examining these laws it necessary to obtain an overall picture by considering first what is known about unfree men who, in English society, were known as serfs, villeins and the like. In North Wales the unfree were known as *ailltion*; in South Wales they were known by a different name.

Taeogion

A *taeog* was not a slave to be bought and sold for the price of four kine, nor could he in law be evicted from the land on which he lived and worked, but if the land was sold, or granted to a free man, he formed part of the transaction and became subject to a new master. Although regarded as servile insofar as certain obligations and dues were expected of him, a *taeog* did not necessarily act in a servile manner to those who were considered his betters; as Gerald stated

> Nature hath given ... the inferior classes of the people of this nation a boldness and confidence in speaking and answering, even in the presence of their princes and chieftains.

There is no reason to believe that the appearance of a *taeog* was any different to that a free person. Unfree women certainly wore headdresses as they are specifically mentions in the laws. A *taeog* lived in a hall — as did the free — and the values placed on the different parts of his body were exactly the same as those of a free tribesman. The hand of a *taeog*, for example, was valued at six kine and 120 pence, exactly the same as the hand of a free person. The same equality applied to oaths; they all carried the same weight and there was nothing in the laws to prevent a *taeog* taking a free man to court.

The principal difference between a *taeog* and a free man was status. Almost all *taeogion* were born to their station, but it was not birth alone that accounted for their lower status, but that the land on which they lived and worked was not their own. Such land might belong to a king, or it might belong to an *uchelwr*, and the landowner's status affected a *taeog's* worth. The blood-fine of a king's *taeog*, for example, was the same as that an unmarried *bonheddig*, namely 63 kine, whereas the pecuniary worth of an *uchelwr's taeog* was half that. A similar method of assessment applied to a *taeog's* honour-price.

Possessions were often valued according to the owner's status. The penthouse of a king, for example, was valued in North Wales at 120d.; that of a free man 60d.; that of a *taeog* 30d. Another important difference between the two classes was that a *taeog* held his land in return for rent in the form of food renders (*dawnbwyd*) and/or labour obligations, whereas a free man gave food renders (*gwestfa*) for the maintenance of the king's retinue — which was a form of tax — and was ever-ready to serve the king in a military capacity. There was also the question of movement. A free man was at liberty to travel wherever he wished, whereas a *taeog*, should he depart, could be brought back to his place of residence. This restriction on movement, however, may have been applicable only to a permanent change of domicile, for a *taeog* was at liberty to hunt animals such as roe-deer, otters and foxes. He must also have had the right in a court of law to enlist the support of distant relatives, many of whom may have resided in far-off vills.

Unfree *Gwelyau*

The majority of *taeogion* held their land of the king and appear to have done so as *gwelyau*, similar to the free men. There is no mention in the laws of a hierarchy among these *taeogion* equivalent to *uchelwyr* and *bonheddigion*. Yet there must have been landholding heads of household (ancestors) and landless descendants (heirs) for them to hold their land on a kindred basis. Their *gwelyau*, however, were invariably quite small, the largest on record consisting of 18 land-holding members; moreover, they do not appear to have been organized in large *cenhedloedd* such as that of Edred ap Marchudd, though they could, according to Gerald, 'recount the names of their forefathers' as far back as 'the seventh generation and beyond that'. Their origin is entirely unknown.

Trefgefery Tenure

Many of the king's *taeogion* held their land by *trefgefery* tenure, living in vills (*trefi*) that corresponded in size to small parishes. Each year a royal officer known as the *maer* visited each vill to declare what crops were to be grown and where. Once the cultivatable fields had been tilled, they were allocated, not to families, but to all adult males (save the youngest sons) who were without serious disabilities, each receiving an equal share. When the harvesting was done the fields became common property again until they were re-allocated the following year. Every eligible male had his own

hall, attached to which was a garden for growing vegetables. The youngest son in any family continued to live with the father to support him in his old age. When the father died, the youngest son inherited his father's hall. If a father died without male heirs, then, according to the *Dimetian Code*, a daughter inherited her father's hall and his share in the fields, though this only applied, presumably, if the daughter was unmarried. It has been suggested that these vills originated in the settlement of foreigners and captives.

The *Maerdrefi*

A king had several courts scattered throughout his realm. Attached to each court (*llys*) was a *taeog* vill known as a *maerdref* — often bearing the name *Maerdy* — the members of which held their land by *trefgefery* tenure. Close by lay the king's demesne — table land (*tir bwrdd*) for providing food for his retinue whenever he was in residence. The *maerdref* community was responsible for working the king's demesne, and this they did under the supervision of a resident officer known as the dung bailiff (*maer biswail*), a man of unfree origin. On the outskirts of the cultivatable fields were the homes of landless labourers — *taeogion* excluded from holding land in the *maerdref*, but holding, instead, vegetable plots, which they cultivated to supplement their meagre wages.

The *Taeogion* of Men other than the King

Little is known of the *taeogion* who were subject to the *uchelwyr* as the laws are primarily concerned with those who held their land directly of the king. The evidence, such as it is, suggests that many of the *taeogion* who were not subject to the king were descended from foreigners who had been allowed to settle on land held by the *uchelwyr* and in the fourth generation the descendants of these foreigners become unfree Welshmen, such as the three *taeogion* of Llywelyn Foelram of North Wales, who were said to be of Irish origin. The most illuminating example of the settlement pattern that existed between the free and 'their' unfree is to be found in the 1334 Survey of Denbigh, which records that, in the Commote of Isaled, 13 *uchelwyr* had in total 74 unfree tenants settled on their land, and 113 *uchelwyr* had no tenants.

Some *taeogion* — presumably those who held their land as *gwelyau* — also had *taeogion* who held their land of them. There is no record of the settlement pattern that existed between the two groups, but their existence is borne out by the laws, which state that the pecuniary worth of a *taeog's taeog* was half that of an *uchelwyr's taeog*, namely 15³/₄ kine.

Military Obligations

The laws did not prohibited the *taeogion* from carrying arms for personal protection, but they do state that, in times of war, all *taeog* vills were obliged to provide the king with one man, one axe and one packhorse for transportation and camp duties. There is, however, evidence to suggest that some *taeogion* — presumably those who lived

in *gwelyau* — may have fought in the wars of Llywelyn ap Gruffudd (1246-82) and in the rebellion of Madog ap Llywelyn (1294-5). Many of them certainly had a military obligation in post-conquest times, as evidenced by 14th century surveys.

Unfree Women

With regard to unfree women, it can be assumed that, for the most part, what was relevant to the free was applicable to the unfree, whereas any differences between the two classes are specifically mentioned in the laws. For example, the *Dimetian Code* states that

> a taeog's wife cannot give away anything without her husband's leave except her head-dress, and she cannot lend anything except the sieve and the riddle, and that as far as she can be heard with one foot on the threshold.

The wives of *taeogion* were undoubtedly hard-working, their days taken up by drudgery and making ends meet. Few are likely to have had either the time or the means to indulge in the niceties of life, such as learning to play the harp, nor are their homes likely to have been graced with the presence of bards, who would have considered it beneath their dignity to entertain them. It can be assumed that unfree women were permitted, with the concurrence of their lord, to 'go the way [they] willeth freely' as the laws hint at them marrying by personal bestowal; moreover, they must have been permitted to marry outside their vills as the alternative would have been continual interbreeding.

When it came to fees and dowries connected with marriage, their assessment in law was less for a *taeog's* daughter than for the daughter of a free man. When a daughter was given as a gift of kin the assessments were

for the daughter of	a free man	a *taeog*
maiden fee, *amobr*	10s.	between 2s. and 6s. 8d.
morning gift, *cowyll*	between 10s. and £1 10s.	10s.
dowry, *agweddi*	£3	between 10s. and £1 10s.

When a daughter bestowed herself in marriage the assessments of her *agweddi* (promised to her by her husband in the event of his death) was

for the daughter of	a free man	a *taeog*
dowry, *agweddi*	6 steers	3 steers

These differences in assessment suggest that the *taeogion* were poor, but this was not necessarily so. A *taeog* in the late Medieval period gave each of his two daughters six cows and ten ewes as their marriage portions and must, therefore, have had considerable resources at his disposal. What is also significant about the above tables is that they show that the laws recognized an unfree woman's right to bestow herself in marriage without the consent of her kin or the lord on whose land she resided, as evidenced by the assessment of her *agweddi* in terms of steers.

Enfranchisement

Unfree men might escape their lowly status if, with the concurrence of their lord, they became clerics, smiths or bards, but the enfranchisement could not be transmitted to sons unless they took up the same profession as their father; others might acquire free status by becoming dung bailiffs. A woman, on the other hand, could marry a free man, thereby acquiring her husband's status as, indeed, would her children, and in Monmouthshire a special marriage fee was imposed on free men who married unfree women. For most *taeogion* partial enfranchisement could only come through the efforts of the Church, which strove to mitigate the burdens associated with servile tenure. The Church even managed to obtain total enfranchisement for some, for the *Dimetian Code* states that, with the king's permission, the consecration of a church in an unfree vill made all the *taeogion* in that vill free.

The Decline of the *Taeogion*

The great famine of 1315-17 no doubt claimed the lives of many *taeogion*, but as a calamity it did not compare with the disastrous advent of the Black Death in the spring of 1349. Wales was depopulated, whole communities were wiped out, or abandoned by the *taeogion* who took flight, never to return. The Black Death made a second visitation in 1361-2, and returned with diminishing severity on no less than eight occasions before 1420. There is no reason to doubt that the *taeogion* suffered more than the free as they lived mainly in coastal areas and river valleys where contact with 'carriers' was more likely. So acute did the labour shortage become that, by the end of the 14th century, many of the great landowners had abandoned the practice of having settled communities of *taeogion* to work the land. It had become far more viable to re-lease abandoned land to individuals — be they free or unfree — in return for cash rents. By then the free men were no longer paying food renders (*gwestfa*) as a form of tax, but were paying, instead, an annual levy in cash called *tunc*. As a result of these changes the distinction between free and unfree became somewhat blurred, the difference being whether a man owned land as opposed to being a rent-paying tenant farmer, or even a landless labourer.

Women who were Slaves

It would have been inconceivable for a woman, whether free or unfree, to marry a slave (*caeth*) as that would result in her becoming a slave, a chattel to be bought and sold for the price of four kine — six if she originated from overseas. A female slave did, however, have a blood-fine equivalent to her saleable value, and also an honour price of 24d. if she could sew, 12d. if she was a slave of spade or quern, but the honour-price was not payable to her — nor the blood fine to her kin as she had no *cenedl* — but to her master. Slaves were very much a part of Welsh society. The Domesday Survey of 1086-7 records that, in the border areas of Wales, 17% of all adult males were either slaves or oxmen.

Most slaves were born as such. Some were slaves as a result of being captured in forays, as may have been the case of a Saxon woman in Gwent who was handed over, in the 8th century, as part of a payment. At one time it was possible for a convicted thief — whether free or unfree — to be handed over in bondage to the injured party as a 'saleable thief', but by the 12th century saleable thieves could redeem themselves on payment of £7 to the king.

When a runaway slave was caught, the captor was entitled to 2s. from the owner. If a man, other than a slave, had intercourse with a female slave, he had to pay the owner 1s. for every occasion, and should the woman become pregnant, he also had to provide another slave to take her place while she was *enceinte*, and then pay maintenance for the child, which became the property of the owner. If, on the other hand, the woman died in childbirth, the man responsible for her condition had to provide the owner with a replacement slave.

A slave owner was liable for any loss or damage caused by his slaves. If, however, a slave was convicted of theft, then the slave was fined 10s. for the first offence. It may seem odd that a slave could be fined, but there is reason to believe that slaves had their own livestock and property; moreover, a 10s. fine may seem a merciful sentence when one considers that a free person faced the death penalty for theft present. The fine, however, was not imposed on the slave out of mercy, but out of consideration for the owner, who stood to lose property worth four kine. Should a slave be convicted of theft a second time, then he or she suffered the loss of a limb, one of the rare occasions whereby Hywel's Laws prescribed mutilation. A third conviction could result in death by hanging, or, according to some authorities, the amputation of a second limb.

That slaves were able to accumulate property is borne out by a 9th-century insertion in the *Lichfield Gospels*, which states that 'the four sons of Bleddri ... gave freedom to Bleiddud ap Sulien and his seed for ever, for the price ... of 4lbs. 8ozs.' of a commodity that remains a mystery. Manumission by this means may not have been an option for a woman, but the *Dimetian Code* states that, should a free man purchase a slave, and then marry her in church, the woman would have the benefit of her husband's privileges. The laws do not specifically say that a female slave could be married to a male counterpart, but they do assess a slave woman's maiden fee (*amobr*) at 12d., payable not to the king, but to woman's owner.

Slavery in Decline

After the war of 1282-3, which ended the 200-year period known as the Norman Conquest of Wales, there was little opportunity for free Welshmen to enslave people taken in forays; this, coupled with successive outbreaks of the Black Death must have reduced the slave population considerably. It is, nevertheless, likely that slavery continued to exist in Wales until the end of the Medieval period.

CHAPTER VII
The Late Medieval Period

Despite Anglo-Norman influences, the *Dimetian* and *Gwentian Codes* of South Wales were closer to the original Laws of Hywel Dda that the *Venedotian Code* of the North, mainly because the *uchelwyr* of the South were resistant to change. In Gwynedd, Hywel's Laws suffered change at the hand of strong princes, two of whom were Llywelyn ab Iorwerth (1201-40) and his son, David (1240-46), for it was during the first half of the 13th century that the *Venedotian Code* was redacted; moreover, a Welshman testified before a royal commission of 1280-1 that David abolished the practice of *galanas* (compensation by way of blood-fines), although in what circumstances remains obscure. Several witness also testified that the men of Gwynedd — presumably during the reign of Gruffudd ap Llywelyn (1246-82) — had been increasingly opting for trials in which the verdict was decided by a jury of twelve landowners, the practice having infiltrated from England where it had become widespread in the early 13th century. However, the greatest blow to Hywel's Laws came after the disastrous war of 1282-3, which resulted in the extinction of Welsh political independence and the start of a 250-year period in which Wales, although conquered, remained outside the English realm.

In March 1284 the victor of the above war, King Edward I (1272-1307), issued the Statute of Rhuddlan, thereby creating out of conquered territory the Principality of Wales, which comprised of the pre-1974 counties of Anglesey, Caernarfon, Merioneth, Cardigan and part of Carmarthen. Within the Principality — which was Crown property — and the newly-created county of Flintshire, the Statute abolished most of Hywel's Laws, replacing them with English criminal law and a civil law that was an admixture of Welsh and English. Edward I made no attempt to abolish the Welsh system of partitionable inheritance and, while it is true that he forbade illegitimate sons from succeeding to their father's land, a way was found to circumvent this rule in that all the father had to do was acquire a special licence that enabled his illegitimate son to acquire hereditary rights. The bond of kinship, therefore, persisted almost unchanged, and the *uchelwyr* continued to be a dominating influence in Welsh society. Many of the *uchelwyr* had been administrators and law enforcement officers in the service of Llywelyn ap Gruffudd, the last independent ruler of Gwynedd, who met his end in the 1282-3 war, and the biggest change for

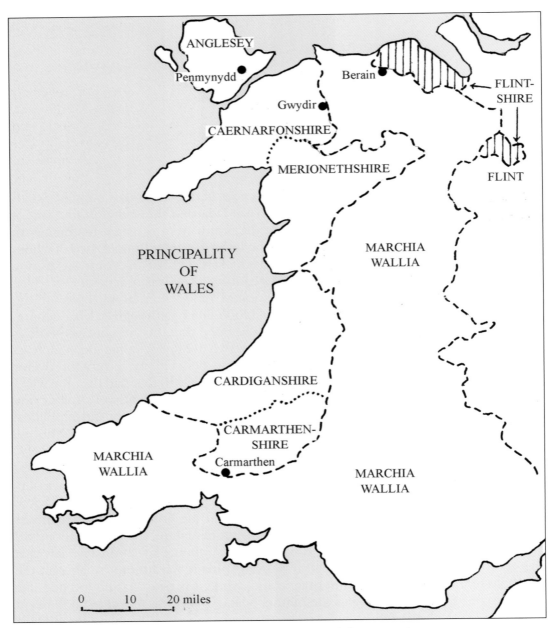

Wales after the Statute of Rhuddlan (1284)

them was that, instead of serving a Welsh prince, they were henceforth employed in the service of the Crown; without them, top foreign officials would have been at a loss in dealing with a Welsh-speaking population that was sullen, if not hostile.

Indeed, it had been long recognized in *Marchia Wallia* that the only way to govern the Welsh was through Welshmen.

Changes to the Position of Women

The position of women within the Principality and Flintshire remained relatively unchanged, except in three important areas, one being that whereas murder was, according to the *Venedotian Code*, both a crime and a tort, punishable by death and compensation, under English law it was solely a crime; a blood-fine was no longer applicable. Officially, women were, therefore, no longer liable to contribute to someone's blood-fine, but there is reason to believe that, in communities where extra-curial arbitration was the norm, the contributions may have continued in secret for 100 years or more. The second important change concerned land.

Unlike their southern counterparts the women of North Wales could not, in default of near heirs, inherit *gwely* land, and there were no provisions for women, whether they lived in North or South Wales, to be endowed with land as a means of support during widowhood. In England a woman could expect to be endowed with land should her husband predecease her. From 1284 onwards many Welsh widows were to benefit from endowment, for within the Principality and Flintshire the Statute of Rhuddlan provided for widows, both free and unfree, by stipulating that 'whereas theretofore women had not been endowed [with land] in Wales, the King granteth that they shall be endowed', meaning that, on the death of her husband, a widow had the right to succeed to one-third of her husband's land, even if it were *gwely* land, which she held until her death, or remarriage, after which the land reverted to her deceased husband's *gwely*. The provision also applied to unfree widows whose husbands had held their land by *trefgefery* tenure; on the death or remarriage of these widows the endowment reverted to the common pool of the unfree community. Endowment, however, gave women only a temporary toehold in the land market.

The third important change concerned rape. In 1275 (nine years before the Statute of Rhuddlan abolished most of Hywel's Laws) the law relating to rape in England had been improved upon in several ways. Firstly, rape became a crime insofar as the Crown could intervene when no private action had taken place within 40 days of an offence. Secondly, rape no longer applied to virgins alone, but to married women as well. Thirdly, the severity of the penalty was reduced from blinding and castration to two years imprisonment and a fine. The reason for this is that the all-male juries of the day regarded mutilation as too severe a punishment when compared to the offence of rape and were, therefore, reluctant to return a guilty verdict.

In 1285 (one year after the Statute of Rhuddlan) the law relating to rape in England was changed again. Not only was rape made a felony, punishable by death (and remained as such until 1841), but the amended law made it possible for the offence to be confused with abduction and elopement. Over the next two centuries

the woman's ordeal came to be regarded as of little import, being incidental to a desire by well-to-do families to safeguard their interests, including a daughter's virginity, which they considered an asset. If an heiress eloped, it did not matter whether a sexual act had taken place, or whether it had been carried out with her consent, her lover was considered an abductor, one with an eye on her inheritance. Almost a 100 year later the Statute of Rapes (1382) enabled a family to disinherit both their 'abducted' daughter and her abductor. In 1487 abduction itself became a felony.

The changes in English law that made rape secondary to safeguarding property must have had a detrimental effect on male attitudes to rape, especially the attitudes of men who, as landowners, were permitted to serve as jurors. It follows, therefore, that the vast majority of rape victims in England would have seen the futility of an appeal. They would have kept silent, put the whole sordid affair behind them and got on with their lives as best they could, but their fear, then, was that they might become pregnant, in which case they would have been branded women of ill repute. If, on the other hand, they managed to conceal their condition, they might resort to some form of abortion. In the final analysis they might resort to infanticide.

An English woman who was prepared to appeal would soon find herself up against a wall of indifference, even disbelief, especially if she postponed her appeal, or if there was no evidence to show that she had resisted. There was no point in her saying that she had been scared, or terrified by threats of violence — she should have fought tooth and nail. It would have been made plain to her by all and sundry that she had no chance against an employer, an official or anyone of higher status — after all, it was her word against his, and he could refute the allegation, or declare that she had consented to the act, or say, as in later times, that she was 'for want of chastity and common decency' or was a prostitute. Indeed, if her body had been violated, then her character would suffer a similar indignity. Her allegation might even be construed as a vicious attempt to blacken a man's character, in which case she could find herself punished for a making a false accusation. Little wonder that so few indictments ever reached court. The women either gave up, or, as often happened in the Medieval period, both they and the accused reached an out-of-court settlement.

It was exceptional for rapists to appear in court; when they did they were usually acquitted for a variety of reasons, one being that male juries considered the death penalty disproportionate to the crime. Very few men were ever found guilty.

How English law relating to rape was received in the Principality (formerly *Pura Wallia*) is unknown, but the fact that, even as late as the early 19th century, the Welsh were by and large still settling their differences by arbitration and not in court, is reason to assume that, in the remote countryside of 13th-century Wales, they continued to settle matters relating to rape in the time-honoured way.

Another consideration is that, unlike their English sisters, the women in the Principality had the support of their kin (and would continue to have that support for a further 250 years), which may have ensured an out-of-court settlement in the victim's favour.

Marchia Wallia

Outside the Principality and Flintshire, Wales was divided into scores of petty lordships, held for the most part by Anglo-Norman Marcher lords. In the Welsh populated areas of these lordships the Laws of Hywel Dda persisted (after 1284) for more than 250 years. Indeed, about 20 surviving manuscripts on Welsh law were actually written in the 14th, 15th and early 16th centuries. That is not to say the Marcher lords had any respect for Hywel's Laws. On the contrary they suffered the laws for the sake of revenue. Homicide, for example, remained a tort in many areas for the simple reason that one-third of the blood-fine — formerly due to Welsh rulers — was payable to the Marcher lord in whose territory the offence was committed. The maiden/virginity fee (*amobr*) was another important source of revenue (to the Crown as well as the Marcher lords). Originally, *amobr* was a once-only payment to Welsh rulers, but by the 14th century it had been modified to incorporate Anglo-Saxon *merchet* (which was payable each time a woman married) and *leyrwite* (a fee that was payable every time a woman lapsed).

Outside the Principality the practice of endowing a woman with land met with slow and patchy acceptance; in the Lordship of Oswestry, for example, the practice was not formerly recognized until 1429. The Marcher lords' attitude towards widows and endowment is exemplified by what was written in the Extant of Bromfield and Yale in 1391; the relevant passage states:

> On land held by Welsh tenure [that is by *gwelyau*] a wife ought not to be dowered from the inheritance of her husband [but] if her husband holds land by ... English tenure, then let her be dowered according to the practice of such tenure. A Welsh woman ought to receive a third of the ... chattels of which her husband dies in possession [and also] land held by him in mortgage [*prid*] ... if a child of their union is still alive. If no child survives, then the widow is to receive half of the movable goods, providing that she has not cohabited with another man during her husband's lifetime and has remained unreconciled to her husband before his death; in that case she forfeits all claims.

Movables continued to form the bulk of most widows' wealth throughout the late Medieval period in both the Principality and *Marchia Wallia*, but by the time of Elizabeth I (1558-1603) the custom — which by then was known as *legitim* — was in decline and, in 1696, it was formerly abolished. As to the reference made to 'land held ... in mortgage (*tir prid*)', this requires explication because (1) the ownership of such land gave women more than just a toehold in the land market, and (2) the Welsh mortgage (*prid*) had a marked effect on the history of Wales.

The Welsh Mortgage (*prid*)

A man held his portion of *gwely* land (*gafael*) on trust for the duration of his life-time, after which his portion had to be partitioned amongst his heirs according to the Laws of Hywel Dda. Therefore, he could not alienate by sale or gift any part of his portion of gwely land. He could, however, mortgage all or part of his portion providing he did so with the consent of his superior (be he king, prince or a Marcher lord) for up to four years at a time. An example of how this worked can be found in the records concerning one Llywelyn ap Goronwy who granted a parcel of land near Ruthin to Bleddyn ap Einion in return for the sum of 10s., which Llywelyn was to repay over a period of four years, without interest as that would have been considered usury. Llywelyn had also to pay to the lord of Denbigh 10d. for a licence to grant the land in *prid*. It was also agreed that if Llywelyn failed to repay the 10s. in the first four years, he would be granted a further four years to make good the payment. In the meantime, Bleddyn would pay Llywelyn an annual rent of 1d. for the period of the mortgage. It is not known whether Llywelyn ever redeemed the mortgage, but it should be pointed out that, had he died without doing so, then his heirs would have been at liberty to redeem the mortgage on payment of 10s. It is possible that this mortgage, like so many others, was never repaid.

Women benefitted from the above practice in that mortgaged land lay outside the system of Welsh tenure for as long as it remained mortgaged; it could, there-fore, be bestowed upon a daughter by a father, or on a wife by a husband, and the woman not only held such land in her own right, but she could pass it on to her children providing, of course, the mortgage was never redeemed. This trend towards some women becoming landowners through endowment, or by bestowal of land held in *prid*, was certainly beneficial in terms of self-sufficiency, for widows especially, but these benefits were offset in the 14th century by a trend which, in some areas, discriminated against married women.

Increasing Male Dominance

In areas where English common law had been introduced, the position of a married woman became that of coveture; that is, she was considered to be under the domination of her husband to the extent that he had complete control over joint property, and could dispose of it as he saw fit 'by the curtsey of England'. Under these circumstances a woman could not gift or bequeath anything other than what her husband would allow.

Wardship

Considerable space has been devoted to provisions made for widows, especially with regard to land, but provisions were also made concerning the future of chil-dren whose parents had died before they became of age. Hywel's Laws refer only

to heirs who were placed under the guardianship of someone belonging to the mother's kin 'lest out of greed a man of the father's kin should betray him, or poison him'. The practice that prevailed in the late Medieval period was similar in that the guardian was at liberty to choose a spouse for the child as the father would have done had he lived, except that it becomes increasingly evident that the guardian, in choosing a spouse, invariably selected someone related to him, or someone he favoured; moreover, it becomes apparent in the late Medieval period that the inheritance of the child, or ward, was also placed in the custody of the guardian, who would administer it as he saw fit, and was entitled to pocket any profits that accrued. It is little wonder, therefore, that wardships were sought after and the cause of many a family feud.

Women at Work

It is a commonly-held belief that Medieval women, especially married women, were responsible for the home, preparing food, bringing up children, providing clothes and, when necessary, helping the men in the fields, but it becomes increasingly evident, from the 14th century onwards, that women were by no means restricted to the home. Records show they had a hand in building English castles as early as 1282 and, from the mid-14th century onwards, they are to be found among the bands of seasonal harvest workers that trekked to the English-Welsh borderland, where they were paid the same wages as men.

Few households depended solely on farming. To survive families had to be flexible, their members engaging in all manner of gainful activities. Women often became laundresses, or sempstresses, or were sent, prior to marriage, to be servants in the halls of the well-to-do. Most wives engaged in occupations that were ancillary to those of their husbands. Brewing was very much a female activity and, if there was surplus liquor, it was sold in a manner that led to the establishment of alehouses. The production of cloth, both woollen and linen, was also a woman's preserve. It is likely that women who engaged in brewing or weaving did so in support of their husband's secondary occupations, for the records reveal that many widows were engaged in such work.

A minority of high-born women were in a position to compete with men in what was supposed to have been a male preserve — strict-metre poetry — and the earliest women on record to do that was Gwerful ferch Hywel Fychan of Powys, otherwise known as Gwerful Merchain (*fl.* 1462-1503). Gwerful is credited with the composition of 40 extant poems, some of which suggest that she declaimed her work in the taverns where, if the quality of her verse is anything to go by, she was a match for any bard. Another woman with similar talent at that time was Gwenllian ferch Rhirid who flourished around 1460. Unfortunately only one of Gwenllian's compositions survive.

The Rise of the Gentry

To understand how the gentry came into being it is necessary to bear in mind that men who adhered to holding only *gwely* land became progressively less wealthy as a result of partitionable inheritance. This is exemplified by the fact that the lands of one Iorwerth ap Cadwgan (*fl. c.*1220) had, by 1313, been partitioned between 27 male descendants, all of whom were *uchelwyr*. Self-seeking *uchelwyr* were, of course, unwilling to accept this decline into obscurity, and one of the earliest men on record to acquire a huge private estate was Ednyfed Fychan, the warrior statesman of Llywelyn ab Iorwerth (1201-40) of Gwynedd, who accumulated landed possessions through grants from his prince and, perhaps more so, through the device of *prid*; at the same time he maintained his connection with the *Cenedl* of Edred ap Marchudd by continuing to hold *gwely* land according to custom.

After Edward I's conquest in 1282-3 a growing number of self-seeking *uchelwyr* followed Ednyfed Fychan's example of creating huge, private estates through the device of *prid* and were similarly able to further their own interests through their employment in the service of the Crown. Such men — who were to become the gentry, or squirearchy, of a later age — were, in the absence of Welsh princes, the acknowledged leaders of Welsh society; they were patronized by the bards and their ability to raise and lead Welsh troops made them invaluable to English kings. The landed interests of the gentry, though scattered far and wide, could be impressive, their tenantry numbered by the hundred, their servants by the score. When they travelled, they did so in the company of retinues, and when they died their private estates, which they held by English tenure, passed undivided to their eldest sons.

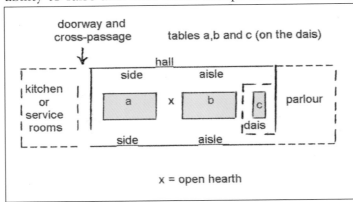

Hall house of the later Medieval period
— 15th century

Material Benefits for High-born Women

Women were as proud of their lineage as were men; moreover, women of gentle stock were to benefit from their marriages to self-seeking *uchelwyr*, both in material comforts and in their role within the household. By the 15th century the home of a squire had become a symbol of his wealth and status. These homes were far more substantial than those of Gerald's day, the most common type being a single-story, timber-framed, hall house; that is, a hall with additional rooms at either end. The upper end of the hall was occupied by a dais, about ¼m. high, beyond which

That there was growing tension between the two families is evidenced by a letter, dated 24 February 1576, in which Katheryn describes herself as 'foolish and fond', and implies by the tone of her letter that she was a woman in distress — but, of course, she wanted a favour of her stepson, John Wynn. She wanted John, a barrister in London, to intercede in a case concerning a kinsman of hers. At the beginning of the letter Katheryn refers to the 'revenge of our [the family's] enemies', and of the discredit she was likely to receive at the hands of her father-in-law, Sir John Salusbury, his brother and their friends unless he (John Wynn) were to 'be her shield' in her hour of 'greatest necessity'.

The case concerned a 'kinsman and late servant' of Katheryn, Jevan ap Thomas, who had injured a neighbour of his, William ap Richard, to the extent that the man had subsequently died. Katheryn claimed that William ap Richard had attacked her kinsman with a 'good pike fork and a long dagger' (whereas her kinsman had only a dagger) and driven him 'back to a hedge where he found a stone under his feet by chance and threw it at' his assailant in order to flee. Despite injury, William ap Richard pursued Katheryn's kinsman for about a mile until his injury forced him to abandon the chase. On the subsequent death of William ap Richard several men had caused Katheryn's kinsman, Jevan ap Thomas, 'to be indicted of wilful murder'. Jevan, trusting upon 'his innocence', gave himself up 'to the law', being emboldened to do so by Katheryn's father-in-law, Sir John Salusbury, and others, all of whom had 'promised to be [Jevan's] faithful friends and aides'. Unfortunately, these influential men 'not only' left Jevan 'destitute of all aid', but they aligned 'themselves with his adversaries' to the extent that they corrupted the minds of both the county sheriff and the Earl of Leicester, who was then one of the principal landowners in North Wales. Although Katheryn was convinced that 'the surgeon will upon his oath verify that the man died ... for want of good keeping than of hurt', and that 'everyone did ... agree ... that the man slain' had been stronger and better armed than her kinsman, she nevertheless implored her stepson to intercede in the matter.

What happened to Jevan ap Thomas is unknown, but he certainly did not hang as his name appears among the witnesses to a lease five years later. As to Katheryn's reference to Sir John Salusbury being an enemy of the family, his enmity may have been due in part to the fact that his grandson, Thomas, had no wish to marry Margaret Wynn.

When Sir John Salusbury died on 18 March 1578, half of his estate went to his wife and the other half was set aside for his two grandsons. The elder grandson, Thomas — who was then about 14 years old — was placed in the wardship of the Earl of Leicester, which came as a surprise to Wynn as he expected to have custody of the boy according to the terms of the marriage contract. In his letter to the Earl, dated 3 April 1578, Wynn stated that three or four days before Sir John Salusbury's death, Sir John had summoned him to his house and:

openly affirmed that he never intended to break ... the bargain concluded between his [grandson] and my daughter as he had done many times [before ... that he] was never privy nor consenting to the [boy's] departure from me, and said how he had sent for the [boy, who was at Oxford, intending to deliver him] unto me if he came home before he died.

Wynn stated further that Sir John had called Lady Jane 'unto him and reconciled me to her of all such mislikings as she had conceived against me, desiring her to take my [daughter] to her' (so that she might be brought up in the Salusbury household).

Wynn's fear that the Earl would oppose the marriage arrangement was allayed when he received a letter from the Earl, dated 23 March, in which the Earl reassured him that, even though, in his opinion, 'the match was made only to defraud me of the wardship, [and that the boy] utterly dissented' to the match, he would not oppose the completion of the marriage arrangements — but Wynn had been 'lulled in the security of his cause, according to his son, John (the barrister), for in a letter to someone close to the Earl, dated 10 April, John makes it plain that his father and Katheryn were staying with Lady Jane at her home in Denbigh where, he claimed, the two women 'so rule my father that he ratifies what they think fit should be done. I would to God my father's eyes were opened to see [how] the sirens [temptresses] enchant him'. It would appear from the contents of this and a subsequent letter that John Wynn was aware of Lady Jane's double-dealing over the wardship of young Thomas, and also of Katheryn's complicity in the matter.

Morris Wynn died in August 1580, leaving Katheryn with a son and daughter begat by him. Katheryn, then, left her late husband's residence at Gwydir to return to Berain, where she was joined by her stepdaughter, Margaret Wynn. A lease, dated 8 March 1581, records Margaret as a witness under the name of Mrs. Margaret Salusbury, proving that by then her marriage to Thomas — who was still at Oxford — had been solemnized. Katheryn's kinsman, Jevan ap Thomas, was also a witness to the lease, evidence that he escaped the gallows.

On 5 January 1583 an agreement was penned for a double marriage. Katheryn was to marry Edward Thelwall, son and heir of the wealthy and influential Simon Thelwall of Plâs y Ward in the Vale of Clwyd. Edward, a widower with three boys, may have been 10 to 15 years younger than Katheryn. The man who was to bestow her was her brother-in-law, Thomas Salusbury (not to be confused with her son, also Thomas). In the second wedding, her ten-year-old daughter, Jane, by her late husband, Morris Wynn, was to become the wife of Simon Thelwall, the twelve-year-old son of the man Katheryn was to take as her fourth husband. Jane was to receive from her stepbrother, John Wynn (the barrister, who now owned Gwydir), a £400 dowry (marriage portion) on her marriage to Simon Thelwall, or, if he died, to either of his two younger brothers. Thus we have another example of how the wealth of two families was kept within a small circle.

It is not known when Katheryn and Edward Thelwall were wed — in all probability it was in 1583, the same year the marriage agreement had been penned. Edward

took up residence at Berain (his father, Simon, was still alive and residing at Plâs y Ward). Young Thomas Salusbury's marriage to Margaret must have been consummated by at least the following year, for she is known to have had a son (who died in infancy) before giving birth to a daughter in February 1586. Whatever joy the second child may have brought to both Margaret and Katheryn, it was soon marred by Thomas Salusbury's execution, in September that year, for his involvement in the Babington conspiracy, the objective of which was to put Mary Queen of Scots on the English throne. No sooner had the execution taken place than royal commissioners turned up at Berain to enquire into Thomas Salusbury's estate. According to John Wynn, it was lucky the commissioners did not find the documents that Katheryn had drawn up — following the death of her first husband — to settle her estate on her son, Thomas. If the commissioners had found the documents, the estates of Penmynydd and Berain would have been forfeited to the Crown.

Having lost one son and come close to losing her estate, it was now imperative that Katheryn found her surviving son, John Salusbury, a wife to provide him with heirs. John, aged about 20 at that time, was heir to the Llewenni estate; it was, therefore, in Lady Jane Salusbury's interest that her surviving grandson should have an heir, otherwise, in the event of him dying without issue, the Llewenni estate would pass to other members of the Salusbury family. There is no reason to doubt that Katheryn and her mother-in-law contrived to find John a wife, and quickly.

Three months after Thomas's execution, on 18 December 1586, John married Ursula Stanley, daughter of Henry Stanley, fourth Earl of Derby. To celebrate the homecoming of John and his bride on 27 December, Katheryn arranged for a masque to be performed at Berain. The couple took up residence with Lady Jane at Llewenni and, when she died sometime between 1595 and 1597, John succeeded to the Llewenni estate. He was knighted Sir John Salusbury in 1601, and his wife, Ursula, provided him with more than enough heirs, for although four of her offspring died shortly after birth, no less than seven children — four of them boys — survived to adulthood. There is reason to believe, however, that a certain amount of ill-will existed between Katheryn and her mother-in-law in the years that followed John's marriage, possibly because Berain had been settled on Thomas Salusbury's daughter, Margaret. Thomas's widow, Margaret, probably resided at Berain from 1586 onwards, for in April that year, Katheryn's father-in-law, Simon Thelwall, died and his son, Edward, inherited Plâs y Ward, which is where Katheryn is known to have lived during her latter years.

Katheryn died on 27 August 1591, aged 56, at Plâs y Ward and her body was moved to Berain before being buried in Llanefydd Church, where no monument survives to commemorate her passing. She had no children by Edward Thelwall, but her six children by her first three husbands, their marrying into wealthy and influential families, and the number of offspring they produced were the reasons why Katheryn became known as *Mam Gymry* — Mother of Wales — as, indeed, Queen Victoria became known as the 'Grandmother of Europe' on account of her offspring.

Many poems were composed in her memory and, as time went by, many stories revolved around her life, some of them uncomplimentary, such as the one that said she had many lovers, besides husbands, whom she disposed of by pouring molten lead in their ears while they slept, then burying them in the orchard at Berain.

Chapter VIII
Marriage in the Early Modern Period (1)

After 300 years of English domination and the abolition of Hywel's Laws it is unsurprising that, by the late 16th century, there was no difference in the legal status of women within the two countries. A woman, if she were unmarried or a widow, was *feme sole*, able to fend for herself, to sue or be sued, and entitled to hold property in her own right. If she were married, she was *feme covert*, subject to her husband's will, unable to enter into a bargain, to sue or be sued except through her husband; nor could she hold property independently of him other than her *paraphernalia* — her clothes and personal ornaments — nor could she bequeath anything beyond that which he was prepared to allow. This state of affairs was to remain unchanged until the 19th century.

As to a woman's extended, often ritualized, rite of passage from *feme sole* to *feme covert* there is plenty of evidence as to how this was achieved among the gentry of Wales, but there is little that relates to the vast majority of people until the 18th century. There is, however, considerable evidence relating to courtship and betrothal among the lower classes in England during the 16th and 17th century, and this, compared with what survived in Wales until the First World War provides sufficient ground to assume that what was customary among the lower orders in one country was similarly so in the other.

Throughout the 250-year period between the late 16th and early 19th centuries, the vast majority of people in Wales were Welsh, both in the countryside and in the towns. The English minority were to be found mainly in the towns and in the fertile lowlands such as the Vale of Glamorgan. The country, however, was not simply divided by ethnic differences; it was also divided according to class. The majority of people, both English and Welsh, were peasants — farmers, smallholders and farm labourers. The average woman within this class married in her mid-twenties, the average man in his late twenties, and they did so for reasons that were mainly economic. The daughters of poorer families usually left home in their early teens to fend for themselves, to take up employment as live-in domestic servants or farm maids for the better off, for which they received room, board and a small wage. These girls were apparently more mobile than boys, moving from one household to another whenever their yearly contracts expired, or whenever their employers upset them. Most girls restricted their

movement to their own or neighbouring parishes, whereas the more adventurous migrated further afield.

Young men who could expect little in the way of an inheritance also engaged in similar service, or set out to seek their fortunes as soldiers or sailors while, in the towns, young men served lengthy apprenticeships as craftsmen. By the time these landless sons had established themselves with sufficient means to maintain a wife they would have been in their late twenties as, indeed, those who inherited their fathers' estates would have done so at much the same age. That is not to say that young people did not fraternize with members of the opposite sex. They simply restricted their serious intentions to a later stage in life when they were better equipped to engage in an extended right of passage, the objective of which was the establishment of independent households. There were, however, many stages on the road to marriage.

Courtship on/in the Bed (Bundling)

A woman's relationship with a man might start when she met him 'out of doors' on a festive occasion, or when he caught sight of her at work, or at communal gatherings such as the yearly hiring fairs where young people assembled to be selected by prospective employers. The next stage — courting — depended on whether the man was prepared to call at the woman's home, or place of employment. His visits would be conducted at night because, according to an essayist who wrote in 1907,

> Everyone who knows the ways of country people is aware that [in the Swansea Valley] courting throughout the night was the custom and that a young man going courting was terrified lest any one should see him 'in broad daylight'.

One reason why courting was conducted 'throughout the night' was undoubtedly work. There is also the statement that 'a young man was terrified lest any one should see him in 'broad daylight', the reason for this being that it might be construed that he and his sweetheart were a couple and, in the event of one party ending the relationship, the other could take the matter to a consistory court of the Church, there lodging a complaint known as breach of promise. The fact that they had been seen together in 'broad daylight', unaccompanied by friends, would have been considered proof that they were a couple, whereas clandestine affairs could not be considered as such.

A young man often went courting in the company of a male companion whose role was to provide moral support, or even physical assistance if, in response to throwing gravel at a window, the girl's father appeared in an aggressive frame of mind. In Wales at a much later date it was common for a farmer's son to be accompanied by the son of a farm servant, 'the farmer's son to see the daughter of the house, and the servant to see the maidservant'. With regard to servant girls, courting would appear to have been tolerated in 19th-century Wales on the ground 'that it would be difficult for him [the employer] to keep any servant if he restricted them in these respects'.

Should the suitor be deemed acceptable he might be allowed to stay while the parents retired to bed. He might even be allowed to court on or in the bed (*caru ar/yn y gwely*) where, fully or partially dressed, sometimes with a bolster between them, he and the woman he wished to court got to know one another by chatting — at least that was the rule by which they were expected to abide. The custom is an old one and, at one time, prevailed throughout northern Europe. There are hints of 'lying together' (*cydorwedd*) in Dafydd ap Gwilym's poetry, but the earliest detailed references to courting on/in the bed are to be found in the works of outsiders, men who visited Wales and reported on what they considered to be quaint customs of the Welsh peasantry, including *caru ar/yn y gwely*, which, known as 'bundling', had by and large died out in England. One of the earliest of these travellers, J. Jackson, came to Wales in 1772 and recorded that, in a farmhouse where he stayed, he witnessed the custom being performed by a farmer's son and a girl of the house. Referring to the couple as Colin and Phebe, Jackson wrote, Phebe

> had taken off her headdress and was adjusting her hair ... She then very deliberately pulled off and folded up her outer garments ... keeping only a short coat over her chammese, the tucker of which she carefully drew very close about her neck. Colin, all this time, with everything on but his hat and shoes ... sat on the bed. Phebe went round and got in on the farther side. The crimson of her cheek brightened as she gave her lover a last look for the evening and, putting out the light [candle], left me and yourself to form our own conclusion from the foregoing transaction.

With each visit gifts would be exchanged — a kerchief, a lock of hair, a coin or, if the suitor were Welsh, he might present his sweetheart with a love-spoon after spending long hours carving the gift as a token of his affection. The earliest known love-spoon is dated 1667, and the practice of gifting these symbols of affection — as well as yarn hooks, knitting sheaths (earliest dated 1680) and a variety of other intricately-made articles — did not die out until the late 19th century.

In the *Report on Education in Wales* in 1847 the custom of 'bundling' was used to epitomize the immorality and backwardness of the Welsh. As the century wore on there were progressive campaigns by church- and chapel-goers of the Welsh middle class to put an end to the practice, but decreasing numbers of farm labourers and female servants continued to court in the time-honoured way until the practice finally died out in the 1920s.

Oldest known Welsh love spoon, dated 1667

Betrothal

If, by mutual consent, both parties wished to take their relationship one step further, the suitor was expected to obtain the consent of the woman's father, brother, or even her employer if she worked far from home — anyone in fact who was considered responsible for her, including the mother if the father were dead. What followed was recorded in 1907 in an essay by one whose bardic name was Gildas (probably the Rev. M. Dawkins of Morriston) who stated that, in the Swansea Valley:

> When the lovers thought it time to enter the matrimonial state the young man would send his father or bosom friend to visit the young woman's parents by day in order to reach agreement upon a dowry ...

Using 'a go-between [or matchmaker] to win over the parents of the young lady' was customary in both England and Wales. It was a very old custom, evidenced in the Welsh Medieval tale of *Culhwch and Olwen*, which says that Culhwch sent his companions to Olwen's father to negotiate for her. In the early Modern period, if agreement were reached, then a date would be set for both the betrothal and a church wedding.

The betrothal was a festive occasion, involving a ceremony in which the woman's father presided over an exchange of vows that were known in England as 'plighting the troth', and the groom pledged the bride's endowment. These vows were extremely important because, in the 12th century, a pope had decreed that the vows made by any couple were binding providing they were made in the presence of witnesses, preferably, though not essentially, in a church porch. By these vows a couple became husband and wife, having licence to sexual intimacy, and it would have been customary for them to take up temporary residence at the house of the bride's father. The Church may have frowned on the practice, but it had to accept that, if the betrothal did not violate incest laws, that it had been the result of mutual consent, and that the trothplights had been 'done rite', then the betrothal was, to all intents and purpose, equivalent to a church wedding. Couples were, however, under considerable pressure to have their customary marriages sanctified as soon as possible, preferably within weeks, in Wales certainly within a year and a day. Whatever the duration, the betrothal was in many ways a trial marriage, one which may well have been a pleasurable experience for the wife, being the centre of attention in her father's house, and also the object of her husband's most impassioned affection. A betrothal could, however, be dissolved providing it was done publicly — in front of witnesses and before the banns were called — in which case all gifts had to be returned. If there was a penalty clause in the contract, a sum of money had to be paid by the defaulting party; it was often left to the church courts to decide who was at fault.

The banns were called on three successive Sundays, the officiating clergymen calling upon the congregation to proclaim any impediment whereby the bride and groom should not be joined in holy matrimony. If no objections were raised, the couple could assume that the community approved of their union; on the other hand,

the banns provided an opportunity for someone — a disapproving parent, or a jilted lover — to expose a skeleton in the cupboard and the issue might, then, be settled in the church courts. The banns were the point of no return, for once they had been called and no objections raised, anyone who failed to proceed with the marriage rendered themselves open to a charge known as 'mock of the church' and were subject to a fine, penance or even excommunication.

Communal (Traditional) Weddings

Prior to the mid-16th century, church weddings in England were invariably festive occasions involving the whole community, with the clergy officiating over the marriage ceremony, and over the festivities that both preceded and followed the actual ceremony, even to the extent of offering their services as caterers, often providing a hall for feasting, music and dance and a bed chamber for the bride and groom. The clergy also indulged in profane rituals to appease their superstitious flock. The Protestant element within the Church of England were determined to eradicate the festivities — which they saw as unwarranted and riotous behaviour — so that marriage would be a solemn occasion, but all they succeeded in doing was to drive the festivities away from the parish church, out into the countryside, into homes, into taverns and onto the village greens with the result that communal weddings became more festive than ever before.

Bidding

While the upper classes restricted the number of guests at their weddings, the small farmers, craftsmen, labourers and servants, did quite the reverse, for a week or so before the appointed day it was customary for the bride and groom to bid everyone in the neighbourhood to attend both the church wedding and the festivities that followed, the reason being that each guest was expected to come with a gift that would assist the couple in setting up an independent household. Although this kind of communal benevolence may be summed up by the maxim that 'A great many can help one, but one cannot help a great many', the gifts were in fact repayments (*pwython*) for similar contributions made by the relatives of both the bride and groom to previously married couples in the community on their wedding days; moreover, the bride and groom were expected to make similar contributions to other newly weds in the future.

The earliest reference to bidding in Wales is to be found in the work of Lewis Morris, an Anglesey gentleman who wrote on a variety of Welsh issues in the 1760s. The custom is also evident in Cumberland, a thoroughly Welsh-speaking area until it was conquered by King William I in 1192, which suggest that bidding may have been a Celtic custom, possibly a development from the aid (*commortha*) that features in Medieval Welsh surveys. Morris claimed that, as a result of bidding, '£30 or £40 is collected this way in money, cheese and butter to the great benefit of a young couple who had not otherwise scarce a penny to begin the world with'. Some 20 years later another writer observed, in South Wales, that:

Before the wedding an entertainment is provided, to which all the friends of each party are bid, and to which none fail to bring or send some contribution, from a cow or calf down to half-a-crown or a shilling. An account is kept and, if the young couple do well, it is expected that they should give as much at any future bidding of their generous guests. I have frequently known fifty pounds being thus collected, and have heard of a bidding which produced even a hundred.

In North Wales, couples appear to have done their own bidding, whereas in South and West Wales a local bard, or bidder (*gwahoddwr*), was engaged to visit the farms and cottages to proclaim the date of the wedding and bid everyone, including servants, to the wedding. At a much later date — in the 1840s — a bidder is described as 'dressed in a white apron, a white ribbon in the button-hole of his coat', carrying a staff decorated with ribbons, and having a bag at his back into which he placed the bread and cheese given to him by the people on whom he called. The bidder might knock on the door with his staff, or he might walk right in, strike the floor with his staff, place his hat under his arm, cough and make his rhymed speech (*rammas*) in such a way as to remind everyone of their obligations, often referring to their donations as the repayment of debts due to the couple's relatives, which had to be

*A bidder with his ribboned staff arrives at a farmhouse to invite
the household to a wedding*

returned not to the relatives, but to the bride and groom on the day specified. A speech used by a Carmarthenshire bidder, John Williams, in the 1840s, has survived in written form; it reads:

> I am desired to call here as a messenger and a bidder. David J. and Ann W. in the parish of Laugharne ... encouraged by their friends to make a bidding on Tuesday next ... [From] their residence in Gosport ... hence to St. Michael's Church to be married ... to return back to the young woman's father and mother's house to dinner [where they] shall have good beef and cabbage, mutton and turnips, pork and potatoes, roast goose ... a quart of drink for four pence, a cake for a penny, clean chairs to sit on, clean pipes and tobacco, and attendance of the best; a good song, but if no one will sing, then I'll sing as well as I can...As [is the] custom with us, in Laugharne, [there will be] a 'sending of gloves' before the wedding, if you please to come, or send a waggon or a cart, a horse and a colt, a heifer, a cow and a calf, or an ox and a half, or pigs, or a child's cradle, or what the house can afford ... or send a waggon full of potatoes, a cartload of turnips, a hundred or two of cheeses, a cask of butter, a sack of flour, a winchester of barley, or what you please, for anything is acceptable: jugs, basins, saucepans, pots and pans, or what you can; throw in £5 if you like; gridirons, frying pans, tea-kettles, plates and dishes ... spoons, knives and forks, pepper boxes, salt-cellars, mustard-pots, or even a penny whistle ...

Guests at a bidding wedding present their gifts (pwython) *to a young couple*

Bidding could also been done by letter, the latest surviving example of which is dated 1901. In any event the *pwython* had to be delivered and, according to the essayist, Gildas, this took place

> On the day before the wedding [when] the friends of the young people assembled, the womenfolk to the young woman's [home] and the menfolk to the young man's, in order to carry the furniture to the young man's house, or to the place where the young couple intended to make their home after entering the matrimonial state. After completing this pleasant task they would spend the rest of the day in innocent and enjoyable conversation, as well as presenting gifts to the young couple, eating and drinking the yellow beer. The following morning, namely the day of the wedding, which nearly always used to take place on a Saturday, they would assemble again.

One of the last recorded bidding weddings took place at Llandewi, Gower, on 8 February 1906 and 'a great number came from miles around' to the extent that the church 'was more than full when they arrived. The ceremony was partly choral'.

Horse Weddings

No wedding, even for the poorest peasants, would be without music and, according to Lewis Morris, the bridal party, on 'their way to church, plays fiddles or harps and danced morris dances all the way', but the most favoured wedding in both England and Wales was the horse wedding (*priodas geffyl*). According to Morris, the groom's friends gathered at his place on the morning of the wedding day to:

> have bread and cheese and a mug of ale at his cost, and these they make their presents or pay *pwython* [wedding repayments], and out of them pick about eight or ten or sometimes twenty of the best mounted to go to the intended bride's house to demand her in marriage.

Their progress was often obstructed by ropes, barricades and sometimes a quintain which, according to one authority, consisted of:

> an upright post, on the top of which a spar turned freely. At one end of this spar hung a sandbag, the other presented a flat side. The rider in passing struck the flat side, and if not dexterous in passing was overtaken, and perhaps dismounted by the sandbag, and became a fair object of laughter.

When they arrived at the house of the bride's father, they would find the door barred and the house occupied by the bride's friends, or, as Morris put it:

> The woman is there with her friends attending on her. Expecting the summons and ready to be mounted as well as they can, sometimes there are 80 or 100 or 200 of them too, having paid their *pwython* there. But take notice, the woman is not be got posses-sion of without much trouble, and arguments in Welsh poetry sometimes [go on] for hours ... In these they demand the girl as a promised wife, and abuse [one] another ... one party within the house and the other out of doors, to the great diversion of the company, each side extolling the wit of their poets.

Once the poetry contest (*pwnco*) was at an end, the bridegroom's party entered the house to search for the bride, who may have hidden or disguised herself; at this point there are several local variation as to what happened next. According to one authority, 'the father ... welcomes his new guests and they are desired to sit down to a cold collation and a mug of ale'. Then, outside, the bride:

> is mounted behind her father, brother or some friend on the swiftest horse ... as soon as she is mounted, [her friends] run away with her ... They don't care whither, and it is common to have legs and arms broken on this occasion ... At last either the double horse is tired or the bride thinks the time long a-coming, she consents to go with them [the bridegroom's friend's] quietly, except [for] a few starts of endeavouring to turn out of the road now and then when a fair opportunity offers, until they get to church.

Horse weddings lasted much longer in Wales than in England, the last recorded occasion taking place at Abergwili, Carmarthenshire, in 1896. The poetry contests are known in no other country than Wales; they were still taking place in Cardiganshire in the 1890s.

The Church Ceremony

By the Early Modern period the church ceremony had moved from the porch to a place in front of the altar, where the couple were required to repeat their betrothal agreement, their choice of words not unlike the vows we know today; after this they were asked the all-important question of whether they consented to the marriage, each answering, if they were English-speaking, 'I will', or 'I do'. The vicar's next question was, 'Who gives me this wife?' to which the father, brother or person responsible for the bride responded. The bridegroom would, then, place a ring on the vicar's book to symbolize his trothplight, and also coins to represent the dowry that he had pledged. The bride might also place a ring or a coin on the same book to show that any property she had would pass to her husband, to do with as he pleased, an endowment known as 'curtsey'. The next stage, if the couple could afford it, was the mass and, if the couple brought a child with them — a result perhaps of a lengthy betrothal — the child would be legitimized. Finally, the vicar gave his 'kiss of peace' to the bride which, in the Medieval period, had been given to all in the belief that it would prevent trouble during the drunken festivities that followed.

Festivities

On leaving the church the couple and their guests made their way in procession to where they would feast, drink and dance, often the home of the bride's father, sometimes the home of the groom's father, or even the couple's new home, or it might even be in a tavern if the wedding had taken place in a town. Later, the male guests put the bridegroom to bed, the female guests doing likewise to the bride. 'After which', S.J. Pratt wrote in his *Gleanings through Wales* (1797), 'the whole company remain in the chamber, drinking jocund health to the newly-married couple and their

posterity, singing songs, dancing and giving into other festivities, sometimes for two or three days'. The reason for this intrusion into the bedchamber was that a divorce — or rather an annulment — could only be obtained when a marriage had not been consummated; the guests were witnesses to the fact that consummation had taken place.

Beggar Weddings

At one time the upper classes had considered it a moral obligation to assist the local poor on their wedding days, providing them with feasts and the brides with small dowries, but faced with increasing numbers of poor from the 16th century onwards they reserved their good intentions to those in their employ. Certain churches also assisted the poor insofar as their congregations were encouraged to place contributions on a special plate, but this, too, was discontinued in the same century because it attracted outsiders. Consequently, the poor resorted to the taverns and the village greens where they invited people to contribute to what became known as beggar weddings, the contributions amounting in some cases to as much as half a year's wages. These beggar weddings, which are to found all over the British Isles, were similar to bidding weddings, except that the well-wishers were motivated more by charity than a communal obligation to repay former kindnesses in the form of *pwython*.

Attitudes hardened against the growing numbers of poor in the 17th century, especially against those from outside the parish, with the result that obstacles were put in the way of poor people who sought to marry in the parish church. In some places limitations were imposed on the number of guests that could attend beggar weddings, and the contribution of any one person was restricted to just a few pence; hence the alternative name penny weddings. Lewis Morris had this sort of wedding in mind when he wrote, in the 1760s:

> The marriage candle large and dancing [flickering] ... Parson [to have] five shillings on the book, as after they come home from church [to indulge in] dinner, custard and paying on a plate, drinking, wooing, dancing, campio, each paying his shot, fighting; putting the couple in bed, throwing the stocking [nowadays a bouquet], drinking posset [hot milk curdled with ale, etc.].

The practice continued under the guise of public bridals until the close of the 19th century, the well-wishers turning up to pay a shilling for food and the right to participate in the festivities, which included games and contests. Naturally, the need to raise money for the couple's benefit was reason enough for the practice to survive, but so, too, was the desire to make the occasion a day to remember.

Marriage by Licence

The upper classes — the aristocracy, the gentry and the wealthy élite in the towns — had an entirely different outlook towards marriage, one that has been exemplified in

the section on Katheryn of Berain. An upper-class woman might live in comparative luxury with servants to wait on her hand and foot, but in other respects she was little more than a convenience, a means of uniting influential families and providing her husband with a son and heir. The bride-to-be and, indeed, her future husband had little say in the matter as any arrangements were usually made when they were quite young. On her big day she experienced none of the festivities associated with the traditional weddings of the peasantry, nor were her vows meaningful as her family, and that of the bridegroom, employed lawyers to commit the marriage arrangements to writing; moreover, the number of wedding guests were restricted.

In the 15th century the upper classes obtained a special dispensation to marry by licence, thereby avoiding the publicity of banns. The licences were obtained for a fee from a bishop or a surrogate; that is, a clergyman authorized to grant licences on a bishop's behalf. By the 17th century couples from all classes were marrying by licence and were doing so for a variety of reasons. When banns were called anyone could stand up in church and declare that a couple were seeking to marry within the prohibited degrees, that either the bride or groom, or both, were under age, or that they did not have parental or family consent. For poor men, such as labourers, there was another obstacle to a traditional wedding in that before a man could wed he was expected to prove that he could maintain a wife and family. If, in the view of the parish, he could not do so, then the parish could deny him the right to a wedding in the parish church. A parish might also deny marriage to a poor couple if the woman was from another parish, often doing so on the ground that she 'would breed' to the extent that her children would be a financial burden to the parish. In these circumstances a poor couple had only to find a surrogate, pay him the fee — assuming they could afford it — and return to the parish with a certificate that had to be accepted as *fait accompli*. All things considered it is hardly surprising that, by the early 18th century, an estimated one-third of all marriages were by licence.

Clandestine Marriages

There were some clergymen, invariably those who were poor, who were prepared, for a small fee, to conduct clandestine marriages without banns or licences. Despite the fact that these marriages were usually conducted at night in ruined chapels, taverns, homes and even fields, they were still valid because canon law recognized that vows, when 'done rite', were the equivalent of a church wedding. A marriage of this sort was not only a cheaper alternative to avoiding parental and parish objections, but for an unmarried woman with child it was the answer to all her problems. By marrying in secret — especially if she had the certificate backdated — she not only protected herself against a charge of premarital fornication, but her child would be legitimized. In any event a clandestine marriage was equivalent to a betrothal, a trial marriage, because in most cases couples who married secretly eventually married again, either by licence or in the traditional way. If, on the other hand, a clandestine union proved to be a mistake, then by saying nothing the two people were free to pursue different

partners. Laymen as well as poor clerics were involved in these arrangements. This was made evident in an investigation carried out in Breconshire in 1730 by William Wynn, who wrote:

> The country people, it is to be imagined, are first married by either this laymen [Cadwaladr] or else by [the parson] Langord and, to screen themselves from public reproach, and the parson that marries [them] from punishment, they some time after apply to the parish minister ... and, paying the parson and the clerk their respective fees, are all married without being asked any more questions [other] than what the church form requires.

Wynn stated that, when confronted, Langord pleaded poverty; of Cadwaladr, Wynn wrote:

> Evan Cadwaladr, a layman, who, on conviction of having married two couples, was forced to flee the county, is now suffered to resettle in the town of Bala, and suspected of doing the like [there]. It is highly probable that he joins ... many hands because few if none of the common sort have for three months past had their banns published without the visible marks of [pregnancy].

It has been estimated that, in the early 18th century, clandestine marriages and illegal, common-law arrangements amounted to over one-quarter of all unions.

CHAPTER IX
Marriage in the Early Modern Period (2)

The New Home

In both the Medieval and Early Modern periods, the object of getting married was to set up an independent household, consisting of a husband, wife, children and — if the couple could afford them — servants as well. For upper-class couples this is unlikely to have been an insoluble problem, but for the offspring of smallholders, craftsmen and labourers it was a different story. An enquiry of 1785 into the consequences of enclosing wasteland provides a glimpse of how a lower-class couple set up home. Although the report relates to conditions in England, the following extract could apply to the peasantry in Wales, especially those who could expect little in the way of either an inheritance or a marriage portion.

> The children of these cottagers ... are sent to yearly service amongst farmers, etc, and if in the course of a few years service the young man can scrape up £20 or £30 and finds a young woman that he likes, possessed with nearly an equal sum, they strike a bargain and agree to marry as soon as they can find a cottage near the common; they then stock their cottage with cows, calves, sheep, hogs, poultry, etc, as much as their little fortunes will admit of. He then hires himself as a day labourer to a neighbouring farmer, and the wife stays home to look after the livestock.

In North Wales it was customary, during the late 18th and early 19th century, for couples to claim squatters' rights by constructing a one-night house (*ty un nos*) on wasteland. A similar custom existed in Cumberland where young people, who were

> always ready to help one another ... would assemble about dawn at the appointed spot, and labouring ... each to an allotted task, would erect, long ere sunset, the clay walls of a dwelling for some young couple who would rely on the bride wain to finish and furnish it.

The bride wain was Cumberland's equivalent to the Welsh repayments (*pwython*) that were recovered at bidding weddings. It was recorded that, in Wales:

> this custom in modern time presumed the right of any newly married residents to a cottage which he had himself, with the help of friends, built upon wasteland in the township [parish] in a single night [smoke seen issuing from the chimney in the morning being claimed to be sufficient evidence of completion], and also a certain area of land round the cottage.

It is believed that in many instances a cottage of this sort was only a temporary dwelling to establish what are now called squatter's rights; that soon after its erection a more substantial cottage would be built close by. The first dwelling would, then, be used for housing cattle.

It has been estimated that, in England and Wales during the Early Modern period, about 70% of all households were occupied by a nuclear family — husband, wife and children. Households with one or more servants amounted to around 30% of the total. Less than 6% contained a three-generation family.

Children

Space does not permit a summary of the superstitious beliefs that dictated what a woman could or could not do during pregnancy; suffice to say that when the child was due a select group of female relatives and friends would be present in the bed chamber, from which the father was excluded. Delivery was supervised by a midwife, someone with experience, though not training, in delivering a child. Once the child had been born the mother was confined to the chamber for up to a month, a period known as 'lying-in', and for this purpose the chamber was physically and symbolically sealed off: daylight excluded, the keyholes blocked, the only light coming from candles. According to Lewis Morris:

> in a week or fortnight's time at most among the poorer sort the mother [then] walks to the parish church to be churched [originally a purification ritual; later a thanksgiving service] and takes along with her her midwife and offers [her] a 12d. or 6d. if poor.

At some point the child would be given a name, the parents and godparents would be reminded of their duties and the child christened in church. With regard to his observations on Anglesey, Lewis Morris wrote:

> When the christening is over, then the father invites home his friends and the parson to drink the health of the woman in the straw, and after dinner this they do for the first part so plentiful till they can drink no more for that day; money to the midwife, to the nurse and to the maid. Home stark drunk.

A nurse, often a wet-nurse, was employed by those who could afford one. If the couple were poor, a nurse might be paid for by the parish relief authorities. Gifts, variously termed *cyflwyno* or *mynd i weld*, were given to the child, or rather the parents, at the time of birth, or at a celebration party. The birth of a son and heir to a landed family usually led to employees having the day off and the tenants celebrating the continuation of the family estate for another generation.

Public Shaming Rituals (1)

Marital discord can occur in any age, and in the Early Modern period both church and manorial courts were responsible for punishing anyone whose marital shortcomings were unacceptable to the community. Nothing illustrates this more than when, at

Rochester in 1602, foreign visitors made enquiries concerning the purpose of a ducking stool. What they were told in reply they recorded as follows.

> They call it the wooden horse, and bad wives are obliged to ride on it into the water. We were further told that in England every citizen is bound by oath to keep a sharp eye on his neighbour's house, as to whether the married couple live in harmony, for though in this realm much liberty is granted to women, no licentiousness is allowed them. If any matrimonial differences are noticed, both parties are ordered to appear before the magistrates, who inquire on which side lies the cause of disharmony. If the husband is an unfriendly or obstinate fellow, he is condemned to pay a fine; if, however, the mischief is on the wife's side, the husband is likewise punished for not maintaining his authority, whereas the wife is placed on the above-mentioned chair and ducked three times up to the neck by the boys who roam about the streets.

Church courts declined in the 17th century, manorial courts in the 18th, and in their place it became increasingly the norm for communities to take matters into their own hands, imposing public shaming rituals upon spouses whose marital relationships were considered unacceptable, the intention being to compel the offending spouses to mend their ways. The type of woman targeted was usually referred to as a scold — a headstrong wife, one 'who by her brawling and wrangling [with her husband and] amongst her neighbours doth break the public peace'. When it came to targeting men the cockold (the husband of an adulteress) and the henpecked (the husband who allows his wife to harass him) were humiliated more than all others for failing to be masters in their own households. In short, public shaming was intended to buttress male domination.

Prior to the early 19th century little has been recorded about public shaming in Wales, after which it becomes apparent that these ritual were frequent occurrences in the South, particularly in the south-west were they were known as *y ceffyl pren*, meaning the wooden horse. There were many local variations to the custom, but what usually happened was that, at nightfall, a crowd of men, their faces blackened and partially dressed in women's clothes, marched in procession to the house of a scold and her unmanly husband. Many of the participants were there to produce 'rough music' by beating on pots, pans and other kitchen utensils, while everyone else added to the unearthly dim by shouting and hooting. It was recorded that in 18th-century Glamorgan two men might be designated 'standard-bearers, one with a petticoat on top of a pole, the other carrying breeches in the same manner, only reversed, with the upside down' to show that the husband was lacking in manly qualities. Another two men impersonated the husband and wife, the one carrying a broom, the other a ladle. At the home of the offending couple the petticoat would be pelted with whatever was at hand until it fell to the ground in tatters, at which point the breeches were raised on high to signal a male victory. In West Wales it was usual for four men to carry a representation of a horse, be it a pole, a ladder or an effigy of a horse, on which were seated straw effigies of the offending couple; both effigies would eventually be burnt.

Sometimes these rituals turned violent, the offending couple dragged from their homes and the husband — not the wife — subjected to both verbal and physical abuse. What other people in the community made of these rituals may be summed up in the words of C. Redwood, who wrote, in 1839, that

> the men everywhere received them [the participants] with shouts and merriment, and sometimes even with bell-ringing; but the women kept within doors, and only mocked at them through the windows…when at length they [the participants] returned to their own village, the women there had collected to scoff at them, and poured out a din of hoots and yells that could not be drowned even by the … kitchen music.

Till Death Do Us Part!

With most men marrying in their late twenties a woman could expect her marriage to last little more than 20 years, the husband by then being close to 50. Divorce was not permissible, although, in England at least, it appears that the poorest people actually believed they were no longer married if their spouse had several times been unfaithful, had left them for a period of seven years, had been reported dead, or had remarried. In Wales and the border counties it was commonly held that 'if a husband failed to maintain his wife, she might give him back the wedding ring, and then she would be free to marry again'. The return of the ring, however, or even a marriage certificate, had to be done in the presence of witnesses who could testify to the act. A public display of this sort would be expedient if, for example, a husband had to go into the workhouse; for a wife to avoid the same fate, she simply returned the ring in the presence of workhouse officials. Sometimes a couple might resort to a fictitious wife sale, the wife being led to market with a halter around her neck and publicly sold, usually for a nominal sum, or even a few pints, to someone who already had an interest in her and who would not remove the halter until she entered his home.

With regard to the law, separation was permissible in certain circumstances, but without the right to remarry, and the decision as to whether this should be so rested with the church courts. However, a marriage could be annulled providing it could be proved that consummation had not taken place. Then, in 1670, an English aristocrat, Lord Roos, was allowed to remarry by a special act of Parliament, following the notorious adultery of his first wife. This act created a loophole in the law, but only the very rich were to benefit from it due to the enormous cost involved. Divorce by other means was not introduced until 1857, and even then it favoured men.

The Puritans

When Henry VIII broke with Rome he unwittingly set in motion a movement to reform the Church of England, and while the Crown and the Church authorities were prepared to make some changes, there were those who protested (Protestants) that the changes did not go far enough. Within a few decades the extremists (Puritans) sought to purify the Church of all traces of Catholicism, demanding a simpler form of worship with the emphasis on preaching. With regard to marriage, the views of

Puritans varied from one extreme to another, but what prevailed were the views of the middle-class Puritans, men who were successful in farming and commercial activities. These men were prepared to accept a woman's right to spiritual equality, but not to property, believing that a wife should always be subordinate to her husband. They acknowledged that children should not be forced into marriage against their will, but as heads of households they insisted on parental consent.

The Puritans disapproved of bundling, but could do little to stop it; nor did they approve of the festivities associated with traditional weddings, preferring the whole business of marriage to be a solemn occasion. What frustrated them most was the Church's inability to enforce its own canons concerning marriage and, as a result of the Civil Wars (1642-51) between King Charles I and Parliament (which resulted in victory for the Parliamentary forces under Cromwell) the Puritans abolished marriage by licence in 1653; in its place they installed civil marriages, conducted by justices of the peace, who were themselves heads of households, men who believed in a patriarchal society in which the nuclear family was of paramount importance. With the restoration of the monarchy in 1660 the laws relating to civil marriages were repealed and the option to marry by licence was not only restored, but it became even more popular than ever before. The number of clandestine marriages also rose; the fact that this marriage practice was lucrative, open to abuse, and made a mockery of parental consent meant that something had to be done.

The Hardwicke Act

In 1753, Lord Hardwicke, First Earl of York and the then Lord Chancellor, introduced the 'Act for the better preventing of Clandestine Marriages'. The Act stipulated that, as of Lady Day 1754, no marriage would be considered legal unless the ceremony had been conducted according to the rubric of the English Book of Common Prayer, that it had been carried out in a church belonging to the Church of England, and that either banns had been called or a licence had been obtained from a bishop or one of his surrogates. The only people exempt from these requirements were Quakers and Jews. The exemption did not apply to Catholics and Protestants; moreover, anyone under 21 had to have parental consent. Any clergyman violating these rules became liable to 14 years transportation; anyone tampering with the register risked the death penalty. Clandestine marriages were no longer recognized, nor would betrothals have any worth in the eyes of the Law. This Act remained in force until 1836 when new legislation rendered it obsolete.

Private Weddings

The Hardwicke Act did not unduly effect the upper classes except that, with the termination of betrothals, well-to-do couples became engaged, having no right to sexual intimacy; beyond that, upper-class wedding continued to be strictly private affairs, the customary practices and good humour of the peasantry having long been dispensed with. The bride and groom simply arrived at the church in separate carriages, each

accompanied by their respective parents, the bride with her bridesmaids, the groom with his groomsmen. Their arrival invariably took place early in the morning, on a weekday while most people were at work. Only a small number of guests would be present in church and the service would be kept simple. The wedding guests then made their way to the home of the bride's father, where they feasted and spent the remainder of the day dancing or playing cards until the couple retired to bed. Musicians were hired for the occasion, but there would be no revelry, no riotous behaviour. Guests might be presents at the bride's home for several days until, eventually, the couple left to take a honeymoon, accompanied by their closest friends. As time went by more and more people of lesser means adopted the format of a private wedding; by the Victorian era (1837-1901) it was customary for the middling sort to have a wedding breakfast, then leave for a seaside honeymoon, unaccompanied by friends.

Common-law Unions

Many predicted that the abolition of betrothals and clandestine marriages would lead to a glut in common-law unions among the lower orders, who viewed the act as a move to increase the clergy's income. Common-law unions were by no means something new, but from 1754 onwards there was a steady rise in numbers until they peaked in the mid-19th century, after which the numbers fell following the introduction of civil marriages in 1836. There were, however, other factors that contributed to both the increasing number of common-law unions and to a rise in illegitimacy.

In the 18th and early 19th centuries, Wales witnessed rural industrialization in which pockets of industrial activity existed in the midst of farming communities and on the outskirts of small towns. In the North, men found work in the slate quarries; in the South they were attracted to limestone quarrying, to coal mining, to the iron-works that sprang up on the northern rim of the South Wales Coalfield and, in the Swansea and Neath areas, to the copper-smelting works. These pockets of industrial activity created a new class among the lower orders — the wage-earners. Women also found work in these semi-industrialized communities. Their wages, poor though they were, enabled them save their own marriage portions without having to leave home, which is what they would have done had they become live-in domestic servants; moreover, their continued presence at home was more than welcome as they contributed to the family income. In short, the Act of 1753, the changing circumstances of people involved in industry and the self-sufficiency experienced by women led to a change in attitude towards male-female relationships. In the mining communities of South Wales, for example, some women

> procure a man to wed them privately, which will not cost above two or three mugs of ale. Sometimes half a dozen couples will agree to a merry meeting and are thus wedded and bedded together. This they call the 'little wedding' and is frequently made use of among miners and others to make sure of a woman...The little wedding does not bind them so effectively [as a church wedding], but after a month's trial they may

part by consent ... the miner leaves his mistress and removes to a minework in some distant county, and the girl is not worse looked upon among the miners than if she had been an unspotted virgin, so prevalent and arbitrary is custom.

Besom weddings

Other parts of Wales had their own distinctive customs relating to common-law unions, the best recorded example being the besom wedding of the Ceiriog Valley in North Wales. When slate quarrying came to this remote valley in the 17th century, the men gave up their traditional way of life to become wage-earners, leaving the women to manage the small, scattered farms and the cottage woollen industry. This division of labour led to the women having 'an independency of character', to the mothers becoming the dominant partner in the home, to the daughters being reluctant to leave the farm, and to the development of the besom wedding. According to the recollection of a 73 year-old woman who had been born *c.*1850,

the besom wedding was a wedding after this manner. A birch besom [broom] was placed aslant in the open doorway of a house, with the head of the besom on the door-stone, and the top of the handle on the door post. Then the young man jumped over it first into the house, and afterwards the young woman in the same way. The jumping was not recognized a marriage if either of the two touched the besom in jumping or, by accident, removed it from its place. I should think this form of marriage was very common in this part of the country at one time, but I never saw it.

Like the pre-1754 betrothal the besom wedding was a trial marriage, one that could be terminated if the union proved barren, or the couple were incompatible; in either of these circumstances,

the one who had made the decision [to separate] would call all members of both families to witness the act, [and] by jumping backwards over the besom the marriage was broken. The wife had the right to jump back, too. But this step had to be taken by either within the first year. Both of them, afterwards, were free to marry again. If there was a child, the father was responsible for its upkeep. In jumping backwards ... if any part of the body touched the besom or the door post, the effort was in vain.

This arrangement apparently suited the women, for according to the old woman mentioned above, the 'women thought much of it, [and] it was the women that spoke about it when' they were young. This is unsurprising as there were several advantages to this kind of union, one being that, in the eyes of the Law, the woman was still *feme sole*; added to which she could take the plunge, knowing that:

it was unusual for a besom marriage to fail. When it did happen, it was not regarded as a disgrace or a hindrance for either party to marry again. If there was a child from the marriage, the father would acknowledge his obligations for the support of the child, and the mother could take possession of her personal endowments ... [and did so because] ... it was customary for wives to keep their property separate from that of their husbands, from generation to generation.

It was the view of one folklorist that 'the maternal instinct of young girls' in the Ceiriog Valley was 'abnormal', that they had 'stronger feelings for motherhood than being a wife', and they 'talk about sex as if they were experienced women'. A Ceiriog girl may not have had the benefits that wealth could bring, but unlike an upper-class woman who was given away as a virgin bride, a Ceiriog girl entered into a union in which she was not subsumed by her partner's identity, for in a besom marriage she retained her maiden name. If she had a child by that union, the child took her name, not that of the father. The child, of course, would be illegitimate, but unlikely to be stigmatized as it has been estimated that, in the valley, about 60% of the children baptized in the parish church of Llansantffraid were registered as born of illicit unions and not simply fatherless. Although it may appear that Ceiriog girls had loose morals and that parental authority was lax, this was necessarily the case as parents were quite capable of expressing their disapproval, for

> if the girl is not acceptable to the family of the young man, the family opposes the marriage, even if the girl is pregnant. In the same manner, if the young man is not accepted by the girl's family, they oppose the marriage, even if she is already with child.

A girl could, of course, run away 'over the mountain' with her lover, but they would inevitably return 'to the home of the bride, and she would show her wedding ring to her mother [and] this was usually followed by weeping, scolding and forgiving'. The bride might remain at her mother's home until a cottage could be found for herself and her husband. A traditional wedding known as a 'feasting' might, then, be arranged and, if so,

> it was customary for the bride, on the morning of her wedding day, to pretend running away, or hiding. Then it was up to the groom and his friends to find her and make believe she was taken by force to the church, thus, showing the groom's conquest.

The besom wedding was known in other parts of North Wales; it is also evident in England, being taken there by itinerant workers. While the practice served a similar function to the pre-1754 betrothal, it may have had its origin in the customary cohabitation arrangements of the Medieval period. It certainly proliferated in the Ceiriog Valley during the late 18th and early 19th century, after which it disappeared in the 1840s due to changes in the law.

Civil Marriages

Irish workers began arriving in Wales in considerable numbers from c. 1800 onwards, either to settle or to earn their fare to America. Many of them, when marrying, made their vows before a Catholic priest, but refused to repeat them in the presence of an Anglican minister. Consequently, the marriages of many Irish Catholics were not recognized in law. It may have been similarly so for many Nonconformists, be they Baptists, Methodists and the like, until the Dissenters' Marriage Act of 1836 permitted Catholic and Nonconformist couples to be legally married in their respective places of worship.

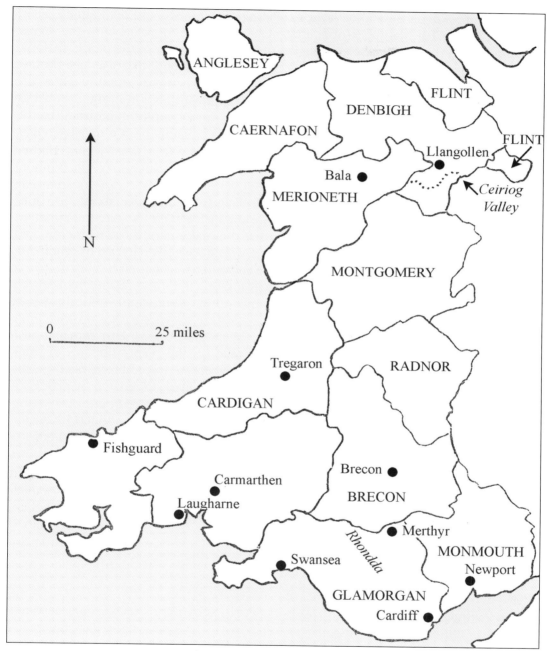

Wales and its pre-1974 counties

The Marriage Act of 1836, which was implemented the following year, was for many even more of a godsend, for by this act couples who wished to be married with

the minimum of expense and without a religious ceremony could do so in a District Register Office. Civil marriages of a similar nature had been available in the 1650s, differing only in that they had been carried out before a justice of the peace. In some respects the civil marriages that followed 1837 functioned like the clandestine marriages of old; their popularity soon put an end to customary rituals such as the besom weddings, with the result that there was a steady reduction in the number of illegitimate births. By the end of the 19th century most couples conformed to the requirements of Church and State, marrying by licence, banns or in a register office; few were living talley (*tali*) by the time of the First World War.

Unmarried Women

A large percentage of women never married. In Ealing, for example, about 25% of all women over 40 are believed to have been spinsters in 1599. Yet, despite the apparent advantages of being *feme sole*, it is unlikely that the majority of these women would have been spinsters out of choice. Many women would have been left on the shelf due to a shortage of eligible males. Men were more inclined to leave their locality in search of work, even emigrate to distant parts of a growing British Empire. Some men settled for careers in the military, or served at sea, while others were simply undesirable, or too poor to contemplate marriage.

Undoubtedly, many women would have been pressurized into remaining at home to care for sick or aging parents, or to take on the responsibilities of their deceased mothers; moreover, the benefits of being *feme sole* would have been meaningless if they were the offspring of poor parents, their lives dominated by drudgery and the worry of trying to make ends meet. Widows may have fared better providing they had been well endowed, whereas grass widows — those abandoned by errant husbands — were likely to have been left destitute. In short, the only women to benefit from the status of *feme sole* were those who were well provided for, or those who were sufficiently strong-willed to fend for themselves.

CHAPTER X
Women of the Early Modern Period

Women's Dress

There are numerous documents and sketches of 18th and 19th century date that provide valuable information about the way women dressed. Upper-class women bought their clothes in the towns, adopting the trends that prevailed among their English counterparts, whereas lower-class women, peasants in particular, relied upon their own efforts to produce homespun cloth, and upon local craftsmen, such as tailors, to provide them with the articles of clothing required, and continued to do so until the Industrial Revolution put an end to the cottage industry. Most of the clothes worn by the lower classes were made from either wool or linen (woven from flax), materials that had been used in Celtic times, but what is striking about the clothing of Welsh women in the two centuries under review is colour, which varied according to the dyes that were available in any given locality. In certain coastal areas of South Wales, for example, scarlet predominated owing to the availability of cockles from which the dye was obtained. Patterns, particularly striped or checked, are also evident in much of the clothing.

Almost all women wore a petticoat (*pais*), usually ankle-length, the skirt full and gathered at the waist, the prevalent colour being red. Over the petticoat went a loose, upper garment known as the bedgown (*betgwn*), usually with tight-fitting, elbow-length sleeves. In the 18th century the bedgown was usually knee-length, exposing the lower part of the petticoat, but in the late 19th century the bedgown was shortened to become a blouse with only 2-3cm. of material below a tight-fitting waistline. Aprons were worn universally, as were stockings, many of them soleless with loops to go around the big toes, which kept the stockings in place while the women went about their business barefooted. Shoes might be worn by those who could afford them, or were kept as Sunday best. Clogs and wooden-soled boots with leather straps over the instep were popular.

Almost all women wore white, linen bonnets with frills, or goffers as they were otherwise known, which required starching, then shaping while they were still wet. The lower classes also wore a flat-topped, straw hat, the brim tilted forward at the front, tilted upwards at the back, which could be worn whilst carrying baskets, pails or pitchers on the head. Another familiar piece of womanly dress was the shawl, which

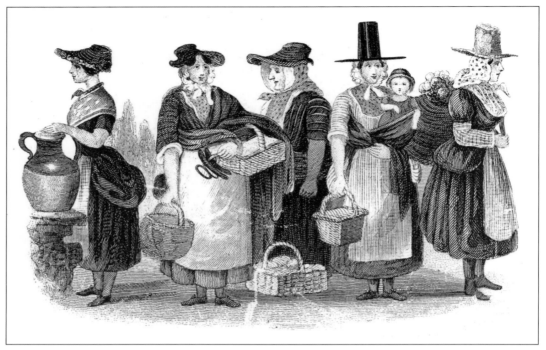

Welsh peasant women in a variety of costumes

could be worn in a variety of ways. The square *fichu* was relatively small, the material folded to form a triangle and worn with one corner hanging down the back; the other two corners met under the chin where they were held together by a pin, or a brooch. The whittle was much larger, having a fringe on one side; it was worn over the shoulders — over the head in wet weather — and could be wrapped around the body. Another way of wearing a large shawl was to wrap part of it around the hips and drape what remained over a shoulder. A shawl provided a unique way of carrying a child, as evidenced by the comments of a woman who claimed, in the late 18th century:

> I have a hundred times seen a woman carrying a pitcher of water on her head, a child or a loaf in this wrapper [shawl], and knitting as she walked.

Today, many would regard the tall, black beaver as a hat peculiar to the Welsh when, in fact, it originated in France where it was current in the late 18th century. Worn with the wide brim level with the eyes, the beaver became fashionable in Britain in the early 19th century. When it went out of fashion in England, its popularity continued in Wales. The beaver, however, was expensive, and only women of means could afford to own one. Cheaper versions resembling top hats were available in felt or straw, and in many sketches they appear to have been worn tilted towards the back of the head. Upper-class women also wore black, or brightly-coloured, tight-fitting jackets with mostly three-quarter-length sleeves, the length of the bodice varying from

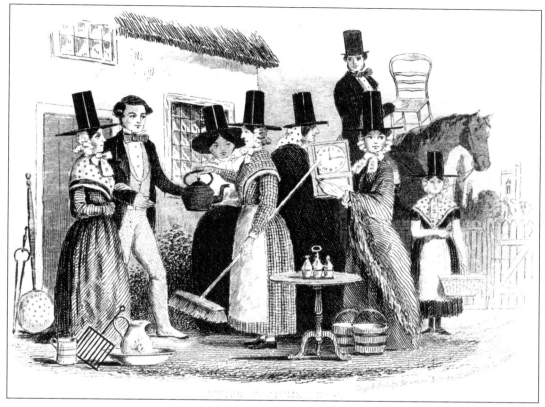

The Bidding — well-dresswd Welsh women present
their repaymens (pwython) *at a wedding*

just below the waistline to the knees. The neckline might be V-shaped, or round, and the jacket could be worn open at the front, or fastened with buttons or fasteners. It is possible that jackets were a development from the bedgowns of the 17th century. Other items worn or carried by a well-to-do woman might include a cloak, cape, gloves, handkerchief, handkerchief satchel and a chemise.

The Last Invasion of Britain

Reference has already been made to how colourful were the clothes of Welsh women, and nothing epitomizes this more than an event which took place in 1797. During the evening of 23 February that year, 1,400 French soldiers, most of them criminals released from French jails, landed to the west of Fishguard under their Irish-American commander, William Tate, whose objective was to liberate the British peasantry so that they, too, could experience the benefits of the French Revolution. Unfortunately, this 'invasion' was a fiasco from the start: many of the undisciplined troops got drunk, some were either killed or captured by locals, and the rest simply stayed where they

were while the local militia closed in. At 8p.m. the following day, Tate sought terms. Then two days later he agreed to unconditional surrender, influenced, to some extent, by the approach of a multitude of curious locals, many of them women who, at a distance, were mistaken for 'troops of the line to the number of several thousand'.

The one local to outshine all others was a woman, Jemima Nicholas, a 47-year-old cobbler, known locally as Jemima Fawr owing to her great size. Armed with a pitch-fork, Jemima captured 12 French soldiers. There have been attempts — by men obvi-ously — to dismiss Jemima's exploits as fanciful, but the British Government was suffi-ciently impressed to award her a pension of £50 per annum, which she claimed until her death at the age of 82.

Other Women of Note

Jemima was not the only woman to make a name for herself during the late 18th and early 19th century. In his *Tours in Wales*, published in 1786, Thomas Pennant described Margaret uch Evans (*c*.1694-post 1786) of Penllyn as:

> the last specimen of the strength and spirit of the ancient British [Welsh] fair. She is at this time about ninety years of age. This extraordinary female was the greatest hunter, shooter and fisher of her time. She kept a dozen at least of dogs, terriers, greyhounds and spaniels, all excellent in their kind. She killed more foxes in one year than all the confederate hunt do in ten: [in a boat she] rowed stoutly and was queen of the lake: fiddled excellently: and knew all about music: did not neglect the mechanic arts, for she was a good joiner: and, at the age of seventy, was the best wrestler in the country, and few men dared to try and fall with her ... Margaret was also a blacksmith, shoe maker, boat-builder and maker of harps. She shoed her own horses ... while she was under contract to convey copper ore down the lakes. I must not forget that all the neighbouring bards played their address to Margaret, and celebrated her exploits in pure British verse. At length she gave her hand to the most effeminate of her admirers, as if predetermined to maintain the superiority which nature had bestowed on her.

Another woman to display strength of character was Hester Lynch Salusbury (1741-1821), a descendant of Katheryn of Berain. Hester not only established herself as a prolific writer, but she proved to be a determined woman when it came to marrying the men of her choice. In 1762 she ignored her father's wishes and married a London brewer, Henry Thrale, by whom she had 11 children, only four of which survived childbirth. Thrale died in 1781. Three years later, Hester caused a great deal of resentment among family and friends when she declared that she would marry an Italian musician, Gabriele Piozzi, whom many regarded as below her class. Unlike her union with Thrale, her marriage to Piozzi appears to have been a happy one.

The two women known as the Ladies of Llangollen were not Welsh, but members of the Anglo-Irish nobility. Lady Eleanor Butler (*c*.1745-1829) was in her early thirties when, in 1778, she left Ireland with her lover, Sarah Ponsonby (1755-1831), thereby causing a scandal, the more so when they took up residence together in a cottage that became known as Plas Newydd, located on the outskirts of Llangollen in North Wales.

They were soon joined by a quick-tempered young woman, Mary Carryl (Molly the Bruiser), who served them faithfully for 30 years. Despite being regarded as eccentric, the Ladies of Llangollen received many well-known guests such as William Wordsworth, Hester Piozzi, Sir Walter Scot, the Duke of Wellington and a German prince.

Unlike the two women mentioned above, there were others who had to earn recognition by their own endeavours without the advantages of gentility; Sarah Siddons (1755-1831) was one such woman. Born in a Brecon public house that now bears her name, Sarah was one of 11 children brought into the world by a couple who were members of a troupe of travelling performers. Despite several setbacks, Sarah became the most famous British actress of her day.

An equally determined woman was Elizabeth Cadwaladr (1789-1860) of Pen-rhiw near Bala in North Wales, the daughter of a Methodist preacher. Unlike Sarah Siddons, Elizabeth never achieved the recognition she deserved. On no less that three occasions she ran away from home, the last occasion to escape an arranged marriage. In London she adopted the name of Betsi Davies. She spent many years at sea, a servant to the wives of ship captains. In her voyages to the West Indies, Australia, South Africa and India she experienced many adventures; on one occasion she single-handedly saved a ship from being overwhelmed by a storm. On her return home, after she had been cheated out of an inheritance, she trained as a nurse at Guy's Hospital. Then, in 1854, at the age of 65, she left for Balaclava in the Crimea to serve in a hospital near the front line. Unlike Florence Nightingale, who had little nursing experience and who has been exposed in recent times as bossy and uncaring, Betsi saved hundreds of wounded men from an appalling death. She was the 'Real Lady of the Lamp'. She died in London, aged 71, a penniless spinster.

The Report on Education in Wales, 1847

When, in 1847, the government published its *Report on Education in Wales* it was seen by the Welsh middle class as an attack on the morals of the Welsh people, for the report contained horrendous accounts of how peasant and pauper families lived; worse, it portrayed working-class women as immoral, their willingness to engage in bundling being their most grievous fault. The most deplorable habitations were to be found in rural districts where people were even more susceptible to illnesses caused by living in damp, overcrowded dwellings than those in the industrialized areas. The most prevalent illnesses, according to the report, were typhus and scarlet fever, but tuberculosis, according to later evidence, was the greatest scourge of all.

The report contained numerous references to rural dwellings, describing to them as:

> universally destitute ... badly built ... clod houses without a window or aperture, but the doorway and ... a hole in the roof ... [which was] wattled ... covered with rushes, consequently not watertight ... the floors are miry ... the firing a scant supply of peat.

[These dwellings, it was said, usually] consist of a single room from 9 to 12 feet square ... [sometimes divided in two by] a large dresser and shelves ... each of these hovels contain on average a [peasant] family of 6 children, with the parents. [If there were] two rooms, the parents sleep in one and the children in the other; if there is but one room, all sleep together ... regardless of age and sex ... [although some] have in addition a sort of lean-to, forming a separate place to sleep in ... the cottages and beds are frequently filthy ... including even those belonging to [some] farmers ... pigs and poultry have free run of the joint dwelling and sleeping rooms.

The humbler classes of the community collect throughout the year a dung-heap, which ... is placed close to each person's door ... composed of horse-dung ... urine, excrement, slops and other common refuse. This compost is much coveted by the farmers. [In] Tregaron ... dung-heaps abound in the lanes and streets ... [and in the churchyard] several of the tombstones were covered with half-washed linen hanging out to dry.

The report described peasant and paupers as:

wretchedly fed and clothed ... very ignorant and superstitious ... [believing] in every charm ... [having no inhibitions about] males stripping to wash themselves in the presence of females ... [nor does it bother them that] drunkenness is but too prevalent [among them], particularly on fair-days and other similar occasions. [The peasants were not, however,] disposed to commit serious crimes, but are addicted to petty thefts and prevarications.

The youths of both sexes are very unchaste ... [due] to the ancient practice of bundling or courting in bed ... [and to the fact that] farmers connive at young people meeting in their houses after the family has retired. The unmarried men-servants [on] the farms range the country at night, and are admitted by the women-servants at the houses to which they come. The Welsh peasant girl ...[is] almost universally unchaste. The first breach of chastity with a woman in the lower class is almost always under the promise of marriage ... so prevalent is the want of chastity among the females that ... most of them were in the family way. It is said to be a customary matter for them to have intercourse ... on condition that they [the couple] should marry if the woman becomes pregnant; but the marriage by no means always takes place ... [so that] illegitimate children are by no means rare, and pregnancy before marriage is a common occurrence.

Y Gymraes

The Welsh middle class was appalled by the report. One Baptist minister, Evan Jones (Ieuan Gwynedd, editor of *The Principality*) launched a woman's monthly periodical, *Y Gymraes* (The Welshwoman), in January 1850, the purpose of which was 'elevation of the female sex in every respect — social, moral and religious ... to produce faithful maids, virtuous women, thrifty wives and intelligent mothers'. His patron may have been an aristocrat, Lady Llanover, for not only does the name Gwenllian Gwent (which is similar to her pseudonym Gwenynen Gwent) appear in connection with an opening address, but much of the content of *Y Gymraes* was a reflection of her views on native dress, the Welsh language, temperance and Nonconformity. The magazine failed in its

appeal to working-class women because it espoused middle-class values, and rather than sympathize with the plight of servants it romanticized domestic service, the truth of which was admirably portrayed in a novel, *Huw Huws neu y Llanfurwr Cymreig*, publish in 1860, which said that, at a hiring fair, Huw Huws

> could see a line of girls of all ages ... hard work had deformed their bodies, bent their shoulders, wrinkled their hands ... men and women walked around this gathering with a critical look of slave purchasers, questioning them in such a way as to show they had ... nothing to expect bar hard, physical labour ... 'If reform is needed in the case of the slaves in America', said Huw Huws to himself, 'it is certainly needed in the case of the women of rural Wales'.

Two years after its first publication, *Y Gymraes* merged with a periodical for young people, but the drive to channel working-class women into service as a prelude to marriage continued until the onset of the Second World War.

The Welsh Language

Although the report of 1847 had been compiled with a view of improving education in Wales, there was, in fact, a hidden agenda. Throughout the early 19th century, Wales witnessed social and industrial unrest on a scale that alarmed the government. The root of the problem, it was claimed, was the Welsh language, the view being that it was primitive and, therefore, constrained the Welsh to live in ignorance. That is not to say Welsh peasants and industrial workers could not read — indeed, many of them could, but only in Welsh, and the people responsible for that were the Nonconformists be they Methodists, Congregationalist or Baptists, for it was in their Sunday schools that people were taught to read the Scriptures in their own language. The answer to the problem, as far as the authorities were concerned, was to educate the Welsh in English.

Three Englishmen were commissioned to compile the report. Of the 334 people who gave written testimonies on which the report was based, more than 80% were members of the Anglican Church, which, at the time, was in decline. The Nonconformists, who greatly outnumbered the Anglicans in Wales, saw the report as a concerted attack by the English authorities and the Anglican Church on the Welsh, the Welsh language and Nonconformity. The middle-class Nonconformists hit back, claiming the report was nothing more than a display of arrogance, that it misrepresented the truth in that the questions asked of the peasants and workers were loaded to show they were ignorant — for example 'Christ was crucified at Bethlehem, was he not?'

Despite the backlash, the authorities had their way and English was taught in day schools and Sunday schools, but progress proved frustratingly slow, so much so that the 'Welsh Not' became a characteristic of the 1860s. When a child was caught speaking Welsh in the classroom, that child had a wooden block hung around their neck by a leather strap. On the block were the words 'I must <u>not</u> speak Welsh in

school'. If someone else was heard speaking Welsh the block passed to him or her. A thrashing awaited the unfortunate child with the block around his or her neck when lessons ended. How widespread the Welsh Not became is unknown, for there is evidence of its use in only a few schools. It was certainly not a part of government policy and, following the Education Act of 1870, the practice appears to have died out at an unrecorded date.

Thrown out of Chapel

If children had suffered as a result of the Report of 1847, then so, too, did young women who became pregnant outside of marriage, for the Nonconformists, in an attempt to improve their image, hardened their attitude towards those unfortunate women, even to the extent of throwing them out of the chapels, thereby denying them participation in communal life. In a later age the Nonconformists were criticized for their hard line. They had clearly been placed in a no-win situation.

Industrialized Wales

From the second quarter of the 19th century to the outbreak of the First World War, both Wales and the women within its borders were to experience tremendous change. The country witnessed the full effects of coal mining, quarrying, metal works, shipping, the construction of canals, better roads and a rail system that reached out to remote parts. Large numbers of men, both from within and without Wales, were to leave their parishes and settle in the rapidly expanding industrial areas. Large numbers of both sexes also left Wales to work in the Lancashire textile industry, while others migrated to the United States and the Dominions. This same period was one of reform, of political and industrial unrest, and for women there were changes in the law that were long overdue, though by no means satisfactory. Then, towards the end of the period, women began to assert themselves.

Separate Spheres

The notion that men and women should have separate spheres took root in middle-class English society during the early 19th century. According to this doctrine the man was head of the household; his role in life was to provide for his family and, if he were a man of means, to participate in public life. The woman's place was in the home where she was expected to be obedient to her husband, to espouse the virtues of motherhood, respectability, godliness, cleanliness, sobriety and thriftiness. These aspirations were soon promoted in Wales, especially after the *Report on Education in Wales* of 1847, and by 1870 they had become firmly established, particularly in the industrialized areas. There are two main reasons for the acceptance of separate spheres, one being that, by and large, Wales was a nonconformist country, and the notion of separate roles for men and women was in line with the teaching of both church and chapel leaders. The other reason was industrialization.

In the South Wales Coalfield, in the coal-mining areas in other parts of Wales and in the slate-quarrying districts of North Wales, the separate roles of men and women became clearly defined. Working-class men went out to work and brought home their wages; their wives stayed at home, rearing children and attending to household chores. The wife became economically dependent upon her husband; he became dependent upon her to support him in a way that enabled him to recover after a hard day's work. He may have claimed to be head of the household, but she was the Welsh *mam*, the one who took charge of the household, who disciplined the children and who, all too often, literally worked herself into an early grave — but to obtain a clear understanding of her lot her surroundings in one particular area should first be considered.

The South Wales Coalfield

Coal has been mined for centuries in many parts of Wales, but nothing can compare with the scale of mining activity that took place in the South Wales Coalfield, an area extending from Burry Port in the west to Pontypool in the east; from the Head of the Valleys in the north to the Vale of Glamorgan in the south. Documentary evidence has established the existence of a coalmine at Llansamlet, Swansea, as early as the 14th century. The demand for coal increased in the late 16th century, but its extraction was confined to specific areas. At Neath and, later, in the lower Swansea Valley, the Loughor Estuary, Tiabach and Cwmavon, 'sea coal' was used for smelting copper, which was shipped, initially, from Cornwall. At the same time anthracite was required to supply the ironworks that sprang up around the northern rim of the coalfield. Coal

The South Wales coalfield

mining, however, did not expand towards full capacity until after 1840 when steam coal was mined to furnish the requirements of locomotives and steam ships. Steam coal abounded in the South Wales Valleys, the Rhondda Valley in particular. People from all over Wales and, later, from the most westerly parts of England, flocked to the South Wales Coalfield to the extent that, by 1911, 63% of the 2 million people residing in the 13 counties of Wales lived and worked in the pre-1974 counties of Glamorgan and Monmouthshire; moreover, the census returns for the same year show that, in Wales as a whole, one man in three was either a miner or a quarryman.

The Home

Housing in the coalfield was always in short supply — despite what was thrown up by employers and speculators — due to large families and to a continuous influx of immigrant workers, both from within and without Wales; overcrowding was, therefore, the norm. The majority of houses were terraced, consisting of two-up and two-down in which there were up to 13 people in residence: husband, wife, several children, one or more grandparents and, if the family was not overly large, one or more male lodgers, many of them relatives or former neighbours from distant parts. It was also

Industrial worker's home c.1925, Folk Museum, St. Fagans.
In the 19th century the contents of any wage-earners home would have been
relatively basic, but the cooking range is likely to have been similar

usual for two moderate-sized families to share the same house and have lodgers. There was no running water in these houses; that was obtained from wells, the river, or by queuing at a tap in the street. The water had then to boiled before it could be drunk. A dry privy at the end of a garden might be shared by several families, the bucket emptied frequently and the contents, along with household refuse, dumped in the most unsuitable places. According to a report of 1893 relating to the Rhondda

> The river contains a large proportion of human excrement, stable and pigsty manure, congealed blood, offal and entrails from the slaughterhouses, and rotten carcasses of animals, cats and dogs…old cast-off articles of clothing, bedding, boots, bottles, ashes, street refuse and a host of other articles ... In dry weather the stench becomes unbearable.

Lighting came from candles or lamps. Cooking was done on an open range, water heated on a hob, and the side oven used for baking bread and roasting meat. Most household activities were carried out in the living room: food preparation, cooking, eating, bathing, relaxation, drying and airing clothes. Furniture was Spartan, even in the early 20th century when the living room might contain a horsehair sofa, high-back chairs, a heavy table, a mirror and ornaments on the mantle piece, a few pictures of family and the king on the walls. Food was basic: porridge, broth (*cawl*), a meat (pork) and potato dinner, bread and butter, bread and milk (sop), bacon, tea, and vegetables that were grown in the garden or, later, on an allotment. In hard times *mam* often went without, which was no mean sacrifice as she worked hard and for longer hours than anyone else. In the July 1925 edition of *The Colliery Workers Magazine*, E. Williams summed up *mam's* day admirably.

> She gets up any time from 5 to 6 a.m., prepares breakfast and sends off, maybe, her son, next comes in another son from the night shift. She then prepares a bath for him, which means the lifting of a heavy boiler on and off the fire. He goes to bed. Then the younger children get up and get ready for school. When they are safely off, she tries to clean up and clear a little bit of the pit dust…Then dinner has to be cooked and her husband got ready for the afternoon shift. Then her son returns again from the morning shift, bringing with him some more dust. The same process has to be gone through again, etc. He then goes off and she again turns round to clean and tidy up before tea-time when the children come home from school…Just as she thinks she can have an hour or two to sew or read, she again has to be preparing water and supper for her husband returning from the afternoon shift, and so it goes on day after day.

This, then, is the environment that a miner's daughter was born into.

The Early Years of a Woman's Life

Most young girls were no doubt expected to assist their mothers in the home, but a small minority, some of them as young as six, are known to have been employed underground, sitting in the dark for up to 12 hours a day, opening and closing the ventilation doors, or dragging carts loaded with coal. The *Mines Act* of 1842 banned

Domestic servant c.*1880*

women and children under 10 from working below the surface, although there is evidence that the practice continued in some mines for a further 20 years, despite the appointment of inspectors. The *Education Act* of 1870 provided an opportunity for young girls to attend elementary schools, where considerable time was devoted to learning domestic skills, the object of which, in most cases, was to produce good working-class wives and efficient servants for the well-to-do. Elementary school attendance became compulsory in 1880, but when intermediate schooling was introduced nine years later few working-class children were to benefit from a curriculum that was primarily academic because it was necessary for them to take a job, rather than be a financial burden to their families.

For most working-class girls that meant domestic service, though rarely did they become one of many in a large household. The majority became lone, or one of two nonentities in middle- or better-paid, working-class households, working long hours for little pay, having only one Sunday off a month in the mid-19th century. The 1901 census for Glamorgan alone recorded that almost 50% of the female work force was employed in domestic service — as maids, cooks and the like — but the true figure must have been much higher because many young women left Wales for service in England, often never to return. One servant girl in Cardiff claimed, in 1912, that she was 'treated more like a slave than a human being ... driven from [six in the morning] until eleven or twelve at night, eating her own meals while running about waiting on others'. Add loneliness to their plight and it is hardly surprising that domestic servants were forever on the move.

The 1901 census also records that almost 25% of working women in Glamorgan were employed as dressmakers, again working long hours for little pay. These girls served a two-year apprenticeship, a fee being deducted from their meagre wages, after which they might continue to work and live in at a draper's store, or work from home, while others were enterprising enough to travel about their neighbourhood, finding work for themselves.

Outside domestic service and dressmaking, women were employed in a wide variety of occupations, but their numbers were so small it is unsurprising that their

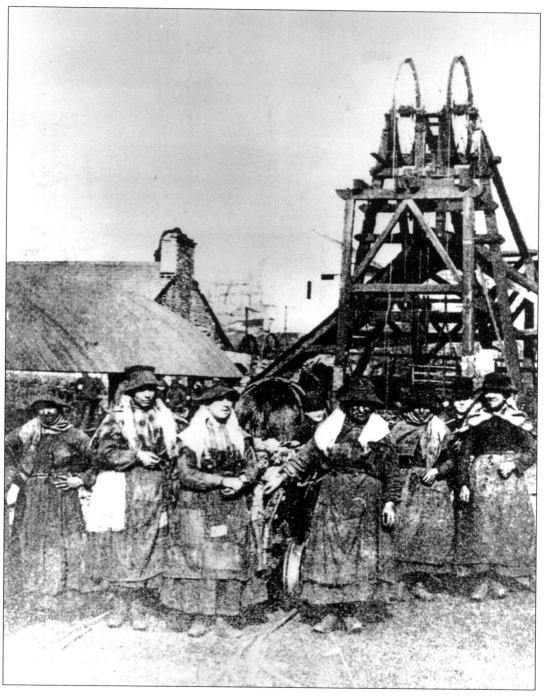

Female surface hauliers at Abergorki Colliery, Treorchy, c.1880

involvement in trade unions did not amount to much. Nevertheless there were occasions when they were prepared to make a stand, as happened in 1911 when 25 Swansea dressmakers — all employees of the emporium, Ben Evans — went on strike for better pay and conditions. The girls gained support from several quarters and there were mass demonstrations of 5-6,000 people. Mary MacArthur, founder of the National Federation of Women Workers, travelled down from London to be of assistance. Most supportive of all was a local industrialist, Amy Dillwyn, who urged shoppers to boycott the store and persuaded her family and friends to withdraw their custom. At a meeting, Amy was reported to have said:

> Employers have no right…to grind them [poor people] down to take unfair wages … Is five shillings a living wage? If 20 girls had an increase of 2s. a week, it would mean a lot to them … I cannot see my way to deal with Messrs. Ben Evans and I hope everyone else will feel likewise.

Relatively few women worked in heavy industry even though the pay was far better than in either service or dressmaking; this was because heavy industry was reserved for men. In 1911 only 23.6% of women in Wales worked; in round figures about 80% of them were single, 10% were widows and 10% were married. It is likely that the single women handed over their wages to *mam* until the prospect of marriage appeared on the horizon.

Marriage

In the early 19th century the average age of a woman on marriage was 23 (25 for a man) and by the latter part of the century this had dropped to 22 and 24 respectively. The drop was small, but what really changed was people's attitude to marriage. An entry in the *First Report of the Commission (Mines)* of 1842 stated that, in the mining communities, the women encouraged bundling to obtain husbands. The report also stated that

> Being pregnant at marriage is very common. Subsequent marriage so as to legitimize the child is the rule. Some few cases of desertion occur [one reason for this being that] public opinion of the miners would be strong against it, so as probably to drive the man away from the neighbourhood.

This state of affairs was to change due to the introduction of the *Marriage Act* of 1836, which led to civil marriages becoming increasing popular in South Wales, so much so that by the First World War the number of couples living talley had dropped to an all-time low. Attitudes towards illegitimacy also changed during the Victorian era (1837 - 1901) and, by the first decade of the 20th century, it had become the norm for a curfew to be imposed on unmarried daughters, who were expected to be home by 10p.m. at the latest, even when they were in their early 20s. Women in the South Wales Coalfield had by then no reason to fear being left on the shelf — certainly not by the 1890s, for so great was the influx of migrant workers

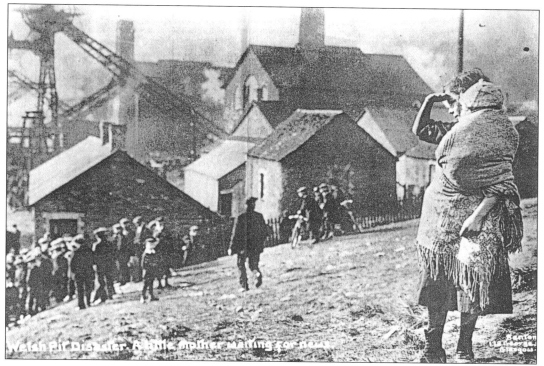

A little mother waiting for news following the worst pit disaster in Welsh History (Senghenydd 1913)

that in places such as the Rhondda Valley there were almost 17 men for every 10 women.

Civil marriages suited the working class: it suited their wage packets and it suited them from the point of view of religion — or the lack of it — for although 19th-century Wales might be regarded a Nonconformist country the fact is that, according to the census of 1851, more than half the population were neither church nor chapel goers. On her wedding day a bride had only to put on her best dress, turn up at the district registry office and leave with a certificate — her marriage lines. As to what day this might occur, according to W.S. Williams in his history of Llansamlet, Swansea, published in 1908:

> the last Saturday of the month was the special day for weddings ... among the workers of the parish. This was the time to receive the pay ... Yes, the day for weddings was normally pay-day, and that pay ... was given to the young wife, every penny of it.

Marriage on a monthly pay-day appears to have been the norm for industrial workers all over Wales (it may have been so for farm workers as well by 1908), for not only were the wage-earning guests in a position to make contributions to the

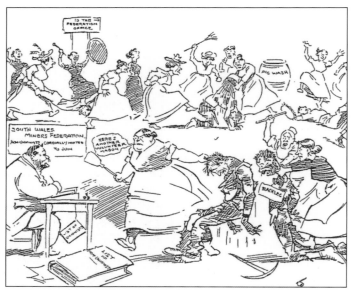

*'Peaceful Persuasion' as depicted in a cartoon
in the* Western Mail, *15 December 1906*

young couple, but the bride, on receiving a full month's pay, was in a position to make a fresh start with the household finances.

Married Life

Setting up an independent household would have been out of the question for most couples unless the husband was at least a skilled worker. Initially, at least, a couple might live with the wife's parents, for then, as now, there was a strong bond between mothers and daughters, and according to one early 19th century source it was common for working-class couples to 'ignore all relationships but those on the mother's side'. This would appear to have been acceptable to the husband; he continued to have a close bond with his workmates, those with whom he shared hardship, danger and a mug of ale, many of whom were male relatives.

Wherever the couple might live, it was the wife who took charge of the household finances. A husband might hand her his wages in full to receive in return an allowance for tobacco and drink, or he might give her an allowance on which to manage. Strictly speaking, these arrangements applied to the latter part of the 19th century, and to the years leading up to the First World War because, previously, workers had been paid 'truck' in the form of tickets which could only be used in company stores, where adulterated food and drink were sold at high prices (tommy rot). Truck was abolished in 1831, but persisted in some areas until the late 19th century when retailing became widespread and workers, through their unions, were able to demand proper wages. Once truck had been dispensed with, enterprising wives found ways of improving the family income; some, according to one collier (in 1939):

> converted their front rooms into shops and hung outside signs advertising tea and salmon ... my wife had caught the craze for shop-keeping, so I had made a counter and shelves ... We had reared two bacon pigs and we were selling bacon and had peas and poultry out in the garden.

Holding the purse-strings may have been a new experience for a young wife, but there would be occurrences that would make managing the household finances diffi-

cult, if not impossible. Her husband could find himself on strike, laid off, have an accident at work, or suffer a disability such as blood poisoning (the result of working in dirty clothes), rheumatism (due to working in damp conditions), constant headaches (from inhaling gas), pneumoconiosis or silicosis (both caused by inhaling dust), or he might be stricken by the dreaded nystagmus (blindness, the result of working in poor light); he could also be killed in an accident or a mining disaster. The worst mining disaster in this period took place at the Universal Colliery, Senghenydd, in 1913 when an explosion underground claimed the lives of 439 miners. For one woman the loss must have been unbearable, being bereft 'in one stroke of her whole household: husband, four sons, two brothers and one brother-in-law'.

Strikes could be the bane of a miner's wife. In the early 19th century unions were little more than local *Friendly Societies*, their members sworn to secrecy, with no effective muscle, but from 1871 onwards these societies amalgamated to form district unions. Then, with the formation of *The South Wales Miners Federation* in 1898, its president, William Abraham (Mabon), was in a position to negotiate rather than resort to strikes. However, not all miners were union members and, in 1906, women set about rectifying the situation with their own brand of public shaming. On 15 December that year the *Western Mail* reported that 'landladies are turning out their non-union members', that a 'shrieking mob of women' had dragged two young men 'out into the street' and stripped them 'of their upper garments' and blackened their faces. In another instance:

> one of the non-unionists residing at Maesteg went to the door ... in his shirt sleeves and a number of women rushed upon him, tore his shirt off ... and dragged him into the street ... [where they] belaboured him with brooms ... [and] threw their dirty water upon him to the accompanying shouts of 'blackleg'. At length he pleaded for mercy, and said that any of the men could go to the colliery office for him and get £1 to pay his subscription.

These instances of women acting in the interest of their menfolk were nothing new. There is a report that, during a strike at Aberdare in 1843:

> large numbers of women and children are in the habit of assembling together, furnished with frying pans ... and other culinary utensils, which they furiously strike with ladles ... [etc., in the presence] of any recusant coal-owner or [strike-breaker].

Children and Pregnancy

Children were considered necessary in that once they were old enough to work they brought additional wages into the household; they were also a support to their parents in old age, or when one of them became incapacitated through injury of illness. It was, however, the sheer number of pregnancies that seriously affected a woman's health. It was not unreasonable, for example, for a woman to claim to have had seven children, three still births and four miscarriages. Many miscarriages were,

according to midwives, a direct result of preparing baths for homecoming husbands, sons and lodgers, for they had to leave the house with buckets, which they filled at the street taps, and carry them back to the house where they boiled the water before tipping it into tubs, or zinc baths. It was not until after the installation of pit-head baths in a few collieries during the 1920s that some miners' wives were relieved of such backbreaking work.

Many children — as many as one in five in some areas — died in infancy due mainly to poor diet and living in damp, overcrowded dwellings, some of them succumbing to outbreaks of cholera, typhus and diphtheria. There were also deaths due to pneumonia, whooping cough, measles, scarlet fever, convulsions and the most persistent scourge of all — consumption, better known today as tuberculosis — which in overcrowded dwellings could wipe out whole families. An article in the *Western Mail*, dated 24 June 1907, laid the blame squarely on the industrial magnates, claiming that the high mortality was due to:

> the failure of the capitalists employing labour to rescue that labour from foul and filthy dwellings, which are death traps and murder holes.

The reference to the state of these dwelling was not an attack upon the house-wives, but on the quality and dampness of their homes. The article also mentioned waste, claiming that 'Merthyr does not destroy its refuse, but it destroys its children'; moreover, it was this refuse that contaminated the water supplies.

Accidents in the home also took their toll, one of the most commonly cited being death by scalding; that is, toddlers falling into tubs of hot water 'while the mother is preparing for the worker's bath'. Yet despite the unremitting housework and the demands imposed upon them by children (many of them in poor health) women in the South Wales Valleys took pride in their housework, even to the extent of scrubbing the pavement outside their front doors, and did so in the belief that 'cleanliness was next to godliness'.

The Ace sisters: Jessie Ace (left) and Mrs. Margaret Wright (1883)

Public Shaming Rituals (2)

From the second quarter of the 19th century onwards the shaming ritual known as *ceffyl pren* entered a new dimension. Instead of targeting scolds, cuckolds and henpecked husbands, the ritual was used overwhelmingly in support of women who, in a predominantly wage-earning society, were financially

dependent on their husbands and were, therefore, no longer seen as a threat to male domination, but as defenceless creatures in need of protection. Although the rituals, which were often violent, were usually carried out by men unattired in women's clothes, it is likely that the attacks were instigated by gossipy women. The kind of men targeted the most were wife-beaters, adulterers and wife-deserters. In 1855, for example, a collier named Dai Dumpin was singled out for beating his wife 'until she lay bleeding and senseless'.

> The news of Dai's violence towards his wife spread rapidly, and next morning a host of colliers and miners procured a plank, and ... pounced upon the wife-beater ... whom they quickly placed athwart a plank, which was carried by four men ... from Penywaun down through ... Llwydcoed Ironworks, accompanied by about one hundred people, many of whom had small branches of ash and other trees, with which they often flagellated the miserable man ... Having been well paraded ... [Dai was] addressed by two of his lynching attendants ... on the wickedness of his conduct ... The parties who had administered to Dai this specimen of Aberdare justice, spent the remainder of the day at several public houses, regaling themselves ... [for] protecting the weaker sex.

Occasionally a woman might be singled out for cruelty towards her stepchildren, as happened at New Quay in the 1880s, or for promiscuous behaviour, as a Llangadog in 1837. Outraged women actively participated in rituals such as these, for it was said, in 1856, that they were often 'the most violent [participants] especially to erring members of their own sex, whom they have occasionally been known to lacerate with knives and pins'.

The Ace Sisters

No account of women in 19th-century Wales would be complete without at least a brief mention of what happened at Mumbles Head, Swansea, in 1883. Beyond the Mumbles headland are two small islands. On the outer island — the Head — stands a lighthouse protected on the seaward side by a stone-built battery emplacement, which, in 1883, was manned by a detachment of gunners. At 8 o'clock on Saturday 27 January that year, a ferocious gale struck the South Wales coastline and drove a German cargo ship into Bracelet Bay and onto the rocks surrounding the Head. The crew of the Mumbles lifeboat did their best to rescue the stranded German sailors, but the lifeboat, battered by waves 10 to 15 feet high, capsized on three occasions, each time spilling crew members into the ice-cold water. The coxswain, Jenkin Jenkins, made it to the inner (Middle) island, from where he saw two crew members, William Rosser and John Thomas, floundering near the rocks skirting the Head. It was reported in the *Cambrian Daily Leader* two days later that:

> Near the lighthouse were Ace, the lighthouse keeper, his two daughters [Jessie and Mrs. Margaret Wright] and three soldiers belonging to the battery. Jenkins shouted to the soldiers to 'save the men' who were then floating about near the rocks. The soldiers seemed stupified and afraid and at this juncture occurred one of the finest

examples of womanly heroism that can be found in the pages of history. Ace's daughters could remain no longer spectators of the scene. They rushed down to the beach. 'Come back, come back!' shouted Ace, 'You'll lose your lives'. 'I'll lose my life before I'll let those men drown', replied one of the heroic girls [Margaret]; and tying their shawls together, they bravely entered the water, pressed forward until up to their armpits, threw out their shawls, one end of which they retained hold of and rescued the lives of two men whom they landed upon the rocky shore ... If Jenkins' account is correct the conduct of the soldiers was cowardly in the extreme.

There were a number of men — none of them witnesses to the event — who insisted on marginalizing the part played by the Ace sisters, preferring to credit a soldier, Gunner Hutchings, with saving the crewmen, Rosser and Thomas. Consequently, the bravery of the sisters was not recognized by the Royal National Lifeboat Institute, nor were the sisters rewarded by the Institute, as was Gunner Hutchings. The Empress of Germany, however, did send the sisters numerous gifts in recognition of their heroism. Even more astonishing — for the sisters at least — a poem was composed by Clement Scott in honour of their bravery, one that was to be taught for many years in schools all over the British Isles.

Despite all the claims and counter-claims as to who did what, it appears that Gunner Hutchings was responsible for saving Crewman Thomas, a fact borne out by Thomas himself, but the other crewman, Rosser, is reported to have said that:

He owes his life to the young ladies, Mrs. Wright and Miss Ace, and that he has them only to thank for saving him from being drowned or dashed to pieces on the rocks.

His statement was supported by Coxswain Jenkins, who said that:

he saw the whole incident from beginning to end ... [and] that it is perfectly true that the young ladies and they alone saved Rosser.

To add to this it was reported that:

both Mrs. Wright and Miss Ace also state most positively that it was they and they alone who seized hold of William Rosser as he floated past and drew him to shore and dragged him out of reach of the waves. They say the soldier was present and helped them after they got hold of him.

In all, one German sailor and four lifeboat crewmen lost their lives that day, the crewmen leaving four widows and 19 children fatherless. The RNLI set up a fund of over £3,600 for the widows and their children.

Chapter XI
Women and Crime in the Early Modern Period

There were many attempts in the 19th century to portray the Welsh as exceptionally law-abiding people when, in fact, they were no different to people in other regions throughout the British Isles. Exponents of a law-abiding Welsh peasantry based their claim on surviving court records, which, when compared with records relating to other parts of Britain, gave the impression that there were comparatively few criminals in Wales. The truth, however, was that the Welsh were by and large still settling their differences by arbitration, or by confronting those who had wronged them, preferring to receive compensation, a compromise or an apology rather than settle matters in courts. Consequently, the official crime figures for Wales were lower than elsewhere. This aversion to settling matters in court was encapsulated by Captain Napier of the Glamorgan Constabulary when he stated, in 1842, that:

> a species of clanship ... renders the Welshman particularly averse to give evidence against his neighbour, even should he belong to a different country than himself.

Female Criminality

Although it is not possible to assess female criminality in Wales prior to the mid-19th century, it can nevertheless be assumed that it was much the same as elsewhere, meaning that only a relatively small proportion of criminals were women — perhaps 20% or less. What is certain is that female crimes did not entirely mirror those committed by men. Women were often involved in violence and unruly behaviour, usually the result of disagreements, too much drink, or defending their honour after insult, but women assaulted women far more than they did men, and they invariably carried out their attacks using hands, feet and teeth rather that weapons. Men committed all kinds of theft, robbery with violence included, whereas women were most likely to be involved in petty theft, targeting small items of no great value such as clothes, food or the contents of someone's pockets, which they surreptitiously took from the person or by shoplifting. Sometimes — usually as innkeepers or the owners of boarding houses — they were receivers of stolen goods, though here again the stolen articles were portable and of no great value, the ill-gotten gains of prostitutes and petty thieves. Some crimes such as infanticide were almost entirely female. Prostitution was not a crime, but 'ladies of the pave' were prosecuted for a variety of

offences associated with their profession — vagrancy, indecency, drunkenness, disorderly behaviour and petty larceny to name but a few.

Female criminals were almost entirely working class, and young, single women were twice as likely to be prosecuted as those who were married, presumably because (1) they had to fend for themselves and (2) when they migrated to towns in search of work, they were more easily lured into prostitution, usually the first step to becoming petty criminals. This was particularly true of the Irish women who were to be found in all the seaports from Holyhead to Newport. More than half the women prosecuted were resident in — though not necessarily native to — Glamorgan and Monmouthshire, the two most industrialized counties in Wales. In his contribution to the education report in 1847, Jelinger Symons maintained that, in the iron districts in particular:

> the lawless vices and rude habits of the men are communicated to the women. In murderous offences by females, no other district (not excepting London) affords so many instances. Even in offences against property committed with violence, the women there more largely participate than elsewhere. This is in some degree owing to the masculine pursuits in the works and the pits, which degrade them to the habits and brutalities of men.

The Death Penalty

When law-breakers were convicted for misdemeanours in the lower courts (the Petty Sessions, presided over by magistrates) they might be fined, subjected to public whippings through the streets, placed in pillories or given short prison sentences in town gaols. When prosecuted for a felony their trial in one of the higher courts was by jury and, if convicted, their punishment could prove to be exceedingly harsh. In the 18th century the ruling classes, fearing unrest among the peasantry and the growing numbers of industrial workers, introduced what became known as the Bloody Code with the result that, by 1800, more than 200 offences — most of them property offences — were punishable by hanging. Juries, however, were reluctant to return a verdict that would result in someone's death. This was particularly so in Wales where they were renowned for their recommendations for mercy and for pardons. In numerous cases juries modified the severity of a sentence simply by reducing the charge which, in the case of theft, was achieved by deliberately undervaluing the goods that had been stolen. Opposition to the death penalty in the early 19th century led to a considerable reduction in the number of crimes that were punishable by death, and from 1844 onwards a hanging in Wales was a rare occurrence. By then, there had long been an alternative to the death penalty, one which many considered to be more humane in that it gave convicted felons time to reform, but which in reality was hell on earth.

Transportation

As an alternative to hanging, transportation to the colonies and plantations in America was introduced in 1717, but when the American War of Independence (1775-83) put an end to this traffic, the British Government had to find an alternative destination.

Then, in 1787, the government announced that Botany Bay in New South Wales, Australia, was to become a penal colony. Between 1788 and 1852 some 147,580 convicts were transported to Australia and (from the 1820s onwards) to Van Dieman's Land (Tasmania); of these, 24,960 were women. In her book *Welsh Convict Women*, Professor Deirdre Beddoe declared that 283 of these women had been tried and sentenced in Wales. The relatively small number of female transportees from Wales is testimony to the reluctance of Welsh courts to endorse even this kind of punishment.

However, the view of the government was that transportation rid the country of undesirables and relieved pressure on overcrowded town gaols. Male convicts were certainly put to work in chain gangs, whereas female convicts, it was said, would be assigned to colonists as domestic and farm servants. But in her book, Professor Beddoe makes it plain there was another, more sinister reason for transporting women. There were simply not enough women in Australia, and by sending female convicts there the government hoped to redress the balance. The women were not, however, transported there as potential wives, for few men (other than ex-convicts) would marry women who were branded drunken whores. On the contrary, women were sent there to sexually satisfy the colonists. This is borne out by the fact that, whereas men were transported for serious crimes, women were dispatched for less serious offences such as petty theft, the more so if they were healthy and in their teens or twenties.

A great deal is known about transportees because the authorities in both Britain and Australia kept detailed records, which enabled Professor Beddoe to trace the process whereby a woman might be sentenced to transportation. For example, Eliza Wheeler, a twenty-year-old from Herefordshire, had been in service to a Swansea woman, who reported her to the police for stealing three silk shawls valued at 2s. in total. After appearing before a magistrate and being formally charged, Eliza was detained in the local gaol until her appearance, in June 1842, at a court of Quarter Sessions where she was sentenced to seven years transportation to Tasmania. The severity of Eliza's sentence in relation to her crime was by no means unusual. Ruth Roberts, a Merionethshire widow with previous convictions for petty theft, had been caught with four stolen cabbages in her possession and sentenced to seven years. Ann Watkins of Monmouthshire, a nineteen-year-old first offender, was sentenced to ten years for stealing a piece of bacon and a loaf of bread.

Some women stole because they claimed to be 'famished with hunger, [or] in want of meat'. Others were simply iniquitous, the product of industrialization, which created boom towns and transformed the South Wales Coalfield into a frontier region. Work in the Coalfield was usually reserved for men, many of whom had money to spend in public houses. Single women who had to leave home in search of work, rather than be a burden to their families, could easily find themselves lured into prostitution. A few months 'on the town' and these girls were soon involved in crime. In pairs, they frequented public houses to single out an intoxicated man, pick his

pockets, or lure him into an alley where one girl engaged the man while the other went through his pockets. Then both girls ran off, leaving the man with his trousers about his ankles.

The majority of Welsh transportees were punished for stealing worn clothing, bedding, food and small amounts of money. Only twelve were sentenced for crimes involving violence, two of them for unlawful killing. In 1850 Mary Jones was sentenced to transportation for life for killing her six-month-old illegitimate child; Hannah Roberts, an eighteen-year-old from Flintshire, received a similar sentence in 1842 for poisoning her husband. These last two crimes were considered heinous, but no more — when sentences are compared — than stealing sheep. In 1817 Mary Williams and Mary Roberts were both convicted at Caernafon for stealing two wether sheep, worth 10s. apiece, and sentenced to transportation for life.

Once sentence had been passed a female convict returned to the gaol where she had already spent time awaiting trial. Town gaols were damp, verminous places in which inmates slept on the floor, their bedding little more than a pile of rags. The gaol at Haverfordwest, for example, had two damp dungeons in which one male prisoner lost the 'use of his limbs and then his life'. Many convict women died of gaol fever (typhoid), which is not surprising as water was often filthy and sometimes full of maggots. Some women languished for years, waiting to be transferred to a port of embarkation, as happened to Mary Lewis who was sentenced in 1793, but did not sail until 1801. Time spent in these gaols was not taken into account as a sentence did not begin until the transportee arrived in Australia.

In due course letters were sent to the county sheriffs, ordering them to convey named prisoners to a port of embarkation in southern England. One such letter was sent to the sheriff at Caernafon in 1825, ordering him to send Eleanor Williams to:

> the ship, Midas, laying at Woolwich ... [and to provide] a certificate specifying concisely the description of ... [her] crime, her age, whether she was married or unmarried, her trade or profession and an account of her behaviour in prison before and after her trial, and the gaoler's observations of her temper and disposition ... and the order of the court by which ... [she] was sentenced.

Most transportees were sent in chains and under escort to London, travelling by sea, or enduring wind and rain on the outside of a stage coach. The infamous Newgate Prison where they were detained was described by the Quaker reformer, Mrs. Elizabeth Fry, as 'a den of wild beasts', the women in rags, 'begging, swearing, gaming, fighting'. Millbank replaced Newgate as a penitentiary for transportees, and for a while conditions improved until, Millbank became a hellhole in its own right.

When conveyed to the ships the name of every woman who embarked was recorded in a register under the name of the ship in which she sailed. Sometimes in convoys, sometimes in lone ships, the transportees were crammed below deck in vessels that were little more than 100 feet long and infested with rats, cockroaches and bugs. Many were already in poor health before they set out on a voyage that could take

up to ten months in all sorts of weather. Little wonder, then, that so many succumbed to dysentery, typhoid, scurvy, smallpox and cholera. If any of them proved troublesome, they were flogged, tortured with thumb screws, or given three to four dozen cuts with a cane. The women were also subjected to sexual abuse. One ship, the *Lady Juliana*, was described as a floating brothel. A mariner on this ship recalled that 'every man on board took a wife from among the convicts', though whether the women had any choice in the matter is debatable. One female convict aboard another vessel is reported to have called the ship's surgeon 'a poxy bloodletter who seduced innocent girls while treating them for fever'.

Surprisingly, a great many women took their children with them. The *Gilbert Hibbert*, for example, had 150 women and 41 children aboard. Some women, such as Bridget Williams from Monmouthshire, took three children with her. The regulations stated that the age of children should 'not exceed, if boys, six years, and girls ten years ... [but if the mother] should have a child at the breast, she must not be removed on board the said ship'. Yet the records show, in 1849, when sailing time had been reduced to four or five months, that Margaret Philips from Monmouthshire, arrived in Tasmania with a baby aged seven months, in which case Margaret must have embarked with her 'child at the breast'. Children were known to have died at sea, while others were certainly born.

The most horrendous voyage on record is that of the Second Fleet — three vessels carrying 939 male convicts and 78 females, four of them from Wales. For most of the voyage these transportees were kept in chains, often up to their 'middle in water'. They were short-rationed and became emaciated. By the time they reached Australia 267 of them were dead, 11 of them women, and nearly 450 were in need of medical attention. A Revd. R. Johnson, who went aboard one of the ships, recalled:

I beheld ... a great number of them laying half and others nearly quite naked without either bed of bedding unable to turn or help themselves ... the smell was so offensive I could scarcely bear it.

Johnson also recorded that:

The landing of these people was truly ... shocking, great numbers were not able to walk, nor move hand or foot; such were slung over the ship's side in the same manner as they would sling a cask ... Upon being brought up to the open air some fainted, some died upon the deck and others in boats before they reached the shore. When they came on shore many were not able to walk, or stand ... hence they were led by others ... [all were] covered almost with their own nastiness ... all [were] full of fleas and lice.

Surprisingly, convict women were not placed behind bars when they disembarked in New South Wales. For the first 30 years they:

were indiscriminately given [assigned] to such of the inhabitants as demanded them and were in general received rather as prostitutes than servants.

A factory-cum-prison opened at Paramatta near Sydney in 1821. This was a three-storey, stone building designed to accommodate 300 women, although it is known to have housed up to 700. Discipline at Paramatta was strict, the women put to work weaving, washing clothes, picking oakum, or doing needlework; they even broke stones. The majority of inmates were considered criminals of the worst kind, unsuitable for assignment. Some of the inmates, however, were there because they had been dismissed from their assignments, or had become pregnant. Many of the children born at the factory died; those that survived were placed in orphanages.

When a colonist or ex-convict turned up at the factory in search of a 'wife', the women were paraded and the man made his choice, often returning for a more suitable replacement. Many women were more fortunate — if fortunate be the right word — in that by the late 1820s over 40% of them were married, almost all of them to ex-convicts. Others, providing they conformed to the rules, were give 'tickets of leave', which allowed them a degree of freedom before they received a pardon. None of the women had any hope of returning home, for unlike men who could work their passage, pardoned women had no such option — they were exiles for life.

New South Wales ceased to be a penal colony in 1840. Thereafter, all transportees were sent to Tasmania. There were two factories on the island, the Cascade factory at Hobart being by far the worst. Conditions at this damp, sunless factory were so cramped they were compared to those on a slave ship. A contemporary wrote of it:

> So foetid ... is the atmosphere after the night's habitations, that ... the turnkeys, when they open the doors in the mornings, make their escape ... with the utmost expedition to escape semi-suffocation.

The transportation of women ended in 1852, by which time an estimated 12,500 females had been sent to Tasmania, at least 100 of them from Wales. What is noteworthy is that the Tasmanian authorities kept detailed records of all transportees, even of their appearances, so that, in the event of an escape, wanted notices could be issued. Eliza Wheeler, for example, had the following description:

WHEELER, ELIZA	*Garland Grove* (the ship she sailed on)
TRADE	Dairy Maid
HEIGHT (without shoes)	4ft. 11¾ins.
AGE	20 years
COMPLEXION	Fair
HEAD	Round
HAIR	Dark Brown
VISAGE	Round
FOREHEAD	Medium Height
EYEBROWS	Dark Brown
EYES	Light Blue
NOSE	Medium
MOUTH	Small

Chin	Round
Native Place	Herefordshire
Remarks	Small cut on left thumb
	Brown mole on left cheek
	Black mark on front tooth

All Welsh female transportees (except perhaps one) were working-class, and descriptions such as the above show they were, on average, under 5ft. tall with dark hair and eyes, their complexion varying from ruddy to dark or sallow. Some were described as pock pitted, the result of disease, and many bore scars or other deformities. A surprisingly large number had tattoos, initials mostly; they were invariably town girls, many of them prostitutes.

To these generalizations may be added the observations of two 19th century writers. An American, W. Sykes, wrote: 'the Welsh woman of the collier class is a formidable antagonist, and the dockland women are sturdy charmers'. Another visitor to Wales, A.J. Munby, referred to the 'picturesque ways and frank and modest charms of the robust and fearless girls who work at ... mountain mines'.

These generalizations — which contrast with the more delicate middle- and upper-class women of the Victorian era — Professor Beddoe attributed to national characteristics and poor diet.

Rape in the Early 19th Century

It is believed that, today, only one in ten rape attacks are reported, which may also have been the case in the early 19th century; in addition, there must have been many instances in the period under review in which no prosecutions took place because the rapist could not be identified, either by name or appearance. To make matters worse, there is reason to believe that when prosecutions did take place only a quarter of them reached the higher courts, and up to half of these ended in an acquittal. One reason for the low rate of convictions was the way in which criminals were prosecuted. Today most of the procedure is carried out by the police and by members of the legal profession. In the early 19th century it fell to the victims, or someone they could trust, to do most of the donkey work, as few would entrust their cause to either the police or members of the legal profession.

If the victim was a woman who had been subjected to a rape attack, or an attempted rape attack, the first thing she had to do was find a magistrate who would issue a warrant. Next she had to find a constable (either an unwaged parish constable, or one of the new 'professional' policemen who were active in Wales from 1835 onwards) to execute the warrant, assuming, of course, she knew who her attacker was. Both the magistrate and the constable would have warned her of the consequences if she failed to get a conviction. They would also have informed her that she would have to produce witnesses — if there were any — and provide evidence (which might simply mean drawing attention to any visible injuries she may have received at the hand of her attacker). There was also the cost of bringing the whole process to a

conclusion — up to £20, more than most women earned in a year. There was some state aid for the poor in cases involving a felony, but it was subject to the magistrate's willingness to allow costs, which would not cover all expenses.

A preliminary hearing followed, one in which the accused and the victim appeared before two or more magistrates at a Court of Petty Sessions. Sometimes a relative or a friend might speak on the victim's behalf, but it was outside the remit of magistrates to deal with a felony and the matter would be referred to a higher court, either the (county) Quarter Sessions, or the Great Sessions (the Assizes after 1830). It was at this juncture that the victim might withdraw her allegation. She might even be encouraged to settle out-of-court, providing the charge was reduced to one of common assault, with the result that the rapist received a lighter sentence than if he had been charged with petty theft.

It could take weeks, even months, for a case to be heard in a higher court, during which time the victim and, indeed, her family might be intimidated or attacked by the accused and his disreputable friends or workmates. If the victim persisted and the case reached court, she would have to suffer attacks on her character, namely that she was 'for want of chastity or common decency', that she had somehow encouraged her attacker, or was a prostitute; even more disheartening, the jury might return a 'not guilty' verdict, or failing that, the jurors might have the charge reduced to one of common assault before returning a guilty verdict. Only if the evidence was over-whelmingly in the victim's favour would a jury return a verdict of 'guilty as charged'. Little wonder, then, that the judicial process has been likened to second rape.

Abortion

Birth control techniques such as douching and the half-lemon used by prostitutes may have a long history, whereas *coitus interuptus* (the withdrawal technique) is known to have been practised by at least the early 18th century because quacks wrote about it, linking it to blindness, deafness and loss of memory. If any of these techniques failed — as invariably they did — the next step in dealing with an unwanted pregnancy was abortion. This might be achieved with the use of herbal mixtures or drugs to induce vomiting, diarrhoea or uterine contractions, and there are stories of women inserting knitting needles into the womb (an extremely risky business) or consuming a bottle of hot gin in a steaming bath in the hope of triggering a miscarriage. Prior to the 19th century, abortion had been a sin to be dealt with by the ecclesiastical courts, the punishment ranging from penance to excommunication.

In 1803, the British Government, alarmed by the number of abortions that would one day effect the military's supply of potential cannon fodder, passed legislation that made it an offence to 'destroy the lives of His Majesty's Subjects by poison, or with intent to procure the miscarriage of Women'. This piece of legislation rendered the abortionist liable to flogging, the pillory or 14 years transportation, the severity of the punishment depending on whether the act had been committed before the foetus moved, or after 'quickening'. Even when an attempt to end a pregnancy failed, the

'intent' to carry out the act was sufficient ground to warrant punishment. The question, then, was whether the failed attempt had been carried out before or after quickening. It was, therefore, necessary during the course of a trial to impanel a Jury of Matrons (married women) to determine whether the foetus had reached quickening. There was nothing new about such juries — they had been used in the Medieval period to determine whether a condemned woman was with child when she pleaded 'the belly', which could result in a reprieve, or, after 1931, to a sentence being commuted to life imprisonment.

The Offences Against the Person Act of 1861 has remained on the statute book until the present day. What is noteworthy about this act is that (1) it rendered the distinction of before or after quickening no longer relevant and (2) it made the pregnant woman — as well as the abortionist — liable to punishment, which, at that time, meant life imprisonment. The relevant section of the act reads:

> Every woman, being with child, who, with intent to procure her own miscarriage, shall unlawfully administer to herself any poison or other noxious thing, or shall unlawfully use an instrument or other means whatsoever with like intent, and whosoever, with intent to procure the miscarriage of any woman whether she be or be not with child ... shall be guilty of an offence, and being convicted thereof shall be liable to imprisonment.

Imprisonment or not, abortion continued to the extent that, by 1900, health officials in Wales were expressing concern about door to door abortionists. When abortion was not used, or failed, there was yet one more option available to women who did not want a child.

Infanticide

In Wales, one of the earliest recorded instances of infanticide is found in the journal of Lady Eleanor Butler (one of the Ladies of Llangollen) who recorded, in 1788, that the body of a 'poor infant [had been] brought down through the fields in a basket ... [and the young mother] sent to Ruthin Jail'. Fortunately for the mother, she 'was acquitted of the murder of her infant' because the judge had not 'enquired minutely into the particulars'. This particular child may have been abandoned so that it starved to death, but in Victorian times (1837-1901) unwanted babies were sometimes given an opium-based drench to quieten their persistent crying so that they might die quietly. Drenches of this sort were, in couched language, advertised in newspapers, as was a horrifying form of infanticide known as 'baby farming'. In the latter case all a mother had to do was reply to an advertisement, which implied that her unwanted child would be adopted for a fee of up to £15. The baby would, then, be disposed of by drowning, suffocation, strangulation or simply battered to death. One London woman is said to have disposed of over 500 unwanted babies in one year. The last baby farmer to face trial was Rhoda Willis, an alcoholic, who received £6 for an unwanted child, which she presumably smothered. For her crime Rhoda ended up on the gallows at Cardiff in 1907.

Penal Servitude

When transportation for women ended in 1852, it was replaced by a punishment that was in some respects much worse — penal servitude. Prior to that date, lengthy prison sentences had been rare in Wales, the usual sentence being no more than three years in a town gaol. A series of acts from 1853 onwards made it possible for convicted felons to be imprisoned for a minimum of five years — seven if they had previously been convicted for a felony. What made penal servitude so inhumane was that, initially, the first 18 months were spent in solitary confinement, the belief being that it gave inmates time to reflect on their past so that they would be more susceptible to religious instruction, but so many inmates went mad or committed suicide that the authorities had to reduce the term of confinement to nine months. Throughout the remainder of their sentences the inmates were kept in separate cells at night. By day they were subjected to hard labour, working in groups in complete silence. The work consisted of sewing mailbags, making mats or picking oakum; that is, untwisting the fibres of old rope for use in caulking ships. Another pointless task involved breaking stones. Contact with the outside world was kept to a minimum. The food was so bad that many inmates suffered digestive disorders and dietary problems such as scurvy. When inmates proved troublesome, they were put in irons, whipped, given solitary confinement, placed on restricted rations or, worse of all, put on a treadmill for up to ten hours a day.

None of the gaols in Wales could meet the requirements of penal servitude, being far too small and lacking adequate security arrangements. To meet the requirements, purpose-built prisons had to be built and, by 1850, a score of such prisons had already been established, none of them in Wales. For Welsh convicts it was simply another form of transportation, albeit to England. No one has so far calculated exactly how many women in Wales were sentenced to penal servitude, but they were certainly fewer in number than those who had been shipped to the far side of the world.

CHAPTER XII
The Move Towards Women's Suffrage

Four Remarkable Upper-class Women

Most upper-class women believed in separate spheres, accepting their role in the home and engaging in charitable works while their husbands kept them in an enviable lifestyle. Lady Llanover (1802-96) was one such woman. With her husband's support she founded a school, endowed two Methodist chapels and, as an avid teetotaller, purchased several local public houses and converted them into tea houses — but what made Lady Llanover exceptional was that she took her role in the home beyond what was considered the norm. Born Augusta Waddington, the daughter of an English aristocrat, she became Lady Llanover when, shortly after her marriage in 1823, her husband, Benjamin Hall of Abercorn, in Monmouthshire, bought the neighbouring estate of Llanover and built, in Gothic style, Llanover Court. By 1834, Augusta had mastered the Welsh language to the extent that, under the name of Gwenynen Gwent (the Bee of Gwent), she won a prize in an eisteddfod for her essays on the Welsh language. Augusta was so taken up with all things Welsh that she organized Llanover Court on the lines of a Medieval prince's court, employing both a harpist and a bard, and insisting that all the servants wore traditional Welsh dress and spoke only in their native tongue. She wrote extensively on such matters as Welsh customs, folk-songs, folk-dancing, cookery and native women's dress, thereby recording for posterity much that would otherwise have been lost in a changing world. It is entirely due to her efforts that, on St. David's Day, young girls attire themselves in Welsh costumes.

Lady Charlotte Guest (1812-95), on the other hand, was one upper-class woman who did not readily accept the notion of separate spheres. An English aristocrat, the eldest child of the ninth Earl of Lindsey, Charlotte (née Bertie) came to Wales at the age of 21 to marry John Guest, the ironmaster of Dowlais, who was 27 years her senior and by whom she had ten children in the space of 13 years. Like so many of her kind, Charlotte helped to cement social relations between her husband and his workforce, involving herself in numerous community projects, including the establishment of several schools. She also mastered Welsh so well that, between 1838-49, she translated 11 Welsh Medieval tales to produce what she called *The Mabinogion*. Later, when ill-health affected her husband, she deputized for him in the running of his business empire, thereby crossing the line drawn by separate spheres. After her husband's death in 1852, she took control of what was then the largest ironworks in

the world, though not without meeting opposition from other industrial magnates on account of her sex.

The daughter of a well-to-do English family, Rose Mary Yeates (1828-1907) became Mrs Crawshay when, in her 18th year, she married the Merthyr ironmaster, Robert Thompson Crawshay, who was 11 years her senior and by whom she had five children. Rose lived in luxury at her husband's 72-room mansion known as Cyfarthfa Castle, near Merthyr. She nevertheless did what was expected of her in the way of charity, feeding the poor, running soup kitchens and establishing no less than seven free libraries in the area — but Rose had another side to her character. She was a feminist and a strong-willed one at that, which must have contributed to a stormy atmosphere at the Castle, for her husband appears to have been something of a tyrant with a vicious temper, one who expected his children to answer to the summons of a dog whistle. Rose, who was well known in London, participated in the early feminist activity of the 1850s, and in 1866 was one of 26 women — all of them residing in Wales — to sign a petition for women's suffrage. By 1873 she had become vice-president of a West of England suffrage society. In many respects Rose was ahead of her time, a believer in euthanasia and simplifying English spelling; she was also a founder member of the Cremation Society of England. She herself was cremated in 1907, five years after cremation had been legalized.

Undoubtedly, one of the most remarkable upper-class women to cross the line drawn by separate spheres was Amy Elizabeth Dillwyn (1845-1935), the daughter of Lewis Llywelyn Dillwyn, a wealthy landowner and industrialist. From the age of five Amy lived at Hendrefoilan, a mansion that her father had built on the outskirts of Swansea. In 1863, at the age of 17, Amy made her first public appearance, travelling by carriage from her father's Knightsbridge home to arrive in Piccadilly along with 250 other debutantes, all of whom were to experience their 'coming out' in the presence of the then Princess Royal. Two months later she attended a Convent Garden concert in the company of her future fiancé, Llywelyn Thomas of Llwynmadoc, suitably chaperoned by his mother and sister. That same year, Thomas proposed and the match met the approval of both families as Amy and Thomas were of the same class. Unfortunately, Thomas died of smallpox before the marriage was due to take place. Although she encountered many suitors following her loss, Amy never accepted the proposal of anyone, but turned her hand instead to writing novels, which she did successfully, using the name E.A. Dillwyn to conceal her sex.

When her father died in 1892, Amy had to leave Hendrefoilan — which passed to a nephew — and took lodgings in West Cross, Swansea. Her father, however, had not forgotten her in his will, bequeathing her the Llansamlet Spelter Works with its workforce of 200 men. The catch was that the Spelter Works was then in debt to around £100,000, enough for most men to file for bankruptcy, but not Amy; she was made of sterner stuff. Travelling daily by the Mumbles train from her lodgings in West Cross to the company's offices in Cambrian Place, she set to work improving productivity until, seven years later, she had paid off her father's debts. In 1902 the *Western Mail* referred

MUNICIPAL ELECTION,

NOVEMBER 1st, 1907.

CASTLE WARD.

ELIZABETH AMY DILLWYN,

The Independent Candidate.

Printed and Published for the Candidate by J. Thomas & Son, 13, Dynevor Place, Swansea.

*Amy Dillwyn, when she stood as an Independent candidate
in a municipal election of 1907*

to her as 'one of the most remarkable women in Britain', whereas locally Amy was an easily identified eccentric, her sombre dress and trilby hat accentuating her masculine appearance. She smoked cigars, took up hockey and water polo, bought a house (Tŷ Gwyn) off the Mumbles Road and continued to support women's suffrage. Then, in 1905, when it became obvious to her that the spelter industry was in decline, she sold her majority shareholding. Fifteen years later, at the age of 75, Amy was seen in Monaco, playing bridge and poker. When she died at the age of 90 she left £114,000 in her will.

Changes in the Law Relating to Women

A series of new laws relating to married women during the period between *c.*1850 and 1914 are testimony to how little their legal status had changed since the late 16th century. A married woman's status was still defined by that of her husband. Any property that she had on marriage automatically became the property of her husband, although a well-to-do father could safeguard his daughter's interests by insisting on a marriage contract. Any earnings she might accrue belonged, in theory at least, to her husband. It was not until the Married Women's' Property Acts of 1870 and 1882 that married women were prescribed the same rights to hold property as unmarried women and widows. The earlier Act of 1870 was little more than a feeble compromise, but the Act of 1882 gave married women the right to retain, use and dispose of their own property, including their earnings, as if they were *feme sole*, so that they were financially less dependant upon their husbands.

The Matrimonial Causes Act of 1857 permitted a man to divorce his wife for adultery, but the act did not grant her the same privilege, for she had to prove not only her husband's adultery, but that it had been aggravated by incest, rape, sodomy, bestiality, cruelty or desertion for two years; even then the husband could retain custody of the children. In any event the legal costs were beyond the means of most couples. However, an act of 1878 empowered magistrates to legalize a separation on the grounds of violent behaviour or desertion. Yet another break with the past took place in 1885, when the age of consent for a woman was raised from 13 to 16, but the deplorable practice of incest was not outlawed until 1908.

Propertied Women

The above changes in the law were little more than a step in the right direction. In other areas, prior to 1870, nothing changed in that women had little or no say in matters outside the home, except through their menfolk. What women needed was a voice of their own, but it was not until after 1870 that they became increasingly involved in public affairs. This involvement was restricted initially to a minority of upper- and middle-class women who held property, or who owned and ran their own businesses — teashops, restaurants, boarding-houses, hotels, shops, public houses and, in the case of Amy Dillwyn, a spelter works. It may be that most of these women were either spinsters or widows, but what distinguished them from all others was that, as owners of property, they were liable to a tax (rates) for poor relief

and, as ratepayers, they were among the first women to gain a toehold in public affairs.

The Education Act of 1870 provided for the establishment of school boards, which were locally elected bodies empowered to build and administer elementary schools. By this act women were permitted to stand for election to school boards, the most notable candidate being Rose Crawshay who sat on two school boards, one of which she chaired despite the fact that her colleagues were all men. Although, for a decade or so, only three women in Wales actually sat on these boards, the act nevertheless created a precedent; it also proved beneficial for young girls, especially working-class girls, in that it provided them with an education that enabled them, if they so wished, to aspire to better things rather than follow in their mother's footsteps. This was especially so after 1880 when elementary education became compulsory.

Nine years later, the Welsh Intermediate Education Act was passed, which led to the establishment of intermediate schools and, later (in 1902), to secondary schools. It was necessary for girls to pass an examination before progressing to either of these new kind of schools, and although further education of this sort was not free, there was an increasing number of free places allocated to promising young women, many of whom eventually became teachers. The first teacher training college for women had been established (with the help of Rose Crawshay) at Swansea in 1872; three more were established by 1914. With regard to higher education, by 1884 women were being admitted to the three colleges that existed in Wales at that time — Aberystwyth, Cardiff and Bangor. Admittedly, almost all the girls enrolled at these colleges were the daughters of middle- and upper-class families, and many of these young women also became teachers and head teachers, some of whom become ardent feminists and suffragists.

Another door to participation in public affairs was opened when, in 1875, female ratepayers were permitted to vote for and serve as guardians on Poor Law boards, the purpose of which was to oversee the workhouses and care for the destitute. Few women took advantage of this opportunity to prove themselves until, in 1894, the property qualification was removed. The following year almost 90 women were elected to serve as guardians and, 16 years later, the first woman to chair a Poor Law board was elected at Brecon. The records make it clear that, by their efforts, these women made Poor Law arrangements in many areas more humane.

The door to public office opened again in 1894 when propertied women were allowed to vote in and stand for election in parish and district councils. The same privileges were extended to include county council elections in 1907; that same year Amy Dillwyn stood as a candidate in the Swansea County Council election, but failed to win a seat because, according to the *Cambrian Daily Reader*, she was a woman, not a man. The first woman to become a mayor did so at Brecon in 1910. That left only one hurdle to go for properties women — suffrage in Parliamentary elections — and men were not going to agree to that, nor were propertied women in a position to force their hand. They needed the support of their less-privileged sisters so that, together, they could campaign for equality with men.

Unpropertied Women

The middle and upper classes of Wales, both English and Welsh, were settled mainly in the coastal areas of North and South Wales, especially in the towns, the Vale of Glamorgan and certain parts of Monmouthshire. The majority of women within these classes did not own property or have to earn a living, being supported by their husbands or fathers; nor did they have to cook, clean or see to their children, for household chores and childcare were delegated to domestic servants. If they were well-to-do and went away for a few days, they took with them several trunks and large hat boxes, as well as their lady's maid, so that they could change their attire five or six times a day, and no dress would be seen twice during the same weekend.

From the second quarter of the 19th century onwards, life for these women had been made easier still by the adoption of birth control techniques that enabled them to limit the size of their families. Condoms made of animal gut had been available as early as the 16th century (they were used mainly by upper-class men to avoid contracting venereal diseases from prostitutes), but the techniques that were in vogue by 1870 were abstinence, *coitus interruptus* and safe periods.

Educated, and with time on their hands, these unpropertied women often involved themselves in charitable works, or became helpers in male-dominated pressure groups. Women did not begin to organize themselves to promote female-related issues until the late 19th century, and most organizations of this sort had their origin and numerical strength in England. Their presence in Wales was marginal, often confined to the Anglicized or industrial areas — for example, the Women's Co-operative Guild, which campaigned in support of a wide range of female-related issues, was founded in 1883, but its presence in Wales was virtually non-existent until a branch opened in the Rhondda Valley in 1914. However, the one cause that attracted large numbers of Welsh women was temperance; consequently the temperance movement in Wales had a strong Welsh identity.

The first mixed temperance society existed in Wales as early as 1835, but in 1892 several women in North Wales founded *Undeb Dirwestol Merched Gogledd Cymru* (UDMGC) — the North Wales Women's Temperance Union. Four years later the UDMGC could claim 106 branches, most of them in North Wales, but they were also to be found in Liverpool, Manchester, London, Birmingham and other places in England that had large Welsh-speaking communities. Most of the women who joined UDMGC were Welsh middle-class, chapel-goers, many of them the wives of ministers and Liberal MPs. They usually met in chapels, and although they were not politically motivated, they were, nevertheless, encouraged to write, speak publicly, lobby local officials and develop skills in organization — all of which gave them the confidence to voice their opinions about other issues.

A similar union — *Undeb Dirwestol Merched y De* (UDMD) — was set up in South Wales in 1901 by Sarah Jane Rees (1839-1916), better known by her bardic name Cranogwen. Unlike the majority of her co-workers, Cranogwen was neither propertied, nor dependent upon a husband to support her. Born in Llangrannog,

Cardiganshire, she proved sufficiently strong-willed as a girl to insist that she accompanied her father to sea, he being a ship's captain. As a grown woman, tall with a husky voice, she taught navigation and mathematics in Liverpool and London; in 1859 she opened her own school in Llangrannog. She wrote poetry, gave lectures on temperance and was one of the few women in her day to preach. For ten years (1879-89) Cranogwen edited a Welsh-language magazine called *Y Frythones* (The Female Briton). Like the earlier *Y Gymraes* of 1850-2, the aim of her magazine was to create the perfect Welsh woman by promoting the doctrine of separate spheres, Nonconformist religion and the cause of temperance. Her magazine differed from the earlier one in that it espoused women's education, something she believed in

Woman in a tailored suit
c.1900

fervently. After retiring from her editorial role, Cranogwen founded the UDMD and, at the time of her death in 1916, this southern temperance union had 140 branches throughout South Wales. Her dream of founding a home for women who had been charged with drunkenness became a reality in 1922 when, in memory of her, 'Llety Cranogwen' was opened in the Rhondda Valley.

In 1884 the Conservative Party founded the Primrose League, the purpose of which was to recruit mainly middle-class women for fund-raising and canvassing activity; it was certainly not to promote women's suffrage. In Wales, where support for the Conservative Party was never strong, the Primrose League was only active in the coastal areas of North and South Wales. The Liberal Party, on the other hand, had overwhelming support throughout Wales in much the same way as the Labour Party has today. In 1891 the Party began recruiting women for the Welsh Union of Women's Liberal Associations (WUWLA), and these women insisted on a say in matters such as Welsh Home Rule and women's suffrage. By 1895 the WUWLA could boast a membership of about 9,000, but five years later its membership had dropped considerably due to division within the Liberal Party over Home Rule. In 1906 the growing Independent Labour Party (renamed the Labour Party in 1910) formed the Women's Labour League (WLL), which supported issues such as the need for pit-head baths. In 1912 the Labour Party became the first party to support women's suffrage.

Outward Signs of Growing Confidence

There can be no doubt that involvement in the temperance movement and other female associations gave women the confidence to air their views in public. In an address to temperance campaigners in 1900 a Mrs Jacob Jones declared that women had:

> By sheer force of intellect and ability, pushed their way into professions, education, taking university degrees, school boards, Poor Law boards (and local) government appointments.

It was during the 1890s that the growing confidence of the New Woman came to be reflected in her dress. It started with the tailor-made costume, a two-piece suit made by men, using materials similar to those used in the making of men's suits. Initially, the skirt, which might be ankle-length or trailing, and the tight-fitting jacket were worn in conjunction with a blouse that was similar to a man's shirt, complete with stiff collar and tie, although during the Edwardian period (1901-10) the blouse became adorned with lace and embroidery. To complete the picture the hair was drawn up at the back and supported by combs; hats, often wide-brimmed, were secured with long hair-pins. The tailor-made outfit was originally intended for travelling, walking or riding a bicycle, but for professional women such as teachers it sent out a clear message: we are on a par with men.

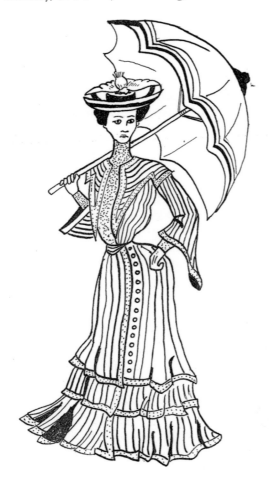

A fashionable lady of the Edwardian period (1901-10)

It should not be overlooked, however, that fashionable Edwardian women had a wide range of ornate, trailing dresses, as well as immense hats adorned with flumes, feathers and artificial fruit. The year 1900 saw the introduction of the famous S-shaped corset which, laced tightly at the waist, forced the bosom forward and the hips back. Over the corset went several petticoats ranging from flannel to silk. Fashionable ladies bought their wardrobes with the pin-money provided by their husbands. In the case of Rose Crawshay this amounted to a staggering £50 a fortnight, more than most working women earned in a year. A

dressmaker, for example, stated in 1909 that she earned between 2s. 6d. and 3s. a day. At that price it is hardly surprising that dressmakers were in such demand by fashion-conscious women who could not afford the luxury of buying new.

Underwear

Until the 19th century the shift (and its replacement the bedgown) was virtually the only item of clothing that women wore next to their skin. Corsets first made their appearance in the 14th century, but were available only to the very rich. Petticoats became fashionable in the 17th century and were available to most women as they were easily made at home. The chemise made its appearance in the 18th century, and below-the-knee bloomers in the early 19th century, the availability of both being restricted to those who could afford them. The Edwardian era (1901-10) witnessed the introduction of not only a variety of new-style corsets, the S-shaped corset being one of them, but also something that had never been worn before — panties. The 'bra' followed in 1912.

Suffragists

Women's suffrage groups existed as early as the 1850s, their objective being that women should be allowed to vote on the same terms as men — not that all adult males had the right to vote. Following the Reform Act of 1884 only propertied males over 21, including working-class householders, had that privilege. The various suffrage groups that existed in England were not a force to be reckoned with until, in 1897, they united to form the National Union of Women's Suffrage Societies (NUWSS), and led by Mrs. Millicent Fawcett the union's aim was to achieve the vote by peaceful means: writing to and lobbying MPs, speaking publicly, distributing literature and taking part in marches on London. Ten years later the NUWSS established its first branch in Wales at Llandudno. The following year an affiliated group, known as the Cardiff and District Women's Suffrage (CDWS), came into existence. By 1913 the NUWSS had set up 28 branches in Wales, the CDWS being the largest in Britain outside London with a membership of 1,200 that same year.

The suffragists within the NUWSS were mainly middle-class women, many of them teachers and head teachers who had benefited from the introduction of inter-mediate and secondary schooling as well as higher education. Opponents to women's suffrage claimed that the movement was alien to Welsh women and that its promotion in Wales was due to resident English middle-class women in the coastal towns and in the Anglicized areas of south-east Wales. The claim has since been discredited; there were many Welsh women involved in the movement, among them the industrialist, Amy Dillwyn, and the wife of a former miner, Mrs. Elizabeth Andrews. The majority of these women were content to use constitutional means to achieve their aim no matter how long it took, but there were some who, frustrated by male opposition, were prepared to adopt militant tactics, and to these the *Daily Mail* applied a term that distinguished them from their constitutional sisters.

Suffragettes

The Women's Social and Political Union (WSPU) originated in England with Mrs. Emmeline Pankhurst in 1903, its aim, initially, to mobilize the public against the Liberal Government, the reason for this being that the suffragettes believed the Conservatives were sure to give some women the vote because the majority of these women were likely to vote for them in future elections. This was not the view of the suffragists, who pinned their hopes on the re-election of the Liberal Party, but when the Liberals were re-elected with a huge majority in 1906 the party proved to be divided over the issue. From then on the suffragettes conducted a campaign of militant activity in order to gain maximum publicity for women's suffrage. Then, in 1912, when the government failed to implement three Conciliation Bills (which were intended to be a compromise whereby some women would be enfranchised) a rift developed between suffragists and suffragettes, the former entering into an alliance with the Labour Party; the latter becoming even more militant, cutting telegraph wires in Cardiff and near Pontypool, planting hoax bombs in Cardiff and Abertillery, and blowing up pillar-boxes in both Cardiff and Bridgend. Those suffragettes who went to prison were prepared to go on hunger strikes. At first the authorities tried to force feed them, but as this could be dangerous to their health the government introduced the Cat and Mouse Act in 1913, which allowed the authorities to release hunger-strikers, then rearrest them when their health improved.

The suffragettes were predominantly upper-middle-class women, and one such woman was Margaret Haig Thomas (1883-1958), the daughter of a Rhondda colliery owner and MP. After marrying the industrialist, Sir Humprey Mackworth, in 1908, Margaret later admitted that she knew nothing about housework and childcare, being dependant on three maids and a cook to attend to the needs of both herself and her husband. She seemed destined to a life of leisure, but it was not to be. In July 1908 she took part in a march on London, which led to her joining the WSPU for which she sold literature, spoke publicly (to be pelted on one occasion with herrings and tomatoes) and jumped on the running board of the Prime Minister's car. Then, in 1913 when she attempted to blow up a pillar-box in Newport, she was imprisoned at Usk where she went on hunger strike until her release under the Cat and Mouse Act.

The WSPU, which was never strong in Wales, established only five branches in the South, four of them in the south-east. This was due to the fact that its members were out of touch with the majority of Welsh people, being hostile towards not only the Liberal Party, but also to the growing Labour Party; moreover, throughout the U.K. the militant activity of its members antagonized both suffragists and pro-suffrage MPs. By 1914 its membership had dropped to the extent that when war seemed imminent the WSPU quickly accepted an amnesty, agreeing to suspend all militant activity. On the one hand the war provided women with the benefits of employment; on the other, it brought hardship and food shortages. It also brought untold grief for the wives, mothers and sisters of the 40,000 Welsh servicemen and the thousands of Welsh seamen who never returned home.

CHAPTER XIII
World War I and the Depression

The First World War

On 4 August 1914 Britain was at war and, straightaway, the well-to-do began cutting back on their expenditure with the result that many women found themselves out of work, or had their hours cut. Among those to suffer most were domestic servants, dressmakers and shop assistants, all of them dependant on the extravagance of people with money — but by the end of September new jobs for women were beginning to reverse the trend as a result of government contracts to provide thousands of blankets, shirts, socks and other articles of clothing for the army.

During the first weeks of war large numbers of men left their jobs to volunteer for service at the front and, in response, several large business in the towns of southeast Wales made provisions to support the wives and children of their absent employees. The government, then, introduced a separation allowance, a proportion of which was deducted from the men's pay. Unfortunately, there were delays in the processing of payments, causing hardship for the families of many servicemen; there were also conditions attached to the payments.

The Defence of the Realm Act (DORA) of 1914 gave a wide range of powers to both civil and military authorities and, in October, the army issued a document known as The Cessation of Separation Allowances to the Unworthy. This required the police to keep an eye on women, especially those who were suspected of drunkenness or immoral liaisons with men. Any woman apprehended on suspicion of unseemly behaviour had her separation allowance discontinued. The move provoked an outcry, so much so that the rules were changed so that only women convicted of drunkenness were penalized. Another breach of civil liberties was that the military had the power to ban certain women from public houses between the hours of 7pm and 6am. The army could also impose a curfew on these women, forbidding them to leave home between 7pm and 8am. Any woman in breach of these restrictions faced a court martial and, in November 1914, five Cardiff women were brought to trial under DORA to be sentenced to two months imprisonment.

The authorities and leading public figures were apparently obsessed with keeping an eye on women while men were away at the front. One clergyman took it upon himself to keep watch on a Cardiff off-licence and counted, in the space of 35

minutes, no less than 115 women leaving the premises with flagons of beer. The authorities were equally concerned about the fact that army camps attracted both prostitutes and local girls with an interest in men in uniform. To deal with these problems and to enforce DORA women were recruited into two organizations. The National Union of Women Workers (WUWW), despite its name, was an organization made up of middle-class volunteers, many of them members of the Cardiff and District Women's Suffragists Society. Unpaid and with only armbands to distinguish them from other members of the public, these women worked in groups, patrolling the streets, parks and docks of large towns such as Cardiff and Swansea, flushing out prostitutes and courting couples from dark places. They had no powers of arrest. Members of the Women's Police Service (WPS), on the other hand, were paid, uniformed officers recruited, initially, from the ranks of suffragettes. They were first employed to patrol the perimeters of army camps to prevent loose women consorting with squaddies and, later became security officers at munition factories.

War had no sooner been declared than upper- and middle-class women were directing their energy onto supporting the war effort in many ways. The various suffrage groups — which already had the necessary organizational skills — were in the forefront, the suffragettes turning their hand to recruitment as well as patrolling army camps. The suffragists directed their efforts into fund raising in support of a variety of causes such as assisting the Belgian refugees (for whom they found accommodation in the towns) and for the Welsh Hospital Unit for Serbia. Other women lent their support to the Red Cross and the St.

Esther, a Swansea woman, with her husband, William, home on leave from the front (c.1916). William, a volunteer, survived the greater part of the war only to die from a gangrenous wound shortly before Armistice Day 1918, leaving Esther to bring up three young sons.

John's Ambulance Brigade, or offered their services as unpaid nurses locally. Some women showed their compassion by forming support groups such as the Swansea Tipperary Club for the benefit of 'the women who wait', and all over Wales women banded together to form knitting or sewing circles to produce socks, scarves and other items of comfort for the men at the front and for those campaigning in the Middle East.

For most women the war meant anxiously waiting for a letter from loved ones, all the while dreading a War Office telegram informing them of the death of a husband or son. For some, such as Mrs. Mary Witts of Newport, those telegrams must have been sole destroying: she lost three sons, all of them before 1917. Even when loved ones returned home wounded, the shock of seeing them helpless and with horrific injuries must have been heart-rendering, as would the burden of nursing these men for the rest of their lives. For some women the waiting never ceased. 'Missing in action' — the words would haunt them for evermore. For a few there might be relief when a son, after deserting, returned home, but relief soon give way to fear, their hearts thumping each time they answered the door. One woman, overcome by the sight of a police uniform, leapt on the back of a constable, hitting him as he tried to arrest her son. She was lucky — she was fined — prison awaited the less fortunate.

Employment

With more and more men enlisting in the armed forces it became necessary for women to step into the breach and, in March 1915, they were called upon to register at local labour exchanges, the intention being that they should take the place of men who had volunteered to serve in the forces. The prospect of having women doing jobs reserved for men met with little enthusiasm at first. Nevertheless, women were taken on as clerks, bookkeepers, librarians and shop assistants in grocery stores and shoe shops, occupations that had all formerly been reserved for men. They were soon driving delivery vans as well, and in Cardiff they even became taxi-drivers. In the spring of 1915 the Cardiff Tramway Corporation made known its intention to employ women as conductresses, only to meet with stiff opposition from the men, but by November that year there were 60 conductresses in the Corporation's employ. The following year women became tram drivers. Much the same happened in Swansea and the Rhondda Valley. The Post Office also took on large numbers of women, and by the summer of 1915 they were serving as telephone and telegraph operators, as post-women, collecting, sorting and delivering the mail. It is not necessary to list all the replacement occupations taken up by women; suffice to say that after the introduction of conscription in January 1916 more and more women became part of the country's workforce. The majority of these women were working-class girls. It is unlikely that their wages were on a par with those of men, but they were certainly far better than in domestic service and other female-related occupations.

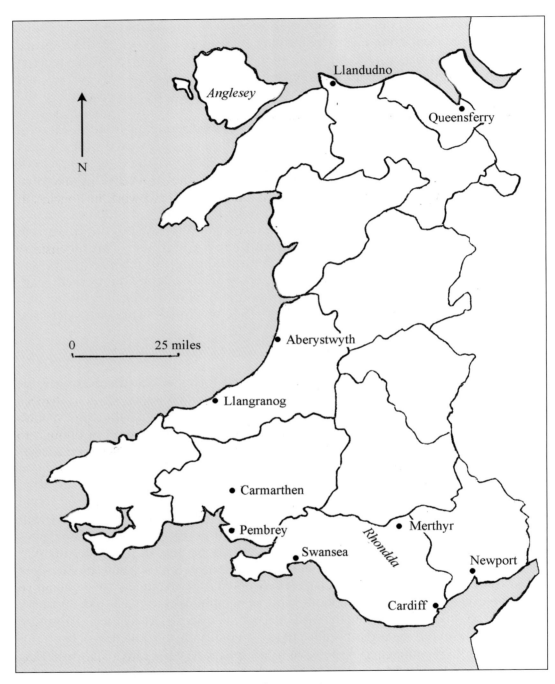

Wales c.*1900*

Munitionettes

From 1915 onwards thousands of working-class women, most of them young and unmarried, were employed in the dozen of so munition factories that were established in Wales. Most of these factories were set up for the purpose of producing shell casings, but two — Queensferry, near Chester, and Pembrey, near Llanelli — were for manufacturing high explosives and filling the shell casings that had been made elsewhere. It has been estimated that at the latter two factories between 70% and 80% of the production staff were women. There are no figures as to how many munitionettes were employed in Wales at any given time, but it has been estimated that some '5,000 women and girls [were] engaged in munition production in South Wales' by May 1916; moreover, an unknown number of Welsh munitionettes found work in England as well, notably in Coventry and Woolwich.

Employment in the explosive factories was considered rewarding with regards to pay, camaraderie and emancipation, but the work could be dangerous. At Queensferry 12,778 accidents occurred during the last two years of the war, 3,813 of which were recorded as acid burns and 2,128 as eye injuries; there were also 763 cases of industrial dermatitis. Surprisingly, there were only four fatalities throughout the factory's existence. At Pembrey, 'the vast arsenal on the dunes', an explosion killed two young Swansea munitionettes in the summer of 1917. One of the girls had a military-style funeral, the coffin draped in the Union Jack, the horse-drawn hearse escorted by a squad of munitionettes in their protective clothing. Traffic in the town had to be diverted as the streets were lined by thousands who wished to pay their respects. Yet despite incidents such as this the muntionettes came in for a great deal of criticism for spending their earnings on cigarettes, make-up, fur coats and 'a good night out with the girls' — and if shameful behaviour and unbridled freedom were not enough to raise an eyebrow, then the bare knees of female footballers must have been an eye-opener for many a man.

Food Shortages

With war went spiralling prices, food shortages and queuing, particularly in the towns where bread, potatoes, tea, sugar, milk, meat, eggs and butter were in short supply. The main cause of the problem was the German U-boats that, by the spring of 1917, were inflicting heavy losses on merchant shipping. The problem was exacerbated by the severe winter of 1916-17, which had a devastating effect on potato crops, so much so that in March women were involved in riotous behaviour in a Caernafon shop, fighting over two sacks of potatoes; in Wrexham they converged on the town square to assail a cartload of potatoes. In South Wales there was talk of famine.

In June, a Welshman, D.A. Thomas (father of the suffragette, Margaret Haig Thomas), was appointed Minister of Food, and his first priority was to bring down the price of bread, which had risen from 5d. in 1914 to 12d. at the time of his appointment; he reduced the price of a loaf to 9d. He also introduced rationing. These measures may appear to have been late in coming, but at an early stage in the war

people were encouraged to grow vegetables in their gardens or on allotments, either individually or in groups. One of the most successful groups to improve food production was the Women's Institute (WI), an organization of Canadian origin. The first branch of the WI in Wales was set up in Llanfairpwllgwyngyll, Anglesey, in 1915, from whence it spread throughout the United Kingdom.

The introduction of conscription in 1916 led to a shortage of agricultural labourers and, to counter this, the government set up the Women's Land Army (WLA). At first Welsh farmers were reluctant to employ women, many of whom they considered to be middle-class townees. Nevertheless, in 1917 hundreds of WLA women took up milking, ploughing, lifting potatoes, cleaning out cowsheds and carrying out a host of other backbreaking tasks, and did so for board, lodge and 12d. a day. Smaller numbers joined the Women's Forestry Corps to plant and fell trees.

Women in Uniform

At the beginning of the war women from all over the U.K. were recruited into the Queen Alexandra's Imperial Military Nursing Service and the Territorial Nursing Service to serve wherever the British army confronted enemy forces. They also volunteered to serve as ambulance drivers in the First Aid Nursing Yeomanry, and as nurses in the Voluntary Aid Detachments. Among the organizations that had a strong Welsh influence and were to be found outside Wales, was the Welsh Hospital at Netley in Hampshire. Supported by charitable organizations within Wales, Netley was a unit staffed by Welsh women for the benefit of Welsh soldiers. A similar creation was the Welsh Hospital for Serbia, a 200-bed unit, staffed entirely by women, for the benefit of Serbian troops.

One of the first women to head a government department was the Welsh suffragette, Mrs. Margaret Haig Mackworth (née Thomas). Early in 1917 she became Director of the Women's Department of the Ministry of National Service. Apart from her commitment to the Women's Land Army, Margaret recruited for the Women's Army Auxiliary Corps (WAAC) and the Women's Royal Naval Service (WRNS). The first contingent of some 50 Welsh WAACs left for France in June 1917 to serve mainly as clerks and drivers. The following year the Women's Royal Air Force (WRAF) came into existence. The first WRAF commandant, Violet Douglas-Pennant (Lady Anglesey) found her male colleagues obstructive to the point that she was obliged to resign, to be replaced by another Welshwomen, Helen Gwynne-Vaughan.

A Limited Victory for Women's Suffrage

The Representation of the People Act, which came into effect on 6 February 1918, gave the right to vote in Parliamentary elections to all men over 21, and to all women over 30 providing they were married or, if single, occupied two rooms and owned furniture. The act also gave married women the right to vote in municipal elections. It has often been said that women were given limited suffrage as a reward for services rendered during the war, and while there is an element of truth in this, the

concessions were in fact the culmination of over 60 years of campaigning. In November that year some six million women had the right to vote in a general election. They could even stand as members of Parliament, though only Christabel Pankhurst, the daughter of Emmeline, actually did so: she stood as the Women's Party candidate in Smethwick, but was defeated by a Labour candidate.

Peace

Some Welsh women were against the war for personal reasons, having lost loved ones. Others were members of organizations that adopted an anti-war stance, the Women's Co-operative Guild being one of them, and there are hints that, between 1915 and 1917, about 50 women belonged to a Cardiff branch of the Women's International League for Peace and Freedom. Peace came late in 1918, bringing relief to millions, but if women thought they were about to witness the dawn of a new age, one in which they would retain their position with regard to employment, they were in for a rude surprise.

Mass Unemployment for Women

Even before the Armistice, Welsh munitionettes in England were being laid off, each with two weeks' wages and rail a warrant to get them home. By January 1919 half the munition factories in Wales had closed. In one sense the munitionettes were lucky: they were entitled to claim out-of-work donations of 25s. a week for 13 weeks, but to qualify they had to report to their local labour exchange every day. If they were offered work — which invariably meant domestic service — and they refused to take it, they forfeited their donations. The press, which during the war had praised them, now labelled them as 'slackers with state pay'. The *Western Mail*, for example, in commenting on the thousands of munitionettes who had returned to South Wales from English-based factories, stated that

> these women war workers were, prior to 1914, either employed in domestic service, or were at home with their parents ... Now they have returned [home] and claimed the donations ... they must realize that domestic service ... must again be their main source of livelihood, that is if they want to do anything at all. Seaside places and other holiday centres throughout the country are said to be now reaping a harvest from young women who are out for a good time on their savings as munition workers, and their donations.

In the private sector women were expected to give up their war-time jobs to demobbed servicemen. If they did not, then the Restoration of Pre-War Practices Act of 1918 was intended to settle the matter once and for all; added to which thousands of civil servants were being thrown out of work. By March 1919 about 500,000 women in Britain were officially unemployed, though not everyone agreed with government figures. In a letter to the *Daily News*, dated 15 February 1919, Mrs. Margaret Haig Mackworth (née Thomas) stated:

There are over half a million women workers at present receiving unemployment allowances, and there are probably an additional million of industrial women at present out of employment.

Domestic Service

The consensus among government officials and middle-class householders was that the only suitable work for working-class girls was domestic service. The problem was that, initially, working-class women who had received good wages during the war had no wish to return to the long hours, the humiliation and the pittance that domestic service offered. The wages of a servant could be as low as 7s. a week (35p. in today's currency), which did not compare favourably with the 25s. out-of-work donation let alone a living wage. This was not, however, the view expressed by a reader of the *Western Mail* who, in March 1919,

> advertised for a domestic help in a Cardiff evening paper for 6 days, specifying any requirement as to expertise, etc., but with no response whatsoever. I find that I am by no means the only 'sufferer' in this respect ... It seems evident that most of the 2,000 women in Cardiff now in receipt of the unemployment donation prefer to remain as they are.

Necessity, however, soon forced many young women to accept what they loathed, rather than be a burden to their families. Others simply saw the futility of continuing to register as unemployed when there was no alternative employment on offer. Consequently, by November the number of women in Britain who continued to register had fallen to 90,000, a third of whom were receiving donations. There are no unemployment figures for Wales, but by 1921 only 21% of the women living within the Principality were in employment, whereas in England the percentage was much higher; moreover, more than a third of working women in Wales were employed in domestic service. This assessment, however, does not take into account the tens of thousands of young women who left Wales for service in the more prosperous parts of England. One migrant domestic from Maerdy recalled that, on her arrival at a house in Croydon, her employer

> took me to my bedroom which was right up in the attic and told me to change into my afternoon uniform and to come down and make tea. Well, if I hadn't been to this training centre, I wouldn't know the difference between afternoon tea and high tea, because we didn't have that kind of thing at home...They [the family] were supposed to be very religious people and I suppose they were. Anyway, evening times we used to have a cooked meal and I would take my place and have whatever was going. I never really had enough, you know, but I would never ask for more. I was too frightened to ask for more ... I didn't feel I was part of the family at all ... they didn't converse with me at all, and when they did it was just to run the Welsh down ... You wouldn't say they were gentry because I met gentry after that and I found that they were far better, nicer people than they were.

The migration may have started as a trickle, but by 1928 the government's Industrial Transference Board was actively encouraging Welsh girls as young as 14 to take up employment in England. Some of these young women found employment in good homes, being integrated to some extent into the families of those they served. Other were not so lucky, being turned away for no good reason, or found themselves in situations that were intolerable. One Rhondda girl who had gone to a London address recalled that

> At one place I was only there one night ... when I went to bed I lit the candle and oh my goodness I picked up the pillow like that and without a word of a lie they [the bugs] were scattering ... I couldn't sleep on the bed so I spent the night on the boards ... I left that place and went to my brother's ... until all these [lumps] had cleared ... but then I went from the frying pan into the fire ... [In my next place of employment] I was starved to death there. She [her employer] locked everything up and ... for my dinner every day I had half a bag of potato crisps for 3 weeks ... and yet I was cooking for them, but being ... slow, I suppose, in those days I wouldn't think of taking anything ... She [her employer] said her daughter was dieting ... and she wouldn't diet if I ate.

Welsh girls were naïve and, therefore, in danger of being lured into the homes of lecherous men, or enticed into prostitution by pimps waiting for them at Paddington Station. The National Vigilance Association (NVA) in London and elsewhere saved many a Welsh girl from the clutches of exploitative families and unscrupulous men, watching out for them at stations and escorting them to the homes of their new employers. Insight into the work of the NVA can be gleaned from the Association's journal, the *Vigilance Record*, which drew attention, in 1930, to

> the very significant and disturbing migration, which has been in progress for some years past, of Welsh girls coming to London to take up employment ... [and] any visit to Paddington Station when the excursion train comes in will convince any of our readers [of the facts] ... but clearly there should be some limit of age ... The NVA, apart from its station work ... lays stress on two points. Firstly girls coming to London should assure themselves beforehand that the situation to which they are proceeding is a safe and desirable one; second ... it is desirable that ... social workers should do something more than offer [advice]. Personal contact should be established by means of friendly visits. We have made enquiries for many years past, and an experiment in the manner of paying visits is now in process, since the names and addresses of a number of such girls are regularly given to the Central Council for the Social Welfare of Girls and Women in London, and [to] the London Welsh Girls Friendly Aid Society.

Professional Women

The migration of thousands of young Welsh girls to the more prosperous parts of England was due mainly to the Depression, which hit Wales hard. There were simply not enough jobs for men let alone women who, according to the doctrine of separate spheres, should busy themselves in the home — theirs, or as servants in someone else's home. The Depression, in fact, made it easy for men to exclude women from

anything that might be regarded as a male preserve, which they did on the ground that it was wrong to employ women when so many men were unemployed. Nowhere is subordination to the economic requirements of men more apparent than in the case of professional women. The war had given women cause to have high expectations for the future; this was particularly so in 1919 when the government passed the Sex Disqualification (Removal) Act, which opened up the professions to aspiring young women. The act stated that

> A person shall not be disqualified by sex or marriage from the exercise of any public function, or from being appointed to or holding any civil or judicial office or post, or from ... any civil profession or vocation.

Fine words, but by 1922 recession had led to the introduction of marriage bars, which resulted in married women losing their jobs. The majority of professional women, for example, were teachers and, despite their salaries being about 20% less than their male counterparts, they could claim to be well paid when their salaries are compared to the pittance that most working women received. By 1926 the vast majority of women teachers were single; if any of them married, the chances were they would be forced to resign. This waste of talent was to be found in the nursing profession as well, only here it was not a matter of replacing them with men, but a way of ensuring that their place as married women was in the home.

The Depression

By 1920 coal exports were falling because 'steamship companies ...[were] steadily adopting oil fuel', but more so because British coal was uncompetitive. This was certainly the case in South Wales where geological difficulties made mining expensive. In an attempt to bring costs down coal owners throughout the UK threatened that, unless the miners accepted lower wages, they would not employ them. This led to the 1921 lock-out, which lasted three months and resulted in the miners submitting to the coal owners' demands. Even then the recession worsened, effecting almost all industries, including agriculture, so much so that by 1925 the unemployment rate in Wales had risen to 13.4%.

That same year the coal owners demanded that the miners accepted further cuts in pay, and that an extra hour should be added to their seven-hour shifts. Miners who refused to accept these terms were locked out on 30 April 1926. Three days later the TUC called a General Strike, and for nine days the whole country came to standstill. The TUC, then, lost its nerve and called off the strike, leaving the miners to fend for themselves. By October the miners' situation had become desperate. That same month some 500 men and women attacked a lorry conveying blacklegs to a colliery near Cymmer. Of the 39 people charged, 16 were women, all of whom were fined. One woman refused to pay the fine and was imprisoned instead. There were several other incidents in which women were involved, but with the approach of winter, starvation forced the miners to capitulate, though not all of them returned to work. Many

were not re-employed because they had been active during the lock-out, or because their pits never reopened.

The situation worsened; unemployment soared as more and more steel works and collieries were shut down. There were hunger marches. There were problems, too, with blacklegs and the creation of company unions, all of which caused resentment and strife within families as well as communities. People refused to speak to those who were labelled blacklegs, other than to call them 'scabs'; nor would they have anything to do with a blackleg's family. Sometimes the blacklegs had to rely on police escorts to get them to work; even then they were likely to be stoned.

In 1931 the government introduced the hated Means Test, which meant that anyone who had been unemployed for more than six months had to declare his financial situation and that of everyone in his household. The following year employment in Wales rose to a staggering 36.5%; in steel producing towns such as Dowlais it rose to an unbelievable 73.4%. Then, in 1934, the government proposed to reduce benefits, causing widespread concern, so much so that on Sunday 3 February 1935, 300,000 people in the South Wales Coalfield gathered in their Sunday best to protest. The following day 1,000 women joined with 2,000 men and marched on the Unemployment Assistance Board's office at Is-coed House in Merthyr. One demonstrator recalled that

> when they were all crowded there the actual gate of Is-coed House gave in and they started moving in ... Well, when we got in the garden somebody threw a stone, through the window, you know; that started it off ... some clerks upstairs had been making faces at us ... and there were stones flying from all directions ... well, they smashed all the windows ... And the police came there, but were helpless ... [The demonstrators] went inside, through the windows; they pulled the stairs away, ripped [out] everything, all the fittings, phone[s] ... and tried to burn the papers there ... [Several men called for calm, but the crowd] wouldn't have it, the only ones who could speak were the [the leaders] Jack Williams and [a women, Ceridwen] Brown from Aberdare.

The following day the government announced that it would put the benefit cuts on hold.

Migration

Not all Welsh people were prepared to sit out the Depression in the hope that things would change. The migration of Welsh domestics to the more affluent parts of England was part of a much larger exodus from Wales during the inter-war years of an estimated 430,000 people — one fifth of the population. The migrants, who were mostly young and from the Valleys, settled mainly in south-east England and the Midlands, starting life anew in places such as Oxford, Coventry, Hounslow and Dagenham; the rest emigrated to the USA and the Dominions. Those who remained endured a life of deprivation.

Survival — the Housewife's Nightmare

If things were hard for families existing on benefit, they could be almost as difficult for families in which the husband was employed. Wages were unbelievably low and many worked only a short week. In either event it was *mam* who had to manage the household finances, meagre though they were. According to a report published in 1929, her choice of food — which had to be cheap and filling — provided a diet

> little beyond white bread, butter or margarine, potatoes, sugar, jam, tea and bacon in limited quantity. Meat was seldom eaten except in very small amounts on Sundays ... Fresh milk was not seen ... except when supplied from a welfare clinic, the usual milk being skimmed condensed.

Purchases might be supplemented by produce grown in gardens or on allotments, by queuing at soup kitchens and by school meals. Even then there was not enough, for not only was there 'an increase in the occurrence of rickets', but according to one Eli Ginsburg

> The children are hungry, the men are hungry, but most hungry of all are the women who deprived themselves so that their husbands and children can eat a little more.

Mam might supplement her meagre finances by reclaiming the ½d deposit on jam jars. She might approach others who were not so hard hit by the Depression to clean, to take in sewing or washing, or 'paper a house through for half a crown'. She might leave the house with other members of her family to scavenge the tips for coal, despite the risk of prosecution — or worse. The Communist journal, the *Rhondda Vanguard*, published an article in 1936 about how 'they die to give their children warmth'. The article stated that 'every day [there were] fresh reports of deaths and accidents in the search for coal on Death-tips'. There was also the risk to health in the damp, overcrowded homes which, apart from the installation of a tap, had changed little since the previous century because it was said, in 1927, by one Marion Philips that:

> In the wretched houses clustered round the silent pit-head, children are being born in houses which have been stripped of every saleable luxury [often on the instructions of the Means Test officials]. The mothers are ill-nourished and living in continuous anxiety and face childbirth without any of the care and comfort they need.

With members of the family wearing 'shabby outer garments and worn-out boots' it is hardly surprising that the Pilgrim Trust reported in 1938 that many women had 'lost all pride in personal appearance and in the appearance of their home', and that their 'outings extended little beyond the small shops at the corner of the street'. There were, however, some women who insisted that a woman's lot should change.

Elizabeth Andrews

While some women concentrated on issues relating to equality with men, others directed their efforts towards improving the lot of their working-class sisters, and one such woman was Mrs. Elizabeth Andrews, born at Hirwaun, Brecknockshire, in 1882. In her autobiography *A Woman's Work is Never Done* (post-1948), Elizabeth gives a noteworthy account of what life was like for a working-class young woman at the turn of the century. She refers to herself as the third eldest of eleven children. Both her parents were devout Christians, members of a Welsh Wesleyan chapel. Her father, Samuel Smith, a miner, had survived a pit explosion only to die many years later of silicosis, as did two of her brothers. Her mother, Charlotte, had been one of five sisters, all of whom had been forced into domestic service at an early age following the death of their mother. Despite eleven pregnancies, Charlotte lived to the ripe old age of 86.

A bright girl, Elizabeth loved school where, once a year, she sat an examination — 'a day of all days' as she recalled, one in which she walked to school dressed in a black and grey-striped frock, a brown holland pinafore and nailed boots. As the eldest daughter in a family consisting of a mother, three miners and six children attending school, Elizabeth had little time for play, being too busy assisting her mother in endless chores. 'There was little chance of play after school', she wrote, 'unless I had a baby in my arms'. At the age of 12 she 'had to leave school owing to ... the coming ninth baby', which died when only a few weeks old. Elizabeth returned to school for another year, but her dream of becoming a teacher came to nought because her 'parents could not afford the train fare to travel to Aberdare for higher education'.

Elizabeth was terrified that one day she would have to work in the local brick-works or colliery screens, but fortunately for her she was sent, at 17, to learn dress-making for 12 months, paying 10s. a quarter for her training. As a qualified dress-maker she travelled about her locality, earning between 1s. 6d. to 2s. a day, plus meals, and carrying her sewing machine wherever she went. Elizabeth, however, was no ordinary girl: at 19 she 'launched out with [her] own workroom and had two apprentices'. Then, at 23, she 'left home to take charge of a workroom in a shop at Llanwrtyd Wells' where, apart from living in and having her clothes at cost price, she received a salary of £30 a year. She, then, moved to larger premises in Ystrad Rhondda to earn £40 a year (on top of living in and having her clothes at cost price) for which she 'had to work sixty-eight hours a week', the shop open until midnight on Saturdays.

At Ystrad Rhondda she became 'keenly interested in politics'; it was also where she met and married (at 27) Thomas T. Andrews, a former miner who worked in insurance and actively supported the Independent Labour Party. Her marriage to Thomas turned out to be a 'real partnership', for in later life she dedicated her book

To the memory of my husband whose devoted partnership and encouragement meant so much to me in all my public life.

Soon after her marriage, Elizabeth became involved in the Women's Co-operative Guild, the objectives of which were to promote co-operation among women, to encourage participation in trade unionism, and to campaign for divorce law reform, improved maternity grants and equal pay for women. In 1914 she became Secretary of the Guild's Rhondda branch, the first to be set up in Wales; she also became a suffragist and a member of the Labour Party. Her involvement in women's issues are well documented — for instance, maternal mortality in Britain had been cause for concern long before the First World War. This was especially so in Wales where death caused by puerperal fever was alarmingly high. In 1918, at the instigation of D.A. Thomas (Lord Rhondda), the government passed the Maternal and Child Welfare Act, which gave local authorities the power to provide health visitors and infant welfare clinics. Even then it took women such as Elizabeth to prompt local authorities into implementing the act. She wrote to all the local councils in Wales; later she wrote

> Our letters were quite courteous and businesslike, but one County M.O.H referred to them as 'wild hysterical effusion' and falling back on a scriptural phraseology, said the Council must be charitable to such people 'as they know not what they are talking about'. In another county we were called a 'lot of interfering busybodies'.

Insufficient and deplorable housing was another cause close to Elizabeth's heart. In 1919, when she gave evidence before the Sankey Commission, Elizabeth stated that:

> Women acquiesce in bad housing in Wales because they have no alternative, under the present circumstances, due to the extreme shortage of houses, a shortage which was very acute in industrial areas long before the war.

Pit-head baths was yet another important issue to Elizabeth. When giving evidence before the same commission, she argued that:

> Pithead baths would reduce the physical strain on the mother caused through lifting heavy tubs and boilers. A midwife of twenty-three years' experience in the same district in Rhondda stated to me that the majority of cases she had had of premature births and extreme female ailments are due to the physical strain of lifting tubs and boilers in their homes.

The campaigns relating to the above issues were all ongoing, sustained by countless women who, like Elizabeth Andrews, were prepared to challenge blinkered men in high places. Condoms, for example, were widely available in the 1930s and there was an increase in illegal abortions, both of which contributed to a substantial fall in the birth rate, but the government's Memorandum 153/MCW of 1930 — which permitted local authorities to set up birth control advice clinics for married women 'in cases of dire necessity — met with sustained opposition from religious institutions and medical officers of health. Despite the damage that repeated pregnancies did to health and the appalling conditions brought about by the Depression, it was not considered right for women to limit the size of their families.

In March 1919, Elizabeth was appointed Labour Party Woman Organizer for Wales, a position she held until 1948. The appointment led to her involvement in a host of social issues, to her travelling about both England and Wales, addressing public meetings, to assisting in by-elections and supporting the miners and their families during strikes and lock outs; all this in addition to her duties as a magistrate.

Changes in the Law

The Divorce Reform Act of 1923 gave women the right to divorce on the same grounds as men. Margaret Haig Mackworth (Lady Rhondda) was one of the first to take advantage of this change in the law, but the cost of such an undertaking was beyond the means of most women, added to which the guilt of one partner had still to be proved, and both parties had to agree to the divorce. Provisions for lowering the cost of legal proceedings were incorporated in the Divorce of Act of 1937; the same act added habitual drunkenness and insanity as grounds for divorce. In 1925 women gained the right to claim guardianship of their children in a manner that was comparable to men; that same year widows had the right to a pension. Two years later a child could be legitimized by marriage to the father. Finally, the Age of Marriage Act of 1929 fixed the minimum age for marriage at 16 for both sexes, though marriages at such a tender age were very infrequent.

Courtship and Marriage

It is likely that, during the Depression, courting in rural areas continued in the time-honoured way, the young man spending his evenings in the kitchen of his sweetheart's home; bundling may even have survived in certain parts. In the towns it had become increasingly popular for young people to indulge in what was known as the 'monkey walk'. In places such as Swansea it was common for working-class boys and girls to congregate on Sunday evenings to walk up and down certain streets in small groups. If the boys passed anyone they 'fancied', they whistled and, if the girls turned, hurled a few witticisms. Then both parties walked on until, passing by again, a conversation might lead to time spent in the nearest café, where arrangements were made to meet again, often as a foursome. On their first date the boys would turn up with their boots polished, the girls in their best outfits. They might walk and talk in the time-honoured way, or the girls might be treated to the pictures, but they would have to be home by 10 or 10.30pm at the latest. There was no thought of going to a pub.

From the early 1930s onwards, dancing became popular in church and village halls, where girls sat on one side of the dance floor, the boys on the other, including regular boyfriends. Strange though it may seem, it was the girls who did most of the dancing; the boys simply watched. If, however, a boy plucked up the courage to cross the dance floor, then heaven help him if the girl he singled out refused to dance: he had to return across the floor in full view of his jeering mates.

It has been said that, in those days, boys classified girls according to whether they were marriage material, or whether they were good for nothing else but sex. Girls, on

the other hand, are said to have been totally committed to talking, reading and dreaming about men — possibly a man's assumption — but girls did apparently have illusions about the perfect man, whom they modelled on film stars such as Valentino. Boys, or course, were usually all talk, some of them past-masters at boasting about their sexual exploits, which may have been pure fantasy on their part as couples were all too often sexually inexperienced on marriage. It was a terrible shame for a girl to become pregnant out of wedlock.

Upper- and middle-class girls were likely to meet male members of their class more formally, often on a one-to-one basis rather than be approached by work or street orientated gangs. A date for these girls might entail a visit to the theatre, a game of tennis, or a ride in a motor car. Engagements were pretty much the same for all, irrespective of class, and lasted for about a year or more; engagement rings became obligatory in the early 20th century.

Most of what we now regard as features of a traditional wedding — the giving away of the bride, the veil, top hats and tails, rice, receptions and honeymoons — originated among the Victorian upper class, but in the early 1930s the upper class introduced the most important feature of all — the white bridal gown (previously the bride had worn a new or best dress). The upper class also led the return to church weddings by banns. When the couple left the church they would find the bridal car festooned with ribbons and old boots, the latter originally a symbol of male domination.

All these features were emulated by the lower orders, as far as their finances would allow, and it became increasingly popular to have receptions at hotels, clubs and cafés — but for most working-class couples the wedding was usually a small affair, the number of guests limited by the size of the home in which the reception would be held. Gifts, however, came from a wider circle of relatives, friends, neighbours and work-mates, a survival perhaps of the bidding. Should the couple honeymoon, even if only for a day at the seaside, it was customary to 'see them off' at the railway station. The male guests then made their way to a pub.

Feminism and Politics

Militant groups such as the WSPU did not survive the war, but former suffragettes such as Margaret Haig Mackworth were natural leaders with a flare for grabbing the head-lines. Before his death in 1918, Margaret's father, D.A. Thomas, had been awarded the title of Lord Rhondda for services rendered during the war. This title passed by special remainder to Margaret who, as Lady Rhondda, tried to take her place in the House of Lords. When refused entry, Margaret engaged in a high profile campaign and would have succeeded in taking her seat but for the underhanded tactics of the lord chan-cellor. In 1920, Margaret founded and later edited the feminist journal, *Time and Tide*, which carried articles ranging from birth control to Stalinist repression in Republican Spain. The following year she established the Six Point Group, the aims of which were pensions for widows, equal right of guardianships, reforming the law relating to child

abuse, equal pay for teachers, reforming the law concerning unmarried mothers and equal pay for women in the civil service.

A few branches of the more moderate NUWSS survived in the post-war era. With partial women's suffrage achieved in 1918, this particular group changed its name to the National Union of Societies for Equal Citizenship; as such it soldiered on until the Equal Franchise Act of 1928 allowed women over 21 the same right to vote as men. Throughout the inter-war period the suffragists, like their suffragette sisters, continued to involve themselves in a wide range of feminist and non-feminist issues, including world peace.

The Eligibility Act of 1918 permitted women over 21 to stand in general elections even though, at the time, they were not permitted to vote until they were over 30. Professor Millicent Mackenzie of Cardiff was the only woman in Wales to stand in the general election of December 1919. Like those who followed her example in the general elections of 1922, 1923 and 1924, Millicent had little hope of winning what was considered a safe opposition seat. Then, in the general election of 1929, two Welsh women were elected to Parliament. As a Conservative candidate Edith Picton-Turberville of Ewenny Priory won a Shropshire constituency. As a reformer of women's legal rights, Edith earned widespread respect for her Sentence of Death (Expectant Mothers) Bill, which effectively put an end to the practice of sentencing pregnant women to death, thereby reviving an old Welsh law that forbade two lives being taken for one crime.

The other successful candidate in 1929 was Megan Lloyd George (1902-66), daughter of the great statesman, David Lloyd George. As a Liberal candidate, Megan won Anglesey with a massive majority and, in her maiden speech the following year, she drew attention to the fact that, in her constituency, the death rate from tuberculosis among women was the second highest in the whole of England and Wales; she said, 'The greater risk to health was for the woman who spent the greater part of her life in those squalid, dark, ill-ventilated cottages'. Megan held onto her seat for 22 years before losing it in 1951 to a Labour opponent. In all that time she proved herself to be an 'electrifying' public speaker, a staunch feminist, a committed radical and an ardent Nationalist, believing that Wales should have its own Parliament. Then, in 1955, when the Liberal Party was at an all-time low and moving 'to the right', Megan joined the Labour Party, being persuaded to do so by the party's leading MPs, all of whom had a high regard for her. Two years later she became MP for Carmarthen, a seat she held until her death from cancer in 1966.

Benefits but No Change

In looking back over the inter-war years, the women of Wales could take pleasure from the fact that they had attained the parliamentary vote on the same terms as men, even though only two of them made it to the House of Commons. They had seen welcome changes, too, in the law relating to divorce, as well as equal right to the guardianship of children. Women had certainly established themselves in the professions, albeit at

the cost of becoming spinsters. Those who moved about in the world of politics and the professions continued to favour wearing suits, the skirts falling to just below the knees. They wore their hair in a bob, hats being indispensable, their fur coats a symbol of their success and respectability.

Working-class women, on the other hand, witnessed little change to their existence. Most young women still had to settle for jobs that entailed long hours for little remuneration. Growing numbers became shop assistants, clerks and typists, but their pay was likewise small. When they married there was virtually no hope of a job, just endless drudgery in damp, overcrowded houses, surrounded by children, prisoners to the doctrine of separate spheres. Yet these women were surprisingly loyal to their menfolk, devoted to their families and dependant on their communities in times of need, which may have been the case throughout the ages.

Life was made harder by the Depression, of which there seemed no end until, in 1938, a few factories came to Wales, as did Woolworth, Marks and Spencer and, at Bridgend, work started on what was to be the largest ordnance factory in Britain. By then rumours of war were rife.

CHAPTER XIV
War and the Welfare State

The wireless brought pleasure into the often drab lives of women during the Depression, but on Sunday 3 September 1939 they heard Chamberlain announce, 'We are now at war with Germany', and once again domestic servants and fashion shop assistants found themselves out of work. Numerous women volunteered for war work, but were told their services would not be required until a later date. In fact the British Government did little to involve large numbers of women in the war effort until the spring of 1941; even then progress was slow, so much so that Megan Lloyd George criticized the government for dragging its heels.

> 'Women', she said, 'have been registered for months past and are still without work. They finally lost heart because they felt there was no place for them in the war machine ... It makes one despair a little to think that we have again to go through the dreary process of convincing employers and managers that women are capable of doing skilled work'.

Volunteers for the War Effort

Despite the government's procrastination, woman in the early days of the war found numerous ways to contribute to the war effort. For a start, conscription for men had been introduced in 1939, with the result that increasing numbers of women took up employment as shop assistants, van drivers, conductresses, brewery workers, railway employees and telephone engineers. Women also served as fire-fighters in the Women's Auxiliary Fire Service. In some Welsh counties small numbers of women were already serving in the Women's Auxiliary Police Corps (WAPC) by 1940; in other counties and boroughs women were taken on as clerks and telephonists, but police chiefs in these constabularies were determined not to have women out on the beat. Not until 1944, when the Home Office insisted that female police officers should patrol in the vicinity of army camps, did chauvinistic police chiefs give in.

Women with nursing qualifications joined the Queen Alexandra Imperial Military Nursing Reserve and other related organizations to serve in all theatres of the war, where they risked bombing and capture by enemy forces, especially in Normandy where some of them landed on D-day plus one. Even in the UK, Welsh

A Swansea conductress

nurses risked injury and death during the blitz of 1941 when both the Cardiff Royal Infirmary and the Swansea General Hospital were bombed. Many Welsh nurses were employed in hospitals in London and the Home Counties where bombing and doodlebug attacks were a common occurrence.

Founded in 1938, the Women's Voluntary Service (WVS) became the largest and best-known organization in which women did a wide variety of usually unpaid work. In their green uniforms they served as ambulance drivers, assisted in hospitals, dealt with evacuation, organized leisure activities, canteens and air raid precautions (ARP), collected scrap metal, raised funds and attended to seamen whose ships had been sunk — the list is endless. Other opportunities to serve one's country were to be found in Civil Defence and the National Army and Air Force Institutes (NAAFI), which provided canteens wherever troops were stationed.

Munitionettes

There were many factories in Wales where large numbers of women were employed to produce war material, ranging from jerry cans to seaplanes. At Broughton, near Chester, in North Wales, they made Wellington bombers — 5,540 of them during the course of the war, but the biggest demand for women came in the summer of 1941 when the government appealed for women to become munitionettes or join the armed forces. An example of their appeal appeared in several newspapers in November that year. The article stated that '10,000 women [in North Wales] are needed ... to tip the scales against Hitler — 5,000 volunteers for the ATS [Auxiliary Territorial Service] and 5,000 volunteers for work in the war factories'. It was pointed out that 'weekly pay' for munitionettes would be 'between £2 10s. 6d. to £2 15s. 6d.', that they would work a '3-shift system', that they would have 'hot, 3-course meals (10d.) served every shift' and that they would get '6 day's paid holiday a year'. Munition factories sprang up all over Wales — for making shell casings and explosives — and in October 1943 the *Aberdare Leader* stated that

Female porters at a Cardiff dock during World War Two

Women and girls of all ages, married and unmarried, wearing turbans and 'slacks', smoking, laughing, haversacks slung on their shoulders, or little attaché cases in their hands ... [contrasted] rather incongruously with 'permed' hair and lipstick ... hurrying in large numbers to the bus or railway station, or, at the end of their day, pouring out of them in a swarm, tired, work-strained, but still laughing and cracking a joke. An unfamiliar sight surely in Wales, where women's place was always regarded as being in the home.

The largest munition factory was at Bridgend where, in its heyday, 35,000 people were employed, the majority of them women, to produce various types of explosives. In its recruitment campaign the government had been keen to alley fears about the side-effects of handling explosives, but as one munitionette recalled:

TNT was a yellow powder. In Bridgend the girls had to wear make-up to protect them from allergy to the powder. Some girls' faces would still swell and their eyes would go yellow inside. They'd have to leave the factory.

Added to this the powder turned the skin yellow and:

It dyed our hair — all according to the colour you were. If you were blonde, you went green; if you were black, you went orange; if you were brunette, you went yellow. They used to call us canaries.

Bevin's breakfast, as depicted in the Welsh Nationalist *in July 1945*

There were other hazards as well. 'Ordinary accidents were split fingers or loss of fingers, burns', and at Bridgend:

> There were about five bad accidents. One day there was a faulty fuse and somebody touched it when they were told to leave it. There were about 30-40 dead that day, two thirds of them women.

Call Up for Women

In March 1941 the government introduced the Registration of Employment Order, which required that all women aged 19 and over — except those with young children and those already engaged in work that was considered vital — to register at their local Employment Exchange, where an official 'suggested' what they should do. If they did not heed the suggestions, they were soon 'directed' to do so. One problem to arise, however, was that childless women — except those with husbands in the forces — could be directed to work anywhere in the United Kingdom. Those who refused to leave Wales found themselves in trouble, as happened to Kathleen Foley of Swansea, who refused to work in Birmingham. In November 1943 Kathleen was fined £25 for her refusal and threatened with one month's imprisonment if she did not pay. The

government pursued its transference policy ruthlessly, so much so that, in 1945, a cartoon in the *Welsh Nationalist* depicted Ernest Bevin, Minister for Labour, greedily devouring Welsh girls in their thousands.

Another problem was that some women refused to be 'directed' because they were members of pacifist organizations such the Women's Co-operative Guild, Plaid Genedlaethol Gymru or the Society of Friends. Other women — Jehovah's Witnesses and Quakers among them — refused to be 'directed' for purely religious reasons, arguing that war work was no different from military service. Rather than meet them head on the authorities redirected large numbers of objectors to auxiliary work in hospitals and similar institutions. Those who refused to be redirected were taken to court and fined, several times if need be. If they refused to pay the fine, they were sentenced to imprisonment for up to one month, at which point the authorities gave up.

National Service for Women

Girls who, at the start of the war, enlisted in the services had the option of joining the WRNS, WAAF or ATS (Auxiliary Territorial Service — known as WAAC during the First World War). All three services had been disbanded in 1920 and revived in 1938-39. The ATS took on the largest number of recruits — tens of thousands of them. ATS pay was poor, even when allowances were made for free board and lodgings. Prior to conscription in 1941 the ATS was offering between 1s. 8d. and 3s. 4d. a day for privates, the opportunity for rapid promotion and 7 days' leave every three months. ATS girls (terriers) did all the jobs that their predecessors had done in the First World War, and more — they served as anti-aircraft gunners, signallers, radar operators and in command centres.

In December 1941 the government introduced the National Service (No2) Act, which made single women aged 19 to 31 liable to conscription into the ATS, WAAF or WRNS, although it was possible for them to opt for Civil Defence or factory work. Unlike the women who were opposed to being 'directed' to war work a few months earlier, women who objected to military service could register as conscientious objectors, but had to do so before they were called up. They were then interviewed and given the opportunity to opt for Civil Defence, munition work, the Women's Land Army or some other service. If they declined any of the alternative options, they had to appear before a tribunal. It is believed that at least 23 women — 11 of them Jehovah's Witnesses — appeared before tribunals. Only two of them attained unconditional registration as conscientious objectors. What happened to the rest is unclear, but nine are known to have appealed to the Welsh Appellate Court, though here again the outcome of these appeals is uncertain; two of the women appear to have been fined £50 each by local magistrates. As to the rest, some settled for conditional registration as conscientious objectors, which meant that instead of serving in the forces, or in munition factories, they agreed to engage in hospital work and other occupations that were not directly associated with the war effort.

Nora Woodman, a Swansea woman,
in her ATS uniform

A young Swansea woman
in her WAAF uniform

The Women's Land Army

When women objected to military service they were often permitted to enlist in the Women's Land Army, which had been disbanded shortly after the First World War. When the WLA was reformed in 1939 thousands of women volunteered their services, but were not taken on until 1942. The work was hard, the weather usually cold and wet, the pay ridiculously low, yet thousands of women, many of them from England, were prepared to work on Welsh farms, either living on the farms or in hostels. Surprisingly, they enjoyed the work. Some of them were still at it in 1950.

Appearance and Dress

The war compelled the government to accept, in 1941, that the country needed women for war work; it also forced the government to recognize the importance of the woman's role in the home. Women were, therefore, bombarded with government propaganda about duty, diet and recipes through the mediums of leaflets, newspaper articles and wireless broadcasts. This was particularly so after food rationing was introduced in January 1940 to ensure that housewives made the most of whatever was in short supply, with the result that most people were to benefit from an improvement in their diet and consequently their health. Unfortunately,

Delve, in her military style utility dress, and Trefor, on their wedding day (1947)

housewives had to queue for food, sometimes for hours.

Clothing was rationed in June 1941, soap in 1942, and this was to prove frustrating for women who, for the first time, had money to spend on themselves. Nevertheless, it was due to the rationing of clothing that the ingenuity of women came to the fore. In an effort to save on cloth the government employed fashion designers to produce what became known as utility clothing, which carried a symbol of two half moons and the figure 41. The design of these clothes made them both easy and economical to make by women who knew how to sew and who owned a sewing machine. There was a certain amount of uniformity in design insofar as military-style jackets had padded shoulders and skirts fell to just below the knees. Plain high-heeled court shoes were fashionable, as were platforms with rubber or wooden soles.

Munitionettes proved particularly innovative when it came to setting fashion trends: slacks, shirt blouses, turbans and siren suits (fashionable overalls with a belt) were all adaptations from working clothes. In the hands of innovative women even gas mask cases were made to appear more feminine. Silk stockings (not on sale in Britain until 1947) were unavailable to women unless they knew a black market spiv or a generous GI; failing that, there was always tanning lotion or gravy browning, and stocking seams could be drawn on the calves with the aid of an eyebrow pencil. Friday evenings were usually devoted to hair. After washing, the hair would be set with sugar and water, then curled using pipe cleaners or metal curlers called 'dinkies', which were left in all night. Most women wore their hair shoulder length, the back turned under to create a 'page boy' look. All hair was kept off-the-face, the front and sides curled to form 'bangs', be they sausage curls or flat 'shell' curls.

For those with money to spend, having a night out was a must, especially when in 1944 there were tens of thousands of GIs stationed in Wales. Girls living in towns needed no encouragement to get out and about, dancing or frequenting the cinema, but country girls were to some extent influenced by evacuees. The blitz brought tens of thousands of children into Wales to be fostered by Welsh women. These children were often accompanied by their mothers, and city women, Londoners in particular, were accustomed to a night out — in pubs of all places, which came as a shock to the chapel-going rural Welsh.

Praise and Criticism

Women who were involved in the war effort, whether voluntary or as a result of conscription, could justifiably claim they were entitled to spend at least some of

Eileen Woodman, a Swansea woman, with her hair piled up in bangs

their hard-earned wages on personal appearance and recreation. No matter where they worked — in factories, hospitals, civil defence or voluntary community work — women found themselves in unfamiliar surroundings and at risk. They were often far from home, they had to travel to and from work during blackouts, they risked injury and death at work and, in many areas, from bombing as well. In 1941 the coastal towns of South Wales became targets for German bombers. Swansea in particular was hard hit during a three-night blitz in February. In all, the town suffered more than 40 bombing raids. A total of 369 people were killed in these raids, 230 during the three-night blitz.

Women were praised both during and after the war for their contribution to the war effort; without them the war would have been lost. Nevertheless, they came in for a great deal of criticism. Before the war no respectable women in Wales would frequent pubs, nor would they be seen smoking in public, but as the war dragged on there were growing complaints about women who smoked, drank and dated servicemen, GIs in particular; worse, Cardiff during the blackouts was said to be awash with couples having intercourse in shop doorways and back alleys. Everyone, it seemed, had a gripe about working women, including women themselves. Miners bemoaned the fact that munitionettes earned more money they did — it was as if the doctrine of separate spheres had been reversed. Almost everyone made jibes about service women being 'ground sheets', or failing that they were labelled lesbians. Even

Esther, a Swansea widow, assesses the damage to her bombed-out home in Landore (1941)

prostitutes complained about loss of earnings to under age girls with a fascination for men in uniform. If married women were known to be misbehaving, their marriages existed on borrowed time, for as soon as their husbands came home on leave, there was always someone who would inform on them, often with dire consequences for domestic peace.

In fact many servicemen were to return home to find their wives and sweethearts were not quite the same as when they left. Women had had a taste of fending for themselves; disagreements were inevitable. The divorce rate rose, which is hardly surprising as many wartime marriages were the result of hasty decisions by couples who had not engaged in lengthy courtships. The number of divorced women living in Wales in 1931 had been 623; by 1951 there were 4,935. In the early 1930s about 55% of divorces in England and Wales had been initiated by the wife; in the early 1940s around 56% of divorces were instigated by the husbands.

The Post-war Years (1945-50)

Even before the war in Europe came to an end (8 May 1945) there were fears of a return to the harsh days of the Depression. Women in particular feared they would be laid off *en masse* because (1) munition factories would close and (2) demobbed servicemen would take over their jobs in other areas. While it was true that large numbers of munitionettes were laid off before VE-Day, and that other wartime factories were to close in due course, there was, nevertheless, a determination on the part of the government to create new jobs — for women as well as for men. In 1945 much of South Wales was designated a development area in which industrialists were encouraged to set up new businesses, both on former wartime factory sites, as at Bridgend, and on new trading estates such as Fforestfach, Swansea. On these estates a large percentage of the workforce were to be women, their low rates of pay

Assembly Department, Smith's Clocks, Ystradgynlais in the 1950s

an incentive for businessmen who wished to produce clothing, footwear, soft drinks — anything from toys to washing machines.

The creation of new jobs contrasted with what happened after the First World War, and there was no concerted campaign to coerce young women into domestic service. Well-to-do families in need of domestic assistance chose to employ women of all ages for so many hours a day as cleaners, cooks and the like; there was little requirement to live-in. The same applied in the public sector, in hospitals, nursing homes and other establishments where care and cleaning jobs were on offer. There were also thousands of women cleaning both company and government offices.

The 1945 general election resulted in a landslide victory for the Labour Party, which was to lay the foundations of the welfare state. That same year saw the implementation of the Education Act of 1944, whereby free secondary schooling became available to all. Pupils who passed their eleven-plus examination went to grammar schools (the former county schools); those who failed (the majority) went to the new secondary schools that were created. More pupils, more schools, all created a demand for more teachers, but it was several years before married women were to benefit from the need for more staff, despite the removal of the marriage bar.

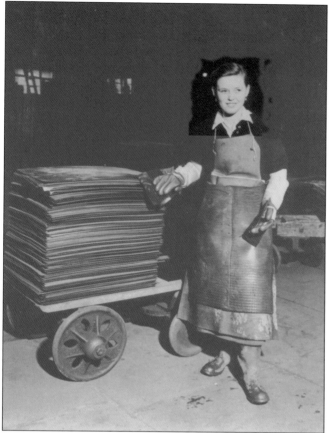

A packing girl wearing protective clothing at Clayton Tinplate Works, Pontardulais in 1967

In 1947 the coal industry was nationalized. The following year the National Health Service was established and became a major employer of women, including married women once the marriage bar relating to nurses was removed. The continued expansion of the welfare state led to an increase in governmental departments, which in turn created more clerical jobs. In the private sector women were steadily increasing their presence in offices, though few were employed as manageresses. It is not surprising, therefore, that the 1951 census recorded that almost 25% of the women in Wales were employed, and the percentage was destined to rise.

Improvements in women's job prospects had little effect on the doctrine of separate spheres, firstly because the wages of most women were little more than half the wages of men employed to do similar work. A woman, if she was married and employed, was, therefore, not the breadwinner; her income only supplemented her husband's wages. Secondly, the National Insurance Act, which came into effect in 1948, served to buttress the dependency of a married woman, for her entitlement to benefits was based on her husband's contributions; she did not pay contributions. Thirdly, a woman, irrespective of whether she was married or not, could not apply for a mortgage, nor could she take on a hire purchase agreement without the backing of a male guarantor.

In 1946 family allowance (later known as child benefit) was introduced, the payments made directly to the mother. These payments were welcomed by everyone with children because the immediate post-war years were characterized by deplorable housing, housing shortages, high unemployment and food shortages — even bread was rationed in 1946 — added to which illegitimacy rose, as did the

divorce rate, whereas the birth rate fell considerably. The rise in the divorce rate was due, in part, to the introduction of legal aid in 1948, which offset the cost of divorce proceedings.

The 1950s and '60s

From 1947 onwards a girl left school at the age of 15, either to take up further education, or to find work. Throughout her teens she would have been enthralled by the pop stars of her day — Bill Haley and Elvis in the '50s, the Beatles in the swinging '60s. In the '50s she may have worn a flared skirt and bobby socks; in the '60s, trousers, jeans, mini-skirts, hot pants and tights became fashionable. All these things were possible because, in the period under review, the standard of living improved dramatically, although women's status in relation to men hardly changed. Until 1968 the age of majority for entry into all legal contracts, including marriage, was still 21 for both men and women; in 1968 the age of majority was reduced to 18. Marriage during this

Carole and Walter, a Swansea couple, on their wedding day (1962)

period became more popular than ever before, and the average age on marriage was still 22 for a woman, 24 for a man. Prior to this a women could expect a two-year courtship, time to accumulate a bottom drawer. Engagement parties became popular during the '50s, as did hen parties, church weddings and honeymoons, but very few women — perhaps 1% — cohabited with a man before marriage.

One of the biggest problems facing newly-weds was where to live. The post-war Labour Government's answer to the chronic housing shortage was to build council houses, many of them prefabricated, but waiting lists were lengthy and a couple's place in the queue depended on a points system in which those with children had priority. In the meantime, a couple might rent a room, often in a parents' home, or they might take matters into their own hands and occupy a Nissen hut in an aban-

doned army camp. For those lucky enough to be allocated a semi-detached council house, especially if they had children, it was like a dream come true; two to four bedrooms, one to two living rooms, a kitchen, bathroom and possibly an outhouse for washing and storing coal; even hot water could be obtained at the turn of a tap.

House building continued under successive governments, the Conservatives encouraging the construction of houses for sale. It was during this period that slums were cleared and grants became available for improvements to pre-war private houses. One of the most significant ways in which the heavy workload of a miner's wife eased resulted from the widespread installation of pit-head baths following the nationalization of the coal industry in 1947. Electricity also seemed destined to make the housewife's life easier, and in the '50s numerous houses in both towns and rural areas were wired and connected to electricity supplies. This enabled the manufacturers of electrical goods to target housewives with labour-saving devices as well as luxuries. By 1970 the majority of Welsh homes had an electric iron, a vacuum cleaner, a washing machine, a refrigerator and a quarter of all homes had central heating.

Young women in the '50s and '60s wanted more out of life than what their mothers had experienced. They did not want to live in abject poverty, or be worn out by endless drudgery, nor did they wish to be burdened with repeated pregnancies and large families. In the '50s it became acceptable for married women to limit the size of their families, although in practice it was the husband's responsibility to use a condom or withdraw. All this was to change following the introduction of the contraceptive pill in 1961. The pill gave married women control over their reproductive organs, and if things went wrong, there was always abortion, which, as a result of the Infant Life (Preservation) Act of 1929, was permissible to prevent a woman becoming 'a physical or mental wreck'. However, at a cost in the mid-'60s of around 250 guineas abortion was not an option for most women. The Abortion Act of 1967 allowed termination up to 28 weeks, providing two doctors agreed to it on grounds that a pregnancy would be damaging to the woman's health, both physically and mentally, or that the unborn child was likely to be handicapped. None of these measures, not even advice on sexual matters, were available to unmarried women, although the National Health Service did begin to offer advice in 1969. It is not surprising, therefore, that during this period the birth rate fell dramatically and the illegitimacy rate rose, being confined almost entirely to teenage mothers.

Newly-weds might wait a year or so before they considered having their first child, both of them working to establish a home. Thereafter it was the norm for the wife to have a small family within the space of four or five years. By the time she was in her early 30s her children were all in school, leaving her free to return to work, either full-time or part-time, thereby supplementing her husband's wages. Alternatively, a mother might place her children in the care of her mother, or mother-in-law, before they reached school age. In close-knit communities a child might leave school to spend an hour or so in the home of a relative or a neighbour,

until such time as one of the parents were due home from work. There were, in fact, all sorts of arrangements to make it possible for a mother to return to work.

Attitudes towards a woman's role had changed to the extent that by 1961 about 50% of working women were married. This was due partly to war work, but more so because Wales was becoming a consumerist society. A mother returned to work primarily for the money, the extra income making it possible for her husband to take out a mortgage, or used to acquire large items of furniture such as a three-piece suite, or even a car, both of which could be obtained on hire purchase. The extra money also made it possible to be generous at Christmas and, in the summer months, for the family to holiday in Spain.

By 1969, nine out of ten households had a television, and the commercial channels bombarded women, especially housewives, with advertisements on innumerable products. All too often an advertisement would present an attractive, well-groomed housewife extolling the benefits of a particular brand of washing powder, or demonstrating the versatility of a certain type of washing machine. Products such as these were promoted as labour-saving devices and, of course, the housewife recognized that in order to have these, and other luxuries, she had to work, but what was not so obvious was that the advertisement served to remind her that her place was primarily in the home. She could argue that she was not like her mother, working long hours, cooking, cleaning and caring for too many children. She had liberated herself from all that; she had labour-saving devices that enabled her to spend more hours in her place of work.

Health-wise, women in the '50s and '60s were better off than their mothers had been prior to the introduction of penicillin in the late '30s, which reduced the number of deaths from puerperal fever. Until then most women gave birth at home. By 1968, 88% of all births took place in hospitals. Better housing combined with antibiotics drastically reduced fatalities due to tuberculosis. There were also programs to inoculate every child in the country against all sorts of diseases, as well as treatment for all kinds of ailments. There were even experts to advise on how to bring up children, such as Dr. Spock who informed mothers that children should be permitted to express themselves, even to the extent of allowing them to do just as they pleased. What did not changed during this period was the housewife's bond with her mother. Unfortunately, the days of the self-sacrificing *mam* were numbered.

In the '50s shopping was carried out in much the same way as it had been during the Depression, the housewife leaving home with a shopping basket on her arm to walk to the local butcher, baker and greengrocer where she queued to be served from the far side of the counter by someone who weighed and bagged much of the produce required. Shopping in this manner was invariably carried out on a daily basis, even at the local Co-op and Home and Colonial stores. In the '60s, when more families had refrigerators, the housewife became increasingly accustomed to making weekly shopping trips by car to a self-service mini-market where she, or her

husband, pushed a trolley. With regard to clothes, furniture and electrical appliances there was always some entrepreneur or company that would provide either the goods or the means to buy them. Packmen were regular callers in the '50s, and throughout the period there was a growth in catalogue buying, company cheques and hire purchase arrangements were available almost everywhere.

In the home, whether she worked or not, it was still considered the wife's place to do most of the housework, the husband often being incapable of cooking a dinner beyond meatballs and chips. His contribution revolved around gardening, decorating and fixing the car. In the days of the Depression even social and leisure activities were segregated, the husband 'wandering off' to an allotment or to the pub, the wife 'popping' into the house next door. If a couple went out together, it might be to church or chapel, which was still the case after the war, but couples in the 50s went to both the pictures and the pub together and, in the 60s, they dined out.

Women of Note

Apart from Megan Lloyd George, only two other women served as Welsh MPs during the period under review. Mrs. Eirene White (née Lloyd Jones), the daughter of a former cabinet secretary, held East Flint for the Labour Party from 1950 until 1970 when she took her place in the House of Lords, the first Welsh female politician to do so after titled women were admitted to the House in 1958. Dorothy Rees won Barry for the Labour Party in 1950, only to lose it the following year, but what made Dorothy remarkable was her humble origin as a docker's daughter. She first became a teacher and, in 1934, a county councillor before becoming the Labour candidate for Barry. After her defeat in 1951 she returned to her former position as a Glamorgan county councillor. All three women gave a good account of themselves. Only one of them ever married; none of them had children.

Women had their place in all the political parties, including Plaid Cymru, usually as helpers rather than decision-makers. Welsh-speaking women were, however, politically active in Cymdeithas yr Iaith (The Language society) founded in the early '60s, and Gwyneth Wiliam was the first of several women to be imprisoned for demonstrating in support of the Welsh language. It is noteworthy that there were as many women as there were men on the executive committee of Cymdeithas yr Iaith.

Between 1945 and 1970 many Welsh women achieved fame in the world of entertainment. Tessie O'Shea left her mark as a stage entertainer. Dorothy Squires became renowned throughout the period as a singer and a variety artist, both on stage and radio. Dame Gwyneth Jones, whose career took off in the '60s, became one of the greatest sopranos in the 20th century. Shirley Bassey was hot property by 1959 and still is even now, more than 40 years later. Both Sian Phillips and Rachael Roberts became world-famous film stars, known for both their beauty and their talent. Petula Clark became a household name in Britain, on the Continent and in

the USA during the '50s and '60s, her continuing success into the '90s being truly remarkable. Finally, as a folk singer, Mary Hopkins's career took off in 1967 when she won acclaim on Opportunity Knocks.

Welsh women achieved fame and fortune in other areas as well. Laura Ashley made a name for herself as a fashion designer in the late '60s, and went on to establish a business empire that, after her death in 1985, was valued at almost £300 million. Mary Quant also became world famous in the '60s as a fashion designer, being responsible for introducing both the mini-skirt and hot pants. Many more names could be added to the list of those who deserve mention for their achievements within Wales and without. Unfortunately, their inclusion is beyond the scope of this work.

CHAPTER XV
The Last Three Decades

Women's Lib in the 1970s

If the years leading up to the First World War saw the first concerted protest by women, then the '70s and '80s witnessed the second — the Women's Liberation Movement (WLM) — which started in America during the '60s. One of the most notable female-related events to take place in the United Kingdom occurred in 1968 when women at Ford's Dagenham plant went on strike in protest about their rates of pay being less than those of their male colleagues. Unequal pay was already an issue on the Continent and, in 1970, the British Government, as a preliminary to joining the European Economic Community (EEC), introduced the Equal Pay Act and the Sex Discrimination Act. Employers were, then, given five years to comply, after which the Equal Opportunities Commission became a watchdog to monitor the situation and support anyone who wished to take their employer to court for failing to offer the same rates of pay to both men and women for doing similar work, or for discriminating against them on account of their sex or marital status. Yet, despite the legislation, women still found themselves in low paid jobs and continued to encounter discrimination in male bastions such as the police.

The WLM did not have a presence in Wales until the formation, in 1970, of the Cardiff Women's Action Group (CWAG), which, by September the following year, claimed a membership of about 20 women. The CWAG campaigned in support of the four initial demands of the WLM; that is, for equal pay for equal work, equal education and job opportunities, free contraception and abortion on demand, and free 24-hour community-controlled childcare (24-hour nurseries). One of the prime objectives of the group was consciousness raising, to make women aware of the aims of the WLM by producing newsletters and handbooks. Its involvement in domestic violence led to the establishment, in 1975, of a much-needed refuge for battered wives in Cardiff and to the formation of the Welsh Women's Aid two years later.

The members of the CWAG were predominantly young, educated, middle-class women and, like feminists in the early part of the century, they had a tendency to split into two circles: social feminists (those who played an active role in practical matters such as domestic violence) and radical feminists who, based at tuniversities, were

more intellectual, more inclined towards debating issues relating to inequality. The division between social and radical feminists became more marked in 1974 with the formation of the Women's Right Committee for Wales (WRCW), which, based at Cardiff, adhered to the more traditional form of feminism, being primarily concerned with achieving equal rights with men. The WRCW organized regular conferences in Wales, mainly at Cardiff, Swansea and Aberystwyth. In 1975 several of its members travelled by minibus to Luxembourg where they petitioned the European Parliament.

Small action groups sprang up in many towns all over Wales, but only the Swansea group need be mentioned here. Founded in 1972, the Swansea WLM had a similar agenda to the CWAG. It also had two circles, one centred on the university; the other, which held regular meeting in Swansea east, was remarkable in that it had a predominantly working-class membership. In 1977 the group opened a refuge for battered women in Morriston; two years later the group set up the Swansea Women's Centre in a council house. In the '80s the WLM broadened its agenda to include rape, pornography and other female-related concerns.

What is noteworthy about the WLM groups in Wales is that not only were their memberships small, but that they insisted on maintaining a Welsh identity, even though some of the women involved were not Welsh-born. This was due to the influences of nationalism and the campaign to save the Welsh language. What these groups were up against were hierarchies in both government and business that were patriarchal and, to a large extent, under the sway of Old Labour. Feminist action groups were, therefore, striving to bring about change by challenging the establishment with their demands. Feminists were also expressing themselves in other areas as well.

Literature and Films

Leaflets and pamphlets were not the only means whereby women endeavoured to promote issues that were meaningful to them. The magazine *Rhiannon* first made its appearance in 1977. Unlike the periodicals of the 19th century this was a feminist magazine containing articles written by women, in both Welsh and English, for the benefit of women in Wales; moreover, it was during the '70s that many eminent female writers surfaced, one of the most noteworthy being Elaine Morgan who wrote *The Descent of Women* (1972), and who was responsible for the television dramatizations of the lives of Vera Brittain and Marie Curie. *Welsh Convict Women* appeared in 1979, and the author, Professor Deirdre Beddoe, subsequently established herself as a broadcaster and the author of several books on the history of Welsh women, her most recent being *Out Of The Shadows* (2000), which provides a well-researched and fascinating account of women in Wales during the 20th century.

In the '80s women established themselves as publishers and film makers in their own right. The Welsh women's press, Honno, for example, came into existence when

a group of women got together in 1985 to publish works that had specifically Welsh connections, and that were written exclusively by women. Two years later Honno launched its first two titles: *An Autobiography of Elizabeth Davies* (the Welsh 'lady of the lamp') and *Buwch ar y Lein* in which the author, Hafina Clwyd, gives a fascinating account of her experiences in London. With regard to film making, only Red Flannel Films need be mentioned here. Founded in 1985 by five women, this community co-operative based at Pontypridd produced films and videos about women in the Valleys, their best known film being *Mam*, which appeared in 1988.

The Welsh Language Society

Founded in 1963 for the purpose of raising the status of the Welsh language and promoting its use in Wales, Cymdeithas yr Iaith (CyI) — the Welsh Language Society — conducted its non-violent direct action campaign throughout the '70s and '80s. The CyI was unique in that it did not have a women's section, nor were its members segregated on account of their sex. When it came to direct action — daubing walls and sign-posts, climbing television transmitters, occupying holiday homes and government offices, and demanding to be tried in Welsh — women participated on the same terms as men. The only time they were segregated was when they were imprisoned. Initially, only men chaired the meetings, but from 1981 onwards this changed to the extent that by 1988 the CyI 'had virtually been taken over by women'.

Most of the women involved in CyI were young, educated Welsh-speakers, many of them students. Angharad Tomos, for example, was a long-term activist, several times imprisoned for the cause, and a writer of renown, being awarded a Prose Medal at the Eisteddfod of 1991 for the best novel of the year. Many of the women held traditional views about their role as women; others such as Menna Elfyn, known for her poetry, 'went to prison as a language activist but came out a feminist' as well. By the early '90s the CyI could claim to have achieved its aims; it could even claim to have been instrumental in forcing Margaret Thatcher to do a U-turn on her plans to scrap S4C.

Lesbians — their 'Coming Out' in the late 1970s

Based on the evidence of her poetry, Katherine Philips (1631-64) — the Matchless Orinda — could well be the earliest recorded lesbian in Wales. Born in London, Katherine née Fowler settled in West Wales shortly before her marriage, at 16, to James Philips, a 54-year-old landowner. Katherine is said to have been 'the first woman writer in Britain to win recognition'. The poetry that she addressed to her female friends, especially Ann Owen (Lucasia), has prompted some commentators to raise questions about her sexuality. If she had been a lesbian, then Katherine did not suffer persecution, being accepted even in royal circles, but it has to be said that in her day

lesbianism was not a crime, nor was it subsequently so, though there were attempts to criminalize it during the first quarter of the 20th century.

A lesbian could, however, find herself at a disadvantage in that, should her marriage end in separation or divorce, she would invariably lose custody of, or access to, her children. This, of course, only applied after the legislation of 1925, which permitted the custody of children to women on the same terms as men; this state of affairs continued until the '90s when a more liberal attitude prevailed. Lesbians could also suffer ridicule, discrimination and abuse both socially and in the workplace. Little wonder, then, that prior to the formation of the Gay Liberation Front in 1970 few women in the United Kingdom were prepared to 'come out' and declare they were lesbians. In Wales, particularly in the Welsh-speaking rural areas, this did not begin to happen until the late '70s when the WLM declared 'An end to discrimination against lesbians', and for women to have the right to determine their own sexuality. This led to the formation of Cymdeithas y Lesbiaid a Hoywon Cymraeg eu Hiaith (the Society of Welsh-Speaking Lesbians and Gay Men) at Aberystwyth.

Greenham Common

Women from all parts of the United Kingdom were involved in the Campaign for Nuclear Disarmament (CND), but when, in 1979, a decision was made to site cruise missiles at a RAF base on Greenham Common, Welsh women initiated a peace protest that was to last more than ten years. It started in 1981 when 36 women and a few men marched from Cardiff to the air-base in Berkshire, where they set up a peace camp outside the main gates. They were led by Ann Pettit, a Welsh-speaker from Llanpumpsaint, who was not only a feminist, but also an environmentalist, a supporter of the role of motherhood and appears to have been anti-lesbian in her views.

Other peace camps sprang up around the base, and within a year the protesters decided that the camps should be 'women-only', arguing that men tended to dominate, were more prone to violence and did little in the way of 'housework' within the camp-sites. Initially, the authorities ignored their presence until four women chained themselves (suffragette style) to the fence. The press branded the women as unwashed and unfeminine, the police made numerous attempts to evict them, sometimes brutally, and laws were changed so that the women could be arrested and imprisoned. One of the most newsworthy events occurred in 1982 when an estimated 30,000 women from all over the United Kingdom 'embraced the base' to pin babies' clothes to the perimeter fence.

Another noteworthy, though tragic event occurred in 1989 when Helen Thomas, a 22-year-old Welsh-speaker from Newcastle Emlyn, lost her life as a result of being hit by a police vehicle. The official line was that Helen had been dancing in front of the vehicle as it approached the base, but a MOD policeman testified at an inquest that

she had been waiting to cross the road when the vehicle swerved into her. Yet despite the testimony it was the official line that prevailed. Later, a high court criticized the way the inquest had been conducted, but made no attempt to change the verdict. Although the last cruise missile was removed from the base in 1991, the last peace camp was not abandoned until three years later.

The Miners' Strike of 1984-5

Wales had been suffering a decline in heavy industry since the First World War. The decline escalated in the '60s and '70s with the closure of numerous collieries as well as the steel plants at Ebbw Vale and East Moors in Cardiff. It was, however, the election of the Conservative Government in 1979 that sounded the death knell for heavy industry. With streamlining in mind, Margaret Thatcher dealt first with the steel industry, closing down numerous plants, including Shotton in North Wales, which proved to be a tremendous job loss. She then rounded on the miners (there were still 20,000 of them in South Wales alone) and they went on strike in March 1984. The

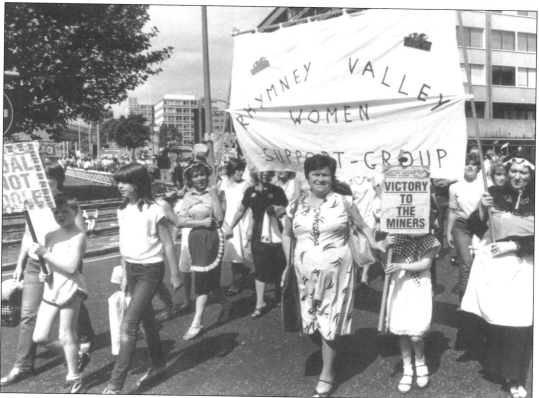

Rhymney Valley women marching through Cardiff in support of the miners' strike, August 1984

strike proved as bitter as any, and not only were the women there to support their menfolk, but they organized as never before, raising funds, running soup kitchens, distributing food parcels and joining the men on the picket lines; they even went so far as to occupy the pit-head baths at Cynheidre. For these women the issue was the survival of their communities. When the strike collapsed in the spring of 1985 it marked the end of an era, for there were only seven pits and 4,000 miners in South Wales by the end of the decade.

Disunity

It would be wrong to assume that the women in Wales who were 'politically' active in the '70s and '80s were anything more than a minority; nor were they united by a common cause. Within organizations such as the WLM there were differences between socialist and radical feminists, the latter committed to an ongoing struggle for equality with men, the former focusing on practicalities such as establishing refuge centres for battered women; moreover, divisions existed within both groups over issues involving race, class and sexuality. There were also divisions over the demands of the MLM. Outside Wales, members of a group known as the Feminists Against Abortion were totally opposed to abortion on demand, declaring it an abuse to women's bodies and the right to bear children. Outside the WLM there were many women involved in issues that were not feminist, but to do with saving their communities as, for example, those who actively supported the miners' strike, or those who, as members of Cyl, took direct action to raise the status of the Welsh language. Indeed, some of the women in Cyl held traditional attitudes towards their role as wives, mothers and homemakers, and no doubt the majority viewed saving the language as far more important than feminism. What the vast majority of women in Wales made of all this is unrecorded, but it may be presumed that many — if not most — were torn between a desire for self-fulfilment and a desire for stability, security and a sense of belonging. Other no doubt took the view that feminism may have liberated feminists, but it did not change the lives and attitudes of the majority of women.

The '80s — the Respectable Face of Feminism

In Wales women had been recruited into political parties since the 1880s — not as decision makers, but as support workers, raising funds, canvassing and making tea. There was little hope of these women having a say in party politics when the hierarchy of the parties were all men, most of them — if not all — patriarchal upholders of the doctrine of separate spheres; nor was there much hope of the male-dominated selection committees nominating women for anything other than unwinnable seats in elections. All this was to change, partly because, in the '80s, more and more feminists chose to fight their cause from within the parties rather than attack from without, and partly because, from

1979 onwards, the Conservative Party's grip on power proved unassailable, forcing both Labour and Plaid Cymru to change their attitude towards female involvement.

In the early '80s, when female activists took over the leadership of the Women's Section in Plaid Cymru, the feminists pushed for equal rights for women, but according to Charlotte Aull Davies, most of the activists within the party 'either viewed their nationalism as of greater importance than their feminism or refused to choose between the two', whereas the rank and file majority considered feminism as foreign to Welsh nationalism. Similar differences existed in the Labour Party, the women sometimes torn between choosing socialism or feminism as their first priority. By the mid-'80s Plaid Cymru was considered to be the more supportive of feminist issues, but this proved short-lived. Labour, on the other hand, had already taken steps that would give it an edge over rival parties in Wales.

From 1970 onward there had been no female MPs from either party to represent Welsh constituencies until Ann Clwyd won a by-election in the Cynon Valley for Labour in 1984. Thereafter she remained the only female MP from Wales until New Labour won a landslide victory in the general election of 1997. Born in 1937, Ann Clwyd (née Lewis) had the benefit of a grammar school education and a place at the University College of Wales, Bangor. A Welsh-speaker, Ann became a Welsh correspondent for both the *Guardian* and the *Observer* as well as a freelance reporter and television producer. In 1979 she was elected MEP for Mid- and West Wales, a post she held until she became an MP in 1984. For 13 years Ann remained the only female Welsh MP, during which time she served as a member of the Shadow Cabinet (1989-94), holding several important posts in succession. After the general election of 1997, Ann became a member of the House of Commons Select Committee on International Development, and has subsequently earned a great deal of respect both at home and abroad. After the general election of 1997 there were four female MPs holding Welsh seats in the House of Commons, all of them members of the Labour Party — Ann Clwyd, Julie Morgan (active in women's organizations during the '80s) for Cardiff North, Jackie Lawrence for Preseli in Pembrokeshire, and Betty Williams for Conway.

To add to these, there have been five female MEPs from Wales in the European Parliament during the last quarter of the 20th century — Ann Clwyd for Mid- and West Wales (1979-84), Beata Brookes (Conservative) for North Wales (1979-89), Glenys Kinnock (Labour) for South Wales East (from 1994 onwards), Eluned Morgan (Labour) for Mid- and West Wales (from 1994 onwards) and finally Jill Evans (one of the original Greenham Common marchers), elected to represent Plaid Cymry in 1999.

Women did well in the election for the first National Assembly for Wales in 1999, winning 24 seats out of a total of 60. They did better still in the Assembly election of 2003, winning 30 seats, and five of them became members of the Assembly Cabinet, thereby outnumbering men five to four.

This switch by growing numbers of feminists from anti-establishment action groups to political parties extended to other mainstream organizations such as the Wales Trade Union Council, which in 1984 set up a Women's Advisory Committee to encourage female participation in trade unions. The same year witnessed the establishment of the Wales Assembly for Women, its purpose to report on the UN Conference on Women. The South Glamorgan Women's Committee came into existence the following year, the only local government body in Wales whereby women had a say in local affairs. These were significant gains in a country dominated by a patriarchal hierarchy; they show that attitudes were changing, albeit slowly.

Women's History

At the UNESCO conference on the history of women, which took place in 1984, feminists made the point that historians have by and large given only a male perception of the past, that women had been relegated to the domestic sphere and would, therefore, appear to have contributed little to human advancement. So successful have British women subsequently been in recovering their past that universities throughout the United Kingdom introduced a master's degree in women's studies, the first to do so in Wales being the University College at Cardiff, which introduced the degree in 1988. Then, in 1996, the South Wales Feminist History and Archives Project was set up at the University of Glamorgan. The following year saw the establishment of the Women's Archives of Wales.

Ethnic Minority Women

Cardiff's black community dates back to the late 19th century, when seamen settled in the deprived, dockland district of Butetown where they married local girls. The black community grew in number with an influx of Afro-Caribbean families in the '50s. Poverty and discrimination were rife in this multi-racial district, and when it came to finding work, women encountered discrimination because of their colour as well as their sex. If they found work, it was invariably menial and poorly paid. Racial legislation did little to improve the situation, and women from the ethnic minorities of more recent times have had to endure social exclusion on account of language difficulties, a lack of child care and cultural differences.

In 1992, the first all-Wales black and ethnic women's conference was held at Cardiff. The following year witnessed the creation of the Minority Ethnic Women's Network (MEWN—Cymru), the principal aims of which were to help ethnic minority women to find work, attend training courses in IT and to overcome both racism and sexism wherever they may be. MEWN—Cymru has since achieved charitable status and in 2000 it secured community funding. There are now networks of black and ethnic minority women in Cardiff, the Vale, Swansea, Newport and North Wales.

Women at the Top

At the other end of the spectrum (with regard to networking) are those women who, in their efforts to be successful, have cause to complain about glass ceilings, by which is meant the attitudes and traditions within a male-dominated society that prevent women attaining top jobs. Women who run their own businesses, on the other hand, have cause to complain of their exclusion from male business clubs and freemasonry where networking takes place, which puts them at a disadvantage because networking is the process of establishing business contacts, often through social activities such as golf. In response to this exclusion women in south-east Wales set up their own business clubs in the '90s, the Women in Enterprise (Cardiff) and the Gwent Women's Enterprise being among the earliest.

In 2001 less that 10% of women held top jobs. One woman to both succeed in business and break through the glass ceiling was Elizabeth J. Muir. Born in Bridgend in 1947, Elizabeth started out as a maths and physics teacher in Cardiff secondary schools. In 1978 she became a sales and marketing controller and, four years later, the founder and Managing Director of the European Marketing Consultancy, The Alternative Marketing Department Ltd, Cardiff. Not only did Elizabeth go on to serve as a board member of several public authorities, but she also became the first female member of the Confederation of British Industry in Wales. In *Our Sisters' Land* (1994) Elizabeth wrote of her experiences on male-dominated board meetings, relating how she got herself heard without having to behave like a man.

Changes in the Law

Prior to the Divorce Act of 1971 the guilt of one spouse had to be proved, and both partners had to agree to divorce. The new act allowed divorce on the grounds of irredeemable breakdown of the marriage and permitted one partner to initiate proceedings even against the wishes of the other. The Marriage Act of 1996 took matters one step further by making it easier to terminate a marriage of short duration. Both these changes in the law were evidently welcome by many women as most divorce petitions (as many as 75% in 1991) were filed by them.

The Consumer Credit Act of 1974 put an end to the practice whereby a woman, should she take out a loan, hire-purchase or a mortgage, had to have a male guarantor. A more noteworthy step towards financial independence came in 1988 when legislation abolished the married couples' allowance in favour of husbands and wives being taxed separately. Legislation in 1992 made it possible in certain circumstances for a husband to be charged with rape should he have sex with his wife against her will. The Employment Act of 1993 made dismissal on the ground of pregnancy unfair, and three years later the Employment Rights Act extended rights on maternity leave, pay and return to work.

Abortion

Different countries have settled the issue of abortion in different ways. In the USA, for example, a woman's right to have an abortion is protected by legislation, whereas in Ireland it is the unborn child's right to life that is enshrined in law. In both countries, as in the United Kingdom, there are those who support the view that a woman has every right to end an unwanted pregnancy — after all, it is her life that is affected; she is the one who has to bear the child and be responsible for it for many years to come. It could be argued that in Ireland the law reflects the attitude of the Catholic Church, which teaches that the Virgin Mary did not object to having a child thrust upon her.

However, if a woman can claim the right to have control over her own body, there are those who argue in favour of an unborn child's right to live. Pro-abortionists counter this by claiming that an unborn child, or foetus, is not a human being because it has neither consciousness nor self-consciousness, in response to which their opponents make the point that a person in a coma has lost consciousness, but the life of that person is not terminated because, given time, he or she might regain consciousness. It follows, therefore, that an unborn child would, if it were allowed to live, acquire both consciousness and self-consciousness.

In the United Kingdom the Abortion Act of 1967 proved to be an ingenious piece of legislation in that it circumvented the issue of whose 'rights' mattered most — the right of the woman, or the right of the unborn child — and placed abortion in the hands of the medical profession. The act, which was intended to put an end to backstreet abortion, declared abortion to be illegal, except when two doctors agreed 'in good faith' that the termination of a pregnancy was necessary to safeguard the woman's physical and mental health, and the health of any existing children the woman might have. The wording of the act was such that it was open to liberal interpretations, so much so that many doctors have come to accept a woman's wish to end an unwanted pregnancy — for whatever reasons — as sufficient ground for an abortion. In effect the act has come to mean not so much abortion on demand, but abortion on request.

There were many attempts to dilute the act in the '70s and '80s, during which time the anti-abortions were forced to recognize that, for practical reasons, the public at large were in favour of abortion during the early stages of gestation. They, therefore, directed their campaign against abortion during the final stages of gestation and, in 1990, the government adopted the proposal of Conservative MP, Geoffrey Howe, that the legal time-limit should be 24 weeks gestation, except when the woman's life was at risk, or when there was a 'substantial risk of serious abnormality' in the foetus. Since then both the Conservatives and New Labour have declared abortion to be outside party politics.

Women most likely to favour abortion are those of the middle and upper classes, or those with qualifications. Be that as it may, almost 200,000 abortions were carried out in mainland Britain in 2001. That same year it was estimated that four women in

every ten terminated a pregnancy at some point in their life. Clearly, with such numbers, there will never be a return to backstreet abortion. Yet pro-abortionists rest uneasy: the moral argument has not been defeated, nor will it ever be. If anything, advances in medical science, in what has been discovered about DNA, and the fact that expectant mothers can see what is developing inside them when they have a scan, have all contributed to the words 'embryo' and 'foetus' being dropped in favour of 'baby' and 'unborn child'. Newspapers, for example, refer to test-tube babies, and when a woman has a miscarriage she loses a child, not an embryo or a foetus. The law on abortion will, in time, most certainly be changed, though whether it will result in women — not doctors — being the decision-makers, or that the time-limit of 24 weeks gestation (one of the highest in Europe) will be reduced, on the ground that a baby born prematurely can survive at 23 weeks, remains to be seen.

Education

In the '70s more and more children received their education in mixed comprehensive schools (introduced in the '60s). At the beginning of the decade boys were out-performing girls. This was not, as some believed, because boys were more intelligent, but because education at that time was gender-stereotyped, the boys attending classes such as science or woodwork, the girls pursuing art subjects or needlework. The Sex Discrimination Act made this form of 'sexism' illegal. Yet girls continued to opt for art subjects that were usually non-vocational and this was to be reflected in their choice of employment. In 1991, for example, it was estimated that approximately half of all female school leavers found work or took up training in the service industry (in caring, catering, hairdressing and retail) and roughly a quarter opted for administrative or clerical positions. Attempts to change attitudes, to widen horizons and to encourage girls to pursue vocational subjects favoured by boys have met with limited success, but the myth that girls are not so intelligent as boys has been well and truly put to rest.

Employment

The majority of women who grew up during the last three decades of the 20th century witnessed the final transformation of Wales from a land dominated by heavy industries such as coal, steel and slate, and by agriculture, to a country in which a service industry (one that provides services but produces nothing) has become a major provider of jobs. Banking, finance and insurance provided employment for both men and women, whereas leisure, tourism and cleaning offered usually low-paid jobs that were taken up mainly by women. Consequently, the number of women of working age who are economically active has risen from approximately 35% in 1971 to 50% in 2001, more than half of them in part-time work. Yet despite the fact that women constitute

half the workforce in Wales, they have not become breadwinners. One reason for this was made apparent by a recent study, which showed that schoolgirls in South Wales anticipate their working life to be disrupted by periods devoted primarily to child-care and by part-time work. Consequently they were not motivated to pursue a career; rather they were prepared to settle for unskilled or semi-skilled work, which is usually poorly paid and offers little prospect of training and promotion.

Another reason why women have not become breadwinners is that Wales is to a large extent gender-segregated where jobs are concerned. This is undoubtedly due to the fact that attitudes as to who does what in the way of work are still rooted in the industrialized past. Men predominate in better-paid craft and related occupations, in managerial and administrative positions, and as plant and machine operatives. Women, on the other hand, tend to settle for low-skilled, low-paid jobs that are already occupied mainly by members of their own sex — jobs that men shy away from — be they secretarial, clerical or cleaning, in shops, hotels or catering. All too often women take these jobs due to their availability, or because such work suits their comfort levels as opposed to pursuing a career with all the commitment that entails. Efforts to break the mould, to change the attitudes of women and employers, have met with limited success: gender-segregation in the Welsh workforce remains as rigid as ever.

There are many mothers who make a positive decision to give priority to caring for their children during pre-school years; others take a different view, and it has long been recognized that the lack of child-care facilities is one of the main reason why so many women do not work, or take on only part-time employment. The demands of child-care prevents them from applying for full-time work, or attending job training schemes, or becoming mature students in the hope of improving their job prospects, and for career women, having children necessitates a break in their careers, which invariably means a loss of seniority and the postponement of advancement; hence the WLM's fourth demand for free 24-hour community-controlled child-care facilities. It was reported in 1996 that 'most countries [within the EU] have achieved or are moving towards comprehensive publicly-funded services for children aged 3-6 years'. Wales, on the other hand, lags behind; hence the high proportion of Welsh women in part-time employment — 50% of the female workforce compared with only 10% of the male workforce. The present Labour Government, however, has made provisions for families below a certain income level to have Child Tax Credit, which they can use to pay for a child-minder. Many local councils provide day nurseries for children over three years of age. Both these options ease the burden for families that cannot afford private child-care.

Feminists also point out that working wives still attend to most household chores and take on more than a fair share of responsibility for children. This

domestic division of labour is deeply ingrained in Welsh culture, but attitudes are changing, albeit slowly. A recent study has shown that women who were born between the two World Wars tend to regard the domestic sphere as their preserve, their view being that men should only be involved in housework when wives are ill or working. Women born between the Second World War and *c*.1970 were found to be more accepting of men's involvement, whereas women born after *c*.1970 'expect' men to help even though they are of the opinion that men are quite useless in the home. For younger women the issue is not whether men should contribute to the housework, but that they are difficult to pin down and their contribution means more trouble than its worth.

Relationships and Parenthood

The 2001 census shows that 37% of all households in Wales were occupied by married couples, 29% by lone persons, 11% by lone parent families and 23% by other compositions, cohabiting couples being one of them.

Much has been said about the decline in marriage during the last 40 years. While it is true the number of females marrying for the first time has dropped by approximately a quarter (from around 18,000 in 1961 to 13,024 in 2001) there has been a tremendous increase in the number of women who re-marry after divorce. In 2001 about 42% of all marriages were unions in which one or both partners had been divorced. Of the 13,024 marriages that took place in Wales in 2001, 56% of them were civil marriages and 44% of them were solemnized in church, two-thirds of them within the Church of Wales. What is also significant is that couples in Wales are, on average, marrying at a later stage in life than they were 30 years ago. In 1971 the average age on marriage was 24.3 years for women, 26.6 years for men. By 1990 the average age on marriage had increased to 27.8 and 30.3 years respectively. The same period witnessed a tremendous drop in the number of teenage brides.

By 2001 the divorce rate in Wales, though lower than in England, has risen to 70 per 1,000 married people. This rise has been due partly to changes in the law, which make it easier to obtain a divorce, and partly to the fact that women are financially less dependant on their husbands than they were 30 years ago; added to which the decline in religion has led to a change in attitudes towards the sanctity of marriage.

In 2001 the percentage of households in Wales that were occupied by cohabiting couples stood at 7%, of which 45% had dependent children. These children constituted 11% of all dependent children. For many couples cohabitation is a temporary arrangement prior to marriage. This is often the case for young couples, or for relationships in which one or both partners are either separated or divorced. In 1986-7 approximately 21% of separated or divorced women were cohabiting.

A lone parent is one who has either never married, or whose marriage has been terminated by divorce or the death of a spouse. In 2001 an estimated 16% of all families in Wales were headed by lone parents, 90% of whom were women, almost half of them either unemployed or claiming at least one type of benefit. About 25% of all dependent children in Wales at that time lived in lone parent households. As with cohabitation, lone parenting is often a temporary situation as many such parents marry or re-marry.

Although there has been a marked increase in the number of teenage pregnancies in Wales, the vast majority of women postpone parenthood far more than they did 30 years ago; moreover, the birth rate for Wales has fallen from 85.1 per 1,000 women aged between 15 and 44 in 1971 to 53.5 per 1,000 in 2001. The number of children born outside marriage has risen dramatically, from approximately 7% of all live births in 1971 to 48% in 2001. In 2001, 63% of all children in Wales lived in married couple households, 25% in lone parent households, 11% with cohabiting couple households, and 1% in other types of households. The number of stillbirths was down to 5 per 1,000 births in 2001, and infant deaths had fallen to an all-time low of 5 per 1,000 infants, which is a tremendous improvement on 213 per 1,000 recorded at Aberdare in the census for 1911.

Profile on Women in 2001

The census for 2001 gives a varied picture of women in Wales at the turn of the 21st century. It shows that, despite attempts to encourage school girls to widen their horizons and raise their career expectations, only a small proportion of them were expected to achieve their full potential in the Welsh workforce; moreover their employment record was likely to fluctuate with periods of unemployment or part-time work according to family commitments. Cohabiting with men whilst in their early twenties was a possibility, but should a woman choose to marry she was most likely to do so between 25 and 34 years of age, and there was a 56% chance that the ceremony would take place in a registry office. If she decided on a church wedding, she was twice as likely to have the ceremony in a building belonging to the established Church in Wales than in any other place of worship. If she had a child, there was a 50% chance that the child would be born outside marriage. There was also a strong possibility that she would in time become a divorcee, usually at her instigation, in which case she was likely to cohabit and then re-marry. Finally, if she survived beyond retirement age, she was twice as likely to reach 75 than a man.

Conclusion

Before addressing the question of 'Where do women in Wales go from here in the next 25 years?' it is necessary to reconsider the past.

2,000 years of Inequality and Servitude

The position of women in Wales during the past 2,000 years is to some extent bound up with whether they had the right to hold property and, in more recent times, whether they could earn a living wage. Apart from what may be surmised, little is known of their position in Roman and Dark Age times. In the Medieval period their position is brought into focus by the Laws of Hywel Dda. According to these laws a woman's place in Welsh society was determined primarily by her status, whether she was free or unfree, and by the fact that she was subject to — though not entirely — the will of her father or her husband. Hywel's Laws recognized her rights, in prescribed circumstances, to separation and divorce, to inherit movable property 'so as to procure a husband', to have a dowry from her husband and, after seven years of marriage, to an equal share in joint property. Without these rights and property she would have been virtually a slave.

In rare circumstances a Welsh woman might acquire land, but the practice of endowing widows with land for life or until they remarried was not introduced until after the conquest of *Pura Wallia* in 1282-3. By the time Hywel's Laws were replaced by English Law in 1536-43 the position of a married woman was that of *feme covert*, which meant that in law she was completely under the domination of her husband. Any property she inherited became, on marriage, her husband's property, which he could do with as he pleased. Divorce was not a consideration until after 1857; even then it was expensive and the prerogative of men. Separation might be permissible in certain circumstances, but the decision rested initially with the church courts and, form 1878 onwards, with magistrates in cases involving violent behaviour or desertion.

With 19th century industrialization came the doctrine of separate spheres, which effectively made married women financially dependent on their husbands, whereas working-class wives in particular became little more than slaves in their own homes. Prior to marriage, many working-class young women had been skivvies in someone else's home, or, if they found alternative work, their rates of pay were so low that it would have been extremely difficult for them to support themselves, reason for them to remain at home and contribute to the family income. They were in many respects trapped by their

dependency on husbands, the family, or in domestic service. The Married Women's Property Act of 1882, however, gave wives the right to both own property and keep any earnings they may have had for doing extras such as washing clothes for the better off.

The right to vote on the same terms as men was something women achieved by their own persistent efforts, the climax of which was the first concerted move by middle- and upper-class women to assert themselves, and improved education opportunities for woman had far more to do with their success than status, the ownership of property or rights in law. The First World War gave hope for better things to come, to all women irre- spective of their class, but the Depression soon put paid to female aspirations. The Second World War provided unprecedented employment opportunities for women; from then on there was no going back. As wage earners in the '50s and '60s working-class women were to experience a better standard of living: electrical gadgets, home improve- ments, furniture on hire purchase, wall-to-wall carpets — it was a time when such women could begin to appreciate the creature comforts of home. The '70s and '80s witnessed the second concerted move by women — mainly educated women — to assert them- selves, to improve their standing in society, to take control of their lives. These were the years that witnessed the introduction of legislation on equal pay, sex discrimination, sepa- rate taxation and moves to end sex role stereotyping in schools (formerly girls had been offered domestic subjects and vocational training such as typing; now they are encour- aged to take similar subjects to boys).

Today women's rights in law are far better than those accorded to them by the Laws of Hywel Dda, and their legal status is immeasurably far better than under English Law in the early Modern period. They are no longer bound by the restrictions imposed upon them by the doctrine of separate spheres, nor of religion, though not all women are prepared to abandon what they consider their traditional role in the home. Women now have a right — on the same terms as men — to vote, to own property, to earn a compa- rable wage, to pursue a career, to run a business and to determine their own sexuality. Undoubtedly, from the late 19th century onwards, their greatest asset has been educa- tion, which enabled them to widen their horizons, to look beyond the home and the communities in which they live. Without education there might never have been a women's suffrage movement, nor a Women's Liberation Movement. Education, in many respects, has been the key to their success in that their perception of who they are has been modified by what they have read and by their relationships with others in the acad- emic world. Indeed, it has been said by more than one mature female student that universities should carry a warning: 'university can seriously damage your marriage'.

Women in the 21st Century — Employment

So where do women in Wales go from here? Radical feminists have argued in favour of equality in all things, a fifty-fifty presence in government, in business management, in the workforce in general, and for a fairer distribution of the domestic workload,

though whether these objectives are achievable remains to be seen. That is not to say a more egalitarian society is unachievable, only that it will take time and be dependent on a change in attitudes. The women's suffrage movement, for example, had been a long running affair, but once partial suffrage had been achieved in 1918 it took only ten years for women to attain the vote on the same terms as men. The women's suffrage movement had, therefore, achieved its aim and today no one would question a woman's right to vote.

The WLM, on the other hand, has witnessed a successful conclusion to its fifth demand (legal and financial independence for women), but has met with limited success in other areas. Take for example pay. In 1986 women in Wales in full-time employment earned on average only 67% of what their male counterparts earned; by 2001 this had changed to 80%. One reason for the remaining 20% pay differential is that, despite the Equal Pay Act of 1970 (which removed only the most blatant inequalities) and the Equal Value amendment of 1983, some employers in 2001 were still offering lower rates to their female employees, confident that the women would not discover the discrepancies in their pay, or, if they did, they would not take them to court. Another reason for the pay differential — and one that is proving a real obstacle to closing the gap — is the rigid gender-segregation in the Welsh work-force, which means too many women cluster in jobs that are still regarded as suitable for women. It remains to be seen whether large numbers of women will break away from the low-paid gender-segregated jobs in the service industry and in offices. Ultimately, it will, for most women, be a matter of choice, of taking jobs that are available in a given locality, or within commuting distance, or settling for employment that suits their comfort levels and fits into their personal circumstances.

In the 30 years or so since its first appearance in Wales the WLM has dissipated, but feminists will continue the fight to eradicate sexism and inequality in education, training, employment and pay, and they will do so in the way they do best — by publicizing their cause, not in as dramatic a fashion as did the suffragettes, but by persistently drawing attention to inequalities wherever they are to found. This kind of strategy was evident in the '90s when mainstreaming was seen as the way forward. Mainstreaming begins with the collection of statistics, which record how many women (compared to men) are in various kinds of employment, how many are in managerial positions and so on. Armed with these statistics, feminists, then, turn their attention to employers in the hope of persuading them to become more female-friendly.

The possibility of another women's movement in the foreseeable future cannot be dismissed, but it is difficult to predict what its objectives might be. Achieving equal opportunities for men and women might, at first hand, be considered the obvious goal, but equal opportunities in education and employment is proving an increasingly complex issue. For a start, equality is no longer about treating men and women the same because, in a male-dominated society, that means treating women as if they were men when, in

fact, they are not the same; they are different both physically and emotionally, and as individuals they have different aspirations.

In her book *Women and Work* (1999), Teresa Rees, EO Commissioner for Wales, stated that 'the legislation [of 1970] raised the level of awareness of issues related to "equal opportunities" in the workplace, but in other respects has been muted in its effect'. Teresa also stated that 'Differences among women are now more apparent [than differences between men and women] on account of class, ethnic origin, the Welsh language, urban and rural location, and disability'. The advantages of class in relation to education and, therefore, employment opportunities are obvious, as are the disadvantages associated with disability or the colour of one's skin, but when issues such as childcare — or the lack of it — are added to the equation, then equal opportunities is not an issue that will be easily resolved.

Women in the 21st Century — Relationships
In the past 2,000 years marriage has changed from the polygamous arrangements of the Celts to the monogamous unions of the Christian era. Today, marriage is in decline. Yet for many women marriage is not simply a bond that satisfies a natural desire for human companionship, it is a commitment, which they see as offering both to themselves and their children stability, security and sense of belonging, which they consider more desirable than independence. The desire for stability, security and a sense of belonging is also apparent among same-sex couples, as evidenced by recent moves to place same-sex relationships on a par with heterosexual marriages. If history provides any clues about the fate of marriage, it may well undergo a revival; if not, the question is, what are the alternatives?

Cohabitation may satisfy a desire for human companionship, but it is not a commitment: it is a convenient arrangement that can be terminated without going to law, one that allows both partners to keep their options open; it may also serve as a trial marriage. There is nothing new about cohabitation. It has fluctuated in popularity (at the expense of marriage) throughout the centuries, sometimes under the guise of a betrothal or some other customary practice such as a besom wedding. In the final analysis the number of women cohabiting at any given time constitute only a minority compared to the number of women who are married.

Undoubtedly, lone parenting is infinitely more desirable than being trapped in an unhappy marriage or cohabitation, but lone parents are often caught in a poverty trap, dependent on state benefit, fearful that if they take a part-time of poorly-paid job, they will lose out on benefit and be no better off; they are also dependent on the support of others, mothers in particular. While lone parenting appears to be on the increase — largely as a result of separation or divorce, or the death of a spouse — it is unlikely to take the place of marriage or cohabitation as most people want to share their lives with someone else, which is why the majority of lone parents eventually cohabitate, marry or remarry.

Women in the 21st Century — the Family

If marriage is here to stay (even though it may no longer be 'until death do us part'), then so is the family — but in what form? The function of the family has in many respects changed over the past 2,000 years. The British Celts, according to Caesar, 'practised a form of polygamy in which the woman had more than one husband, all living in one large house', which suggests the husbands were 'all living in one large house', the women and children having separate quarters. Whatever the truth, the nuclear family (consisting of husband, wife and children) was of little import; rather it was the kindred group that was important, and with so many relatives living in close proximity it is hardly surprising that the Celts were regarded as quarrelsome.

Many aspects of Celtic society are evident in Welsh society of the Medieval period, but there is one noteworthy difference — the Welsh were Christians, which is why their marriages were monogamous, why the nuclear family became the basic social unit, and why, since then, the goal of most couples has been to establish an independent household, free from the constraints of parents and other relatives. The function of the woman within a household differed according to class. The consort of a Welsh prince, for example, was expected to produce heirs, as well as marriageable daughters to cement alliances; beyond that they were relegated to a somewhat autonomous existence, their children fostered on families of inferior status. Among the gentry and the families of industrial magnates of a later age, well-born women were still expected to provide heirs, but they were also responsible for managing the household and improving the relationship between their husbands and the local community, usually by charitable works. Upper-class families placed their children in the care of nannies, governesses or private tutors. Middle-class families sent their sons — if not their daughters — to boarding schools. Peasant wives were expected to provide offspring for assistance and support — at an early age children were expected to assist in the home and in the workplace; in later life they were expected to be a support to parents in sickness and old age.

Families were always large, irrespective of class, but from 1870 onwards couples were beginning to limit their size, prompted perhaps by a growing awareness of the dangers of repeated pregnancies. Working-class couples may also have been influenced from 1880 onwards by compulsory schooling, which made children economically unproductive until they reached their early teens. This decline in the size of families accelerated after the introduction of the pill in the '60s and, today, the number of children born is below what is required to sustain the population. Indeed, the population of Wales would have declined considerably had it not been for the fact that people are living longer.

The notion of regarding children as children in the modern sense is not new — its early development appears in 18th-century literature. In the '60s, when the pill accelerated the decline in the size of families, women had more time to devote to fewer children and were often influenced by so-called child experts. Today, having children is regarded by perhaps the majority of women as a pleasurable, maturing experience, which becomes

even more fulfilling when there are grand-children. Mothers are no longer influenced by dynastic considerations or economic necessity, nor by outmoded demands for strict discipline, though whether recent moves to outlaw smacking will be embraced by the majority of women remains to be seen.

It may be that motherly instincts are the reason why women continue to take greater responsibility for children than men. However, the need to work, or to attain self-fulfilment from a career, conflicts with the demands of motherhood. When women take on both roles, whatever time and effort they devote to one role will always be at the expense of the other. Yet despite this conflict of interest, the family, in spite of its shortcomings, will endure for the simple reason that the alternative — placing children in community-controlled homes — would be unacceptable, for no children's home can provide the stability, security and sense of belonging that only a loving mother can give, irrespective of whether she is the natural, adoptive or foster-mother of a child.

Other Considerations

From time to time the media reports on reproductive issues such as artificial insemination, *in vitro* fertilization, cloning, the prospect of designer babies and the like, all of which have a tremendous impact on women who wish to conceive other than by the sexual act. All too often conception under these circumstances can result in costly legal actions. What may prove to be yet another moral and legal minefield, or simply a blessing is that it is predicted that by 2025 there will be mass use of artificial wombs into which women will have their embryos placed, thereby reducing the length of gestation, leaving them free to further their careers.

There are, of course, other considerations that will have a bearing on where women in Wales go from here. At the moment we live in stable and prosperous times. We have no right to assume that it will always be so, or that western nations will continue to be the more affluent. People are on the move, either seeking asylum, or in search of a more prosperous existence, and the movement is on a seemingly unprecedented scale, perhaps more so than during the 5th-century collapse of the Roman Empire. There may be natural disasters — the effects of global warming being one of them. There may be wars, epidemics and food shortages. There will almost certainly be recessions. Any catastrophic occurrence could seriously effect both stability and prosperity, which in turn would effect job opportunities and education.

Whatever the future may hold, some women will want to be home-makers, others will pursue a career and some will elect to combine the two as best they can. Whatever their choice, one thing is certain: the women of Wales will show an independence of mind; they will, as individuals, do what they want to do. They may, as young women, yield to peer pressure and prevailing attitudes, but as mature adults they will, when pressed, speak their mind, dig their heels in and show how spirited they really are — all 1½ million of them.

Further Reading

Welsh Tribal Law and Customs in the March, by T.P. Ellis (1926)

Geraldus Cambrensis: The Itinerary through Wales and the Description of Wales, Sir Richard Colt Hoare

The Welsh Law of Women, D. Jenkins & M.E. Owen (eds.), Cardiff, 1980

The Mabinogion, Revised edition, translated by Gwyn Jones and Thomas Jones, 1989

The Twilight of Welsh Law, R.R. Davies, 1966

Katheryn of Berain: A Study in North Wales Family History, John Ballinger, 1929

Dafydd ap Gwilym, Poems - a selection of poems, Rachel Bromwich, 1987

Class, Community and Culture in Tudor Wales, ed. J. Gwynfor Jones, 1989

Women & Gender in Early Modern Wales, ed. Michael Roberts and Simone Clarke 2000

For Better or Worse: British Marriages 1600 to the Present Day, John R. Gillis, 1985

Lewis Morris ac arferion priodi yng Ngheredigion (Lewis Morris and marriage customs in Cardiganshire), Dafydd Ifans (Ceredigion vol. VIII 2, pp. 193-203)

West Glam Customs, Folk III, p. 50-52, Trefor Owen

Welsh Costume in the 18th and 19th Century, Ken Etheridge

Women of Wales, Leonard T. Davies and Averyl Edwards, 1935

The Dragon Has Two Tongues: Welsh Women's History — available at the Gwynedd Archives Service and the Miners' Library, Swansea

Welsh Convict Women, Prof. Deirdre Beddoe, 1979

Crime in Nineteenth-century Wales, David J.V. Jones

Coal Society, David Egan

Our Mothers' Land: Chapters in Welsh Women's History 1830-1939, A.V. John, 1991

Our Sisters' Land: The Changing Identities of Women in Wales, ed. Jane Aaron

The Men of the Mumbles Head, Carl Smith

Amy Dillwyn, David Painting

Out of the Shadows, Prof. Deirdre Beddoe, 2000

Women: Wales and the Second World War, Fay Swain

The Family & Social Change: A Study of Family & Kinship in a South Wales Town, C. Rosser and C. Harris, 1965

Women in Wales: A Document of Recent History, Luana Dee

Abortion: Whose Right? Ellie Dee

Women and Work: 25 years of Gender Equality in Wales, Teresa Rees, 1999

Index

BY THE SAME AUTHOR

A History of Gower

ISBN 1-873827-13-X

162 pp. Illustrated. Card cover

Logaston Press, 2002 £9.95

This book covers the history of Gower and Swansea from Roman times to the mid-19th century. It tells of Celtic saints, of how the Welsh lived before and after the arrival of Anglo-Norman conquistadors. With the aid of maps and pictures, it gives insight into how the landscape was shaped by English settlement and how Swansea came into existence. For 200 years battle lines were drawn, castles attacked, towns burned, to be followed by plagues and finally a more peaceful coexistence, both sides benefiting from the growing prosperity of Tudor times. Swansea had a part to play during the Civil War, gun-running for the king, changing sides in the face of opposing forces. In the 18th century smugglers were active in the peninsula, and the growing coal industry in the Swansea Valley was to lay the foundations for Swansea to expand and become the copper metropolis of the world, home to the Vivians, Dillwyns and other industrial magnates.

BY THE SAME AUTHOR

The People of Gower
ISBN 0-9546544-0-4
136 pp. Illustrated. Card cover
Draisey Publishing, 2003 £9.95

This book tells the story of man's presence in the Gower Peninsula and its upland extension between the Tawe and Loughor rivers. What happened in this unique area, where man's past achievements in earth and stone abound, is a reflection, albeit on a smaller scale, of the rise and fall of successive cultures that existed in Wales and, indeed, mainland Britain from Stone Age times to c.1400.

The people who spearheaded these intrusive, often invasive cultures settled, initially, in relatively small numbers in the coastal lowlands where they coexisted with, and eventually imposed much of their cultural identity on the indigenous inhabitants, leaving the natives in the upland areas to carry on in their time-honoured ways for centuries until they, too, became absorbed into the intrusive cultures.

Some newcomers, like those who initiated the Neolithic period, introduced farming, and in the remains of their megalithic tombs the bones of their dead show them to be the ancestors of the short, swarthy Welshmen of historic times. Others, such as the Celts, appear to have established themselves as a warrior aristocracy, bringing with them a language which, although subject to change, has survived to the present day. Above all it was the Anglo-Saxons and later Norman-dominated English who imposed an overwhelming cultural identity on mainland Britain and, in doing so in Wales, shaped the Gower landscape that we know today.